Plantation Homes

of Louisiana and the Natchez Area

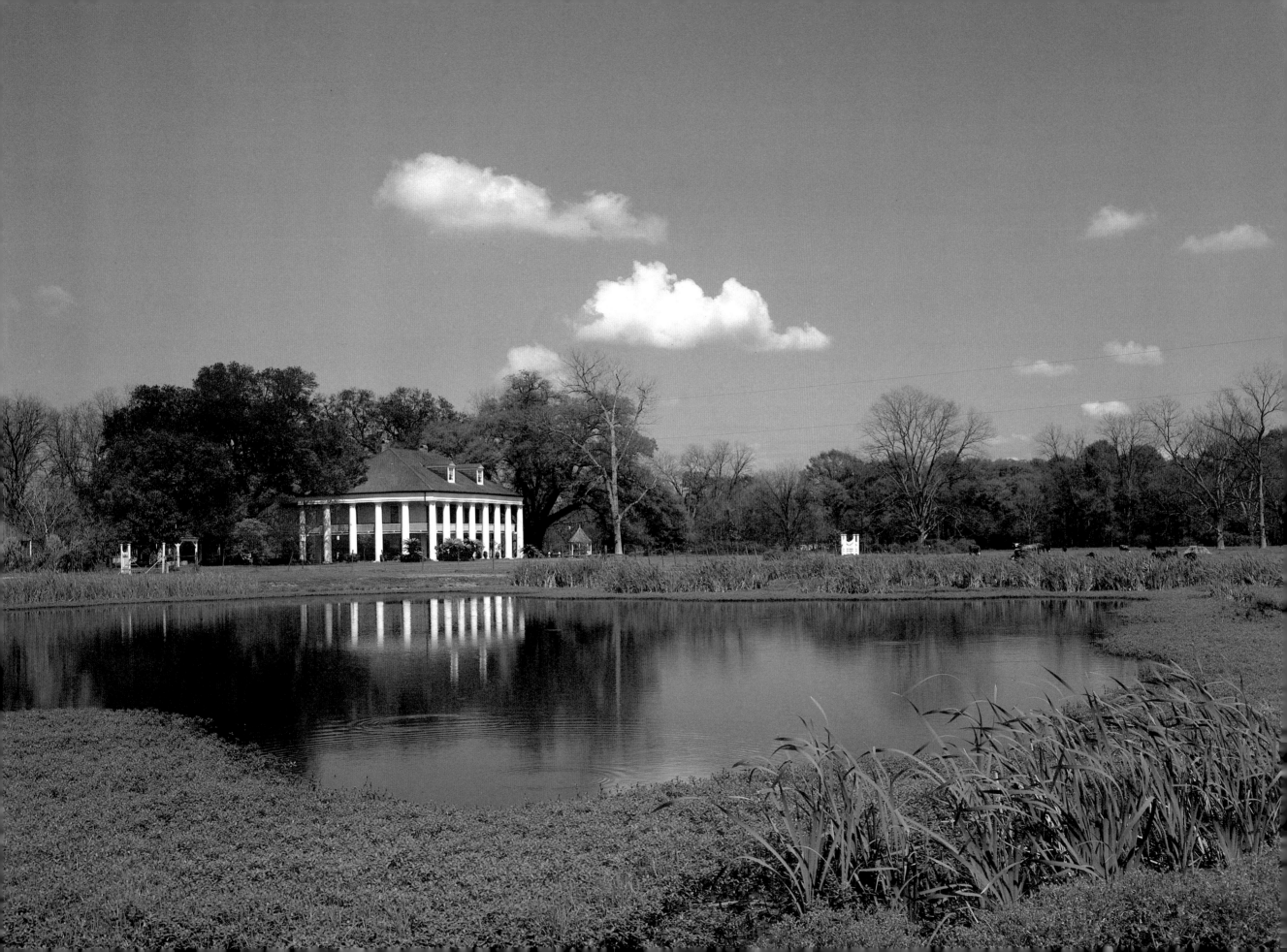

Plantation Homes

of Louisiana and the Natchez Area

Photographs and text by
David King Gleason

Louisiana State University Press
Baton Rouge and London

For my wife, Josie

Copyright © 1982 by Louisiana State University Press
All rights reserved
Designer: Joanna Hill
Typeface: Trump Mediaeval
Typesetter: G & S Typesetters, Austin, Texas
Printer and Binder: Dai Nippon, Tokyo, Japan

Library of Congress Cataloging in Publication Data

Gleason, David K.
 Plantation homes of Louisiana and the Natchez area.
 1. Historic buildings—Louisiana—Pictorial works.
2. Plantations—Louisiana—Pictorial works. 3. Louisi-
ana—Description and travel—1981– —Views. I. Title
F370.G56 976.3 82-7723
ISBN 0-8071-1058-2 AACR2

The author gratefully acknowledges the assistance of
Gisela O'Brien, who made the color prints for this book;
Donna Hall, who made the black and white prints; and
Craig Saucier, who served as research assistant.

Third printing (February, 1984)

Contents

Preface vii
A Note on the Architecture ix

New Orleans and the Lower Mississippi

Magnolia 3
Mary 4
Orange Grove 5
Kenilworth 7
Beauregard House 8
Pitot House 9
Seven Oaks 10
Destrehan 12
Home Place 13
Evergreen 14

San Francisco 16
Valcour Aime 17
Felicity 19
Oak Alley 20
Welham 22
Jefferson College 23
Tezcuco 24
Houmas House 25
Bocage 27
L'Hermitage 28

Along the Bayous

Belle Alliance 31
Madewood 32
Ducros 33
Rienzi 34
Rosella 35
Arlington 36
Oaklawn Manor 37
Last Island 38
Irish Bend 39
Shadows-on-the-Teche 40
Bayside 41
Darby House 42

Acadian House Museum 44
Lady of the Lake 45
Chretien Point 46
Hinckley 48
Magnolia Ridge 49
Macland 50
Homeplace 51
Sunflower 52
Oakwold 53
Bubenzer 54
Wytchwood 55
Loyd's Hall 56

Cane River Country and North Louisiana

Magnolia 59
Melrose 60
Oakland 61
St. Maurice 63

Land's End 64
Layton Castle 65
Arlington 66

The Natchez Area and Downriver

Winter Quarters 69
Windsor Castle 70
Springfield 71
The Burn 72
Monmouth 73
D'Evereux 74
Auburn 75
Elms Court 76
Dunleith 77
Rosalie 79
Stanton Hall 80
Longwood 81
Cherry Grove 82
Rosemont 83
Richland 84
The Shades 85
East Feliciana Parish Courthouse
 and Lawyers' Row 86
Asphodel 87
Oakley 89
Rosedown 90
The Myrtles 91
The Cottage 92
Waverly 93

Afton Villa 94
Highland 95
Oakland 97
Live Oak 98
Ellerslie 99
Greenwood 100
Como 102
The Last Cabin 103
Labatut 104
Parlange 105
Valverda 106
Mound House 107
Live Oaks 108
Trinity 110
Monte Vista 111
Stewart-Dougherty 112
Magnolia Mound 113
Mount Hope 115
Tally-Ho 116
Nottoway 118
Indian Camp 123
Mulberry Grove 124
Belle Helene 126

Notes on Photography 131
Index 133

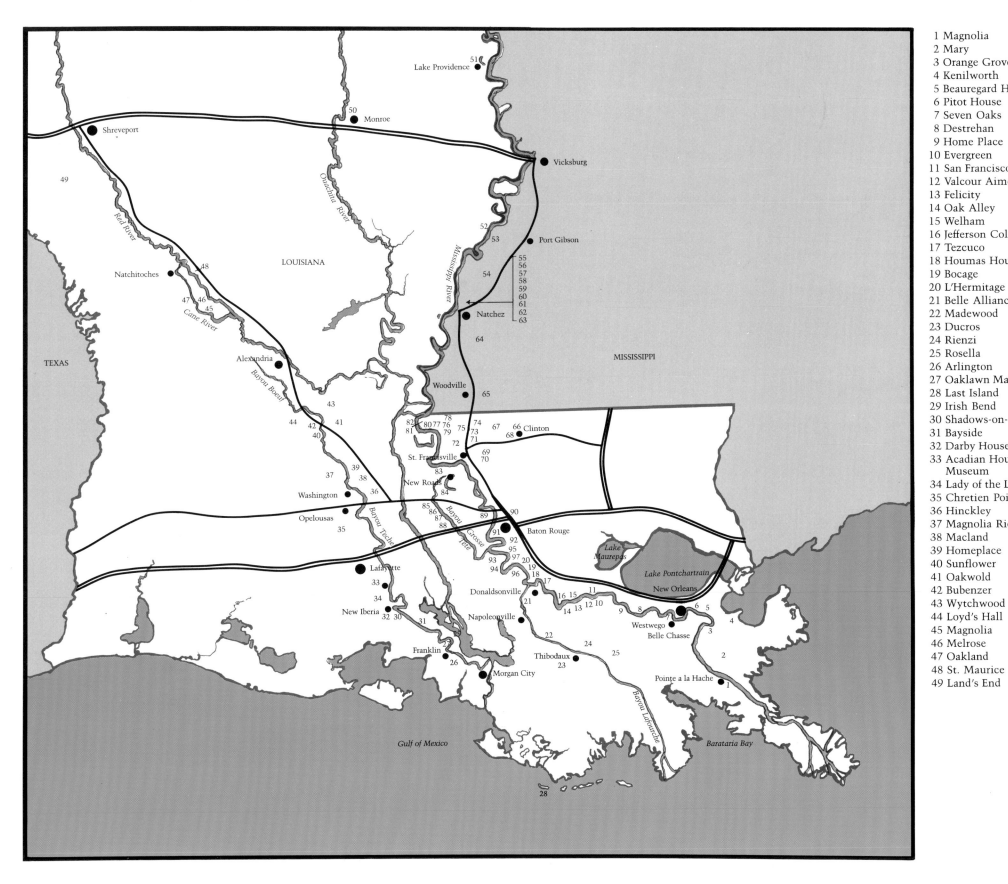

1 Magnolia
2 Mary
3 Orange Grove
4 Kenilworth
5 Beauregard House
6 Pitot House
7 Seven Oaks
8 Destrehan
9 Home Place
10 Evergreen
11 San Francisco
12 Valcour Aime
13 Felicity
14 Oak Alley
15 Welham
16 Jefferson College
17 Tezcuco
18 Houmas House
19 Bocage
20 L'Hermitage
21 Belle Alliance
22 Madewood
23 Ducros
24 Rienzi
25 Rosella
26 Arlington
27 Oaklawn Manor
28 Last Island
29 Irish Bend
30 Shadows-on-the-Teche
31 Bayside
32 Darby House
33 Acadian House
 Museum
34 Lady of the Lake
35 Chretien Point
36 Hinckley
37 Magnolia Ridge
38 Macland
39 Homeplace
40 Sunflower
41 Oakwold
42 Bubenzer
43 Wytchwood
44 Loyd's Hall
45 Magnolia
46 Melrose
47 Oakland
48 St. Maurice
49 Land's End

50 Layton Castle
51 Arlington
52 Winter Quarters
53 Windsor Castle
54 Springfield
55 The Burn
56 Monmouth
57 D'Evereux
58 Auburn
59 Elms Court
60 Dunleith
61 Rosalie
62 Stanton Hall
63 Longwood
64 Cherry Grove
65 Rosemont
66 Richland
67 The Shades
68 East Feliciana Parish
 Courthouse and
 Lawyers' Row
69 Asphodel
70 Oakley
71 Rosedown
72 The Myrtles
73 The Cottage
74 Waverly
75 Afton Villa
76 Highland
77 Live Oak
78 Oakland
79 Ellerslie
80 Greenwood
81 Como
82 The Last Cabin
83 Labatut
84 Parlange
85 Valverda
86 Mound House
87 Live Oaks
88 Trinity
89 Monte Vista
90 Stewart-Dougherty
91 Magnolia Mound
92 Mount Hope
93 Tally-Ho
94 Nottoway
95 Indian Camp
96 Mulberry Grove
97 Belle Helene

Preface

If one traveled by steamboat, and the bayous were still navigable in their upper reaches, as they were in the 1800s, then this book would be a useful guide to the old plantation houses of Louisiana and also provide a glimpse of houses in the Natchez area. For this is how we shall view these charming and handsome homes, by steamboat, following the waterways along which they were built, proceeding up the Mississippi to New Orleans and beyond to Donaldsonville, turning down Bayou Lafourche and then heading west to Bayou Teche, continuing into the Evangeline country near Lafayette.

We'll travel on to Washington, a steamboat town at the juncture of three bayous near Opelousas, and turn north toward Alexandria along Bayou Boeuf. Then we'll head northwest to Cane River country, the old course of the Red River, which flowed by Natchitoches, the oldest city in the Louisiana Purchase, and continue to northwest Louisiana.

At this point we'll head overland eastward to Monroe, another steamboat town, on the banks of the Ouachita River, and rejoin the Mississippi at Lake Providence, an old bed of the great Father of Waters. We'll steam downriver toward Natchez, once a part of territorial Louisiana, make a brief visit there, and make our way overland to the Feliciana parishes north of Baton Rouge. We'll join the river above St. Francisville, making a stop on False River, and continue south along Bayou Grosse Tête. We'll rejoin the Mississippi at Baton Rouge and follow its winding course toward Donaldsonville and New Orleans.

In the 1850s more millionaires were to be found between Natchez and New Orleans than in the rest of the seventy-five-year-old republic, and a stately procession of their great mansions overlooked the banks of the Mississippi River. New Orleans, still strongly French and acquired by the young nation less than fifty years earlier, was in terms of exports the nation's largest port. Louisiana's population had exploded tenfold in that interval to over 700,000.

Considered a liability by the French and Spanish, this territory along the lower reaches of the Mississippi generated tremendous wealth and created a style of life that to many has not since been equaled.

Four events contributed to this rapid growth in the Delta country. In the 1790s Eli Whitney found an effective way to remove seeds from cotton, and Etienne de Boré developed a process, in New Orleans, to granulate sugar. In 1803 Napoleon sold the Louisiana territory to the United States, and in 1811 Robert Fulton invented his steamboat.

Modified five years later by Captain Henry Shreve to handle the shifting, sometimes treacherous waters of the Delta, the steamboat made accessible the fertile, virgin lands along Louisiana's uncounted waterways, allowing planters moving in from the East to meet the ever-increasing demand for cotton and sugar.

Fortunes could be created almost overnight. The area between Natchez and New Orleans attracted scores of would-be entrepreneurs not only from the older slave states of the Atlantic coast but also from the North and from Europe. Doctors, lawyers, and merchants plowed their profits into slaves and land and quickly became planters—a planter being defined as one who owned over thirty slaves.

While the production of cotton was lucrative, sugar offered the potential for even greater wealth. It also carried the greater risk. Three good years could make a millionaire, but three successive years of early frost, hurricane, or flood could consume a fortune. Sugar also required a far greater outlay of capital to enter the business. Along the Mississippi, the saying went, it took a rich cotton planter to become a poor cane farmer. In addition to the manpower necessary to plant, cultivate, and harvest the cane, the planter also had to construct his own sugar mill and equip it with the heavy steam-driven machinery required to squeeze the sweet juice from the cane, cook it in vacuum pans, and granulate it into a marketable product.

Because of the dangers of early frost, cane cultivation took place primarily below the 31st parallel, which divided the Feliciana parishes of Louisiana from the Natchez district of Mississippi.

The great wealth generated by cane and cotton allowed planters to live in a princely style. They traveled worldwide, returning with English clothing, French wallpaper, and Greek and Italian statuary. Skilled artisans and furniture-makers came from Europe and New England and remained in the Delta for thirty years, their services in ever-increasing demand.

The banks of the Mississippi became a showplace for white-columned mansions, each larger than the last, each overlooking the broad avenue of the river, and each surveying its own rich alluvial fields to the rear, planted in cane and cotton, extending toward the horizon.

If the rewards for a successful operation were princely, then the plantation itself was feudal, a little kingdom, complete within itself. It produced its own food, fiber, and shelter. The master's house was regal, exquisitely appointed, with the latest accessories of an expanding technology. Louisiana mansions were among the first to have their own gas plants for illumination, hot running water and indoor plumbing, and a bell system that brought house servants to a specific room.

The plantation had its own hospital, chapel, and even served as a hotel. Suitors were put up in the garçonnière, a separate structure for young men. Guests brought their personal body servants and trunks of clothing to stay for weeks.

Planters' families traveled regularly. New Orleans, with the first opera house in the country, and Natchez with its sparkling society, were not far from the plantation by steamboat at any time. They summered at favorite watering spots in the North, and toured, and were sometimes educated on, the continent.

It was not an entirely idyllic existence, however. Young wives died in childbirth, and families were shattered by disease. New Orleans, a city of 170,000 in the summer of 1853, suffered over 40,000 cases of yellow fever, in the largest epidemic on record in the antebellum South.

The Civil War, of course, destroyed the planter's capital investment when it eliminated the institution of slavery. The great house became a liability, if it had not been burned by Union troops, and often became a refuge for squatters or a barn for cattle, with hay strewn on a polished ballroom floor and chickens on the veranda.

The Mississippi continued its centuries-old habit of meandering through its floodplain, and swallowed a number of great mansions too large to be moved. Other manor houses were destroyed by fire, set either by lightning or drifters, or by the twentieth-century practice of bringing the kitchen into the main building. Still others were acquired by absentee owners who had purchased the surrounding acreage for investment purposes, and were simply allowed to decay, ravaged by looters.

Of the great procession of mansions along the rivers and bayous of Louisiana, only a few remain, but an infusion of new capital into the Delta and a renewed interest in the heritage of the area have encouraged the state, corporations, and individuals to preserve a number of plantation homes, retaining a gentle reminder of an earlier age of grace and chivalry.

A Note on the Architecture

by William R. Brockway
Fellow, American Institute of Architects

The plantation architecture of Louisiana and the Natchez area is a rich blend of many ingredients. In the examples still standing, we may read the political, social, economic, and technological history of a proud and independent people.

The earliest settlers were displaced Europeans, principally French and Spanish and, at a later date, English. Each wave of migrants brought architectural concepts from these other societies, altering designs as necessary to cope with the exigencies of climate, available building materials, and personal wealth.

Thus, we can detect a certain family resemblance between many early eighteenth-century Louisiana houses and contemporary structures farther north in Canada and the Illinois country. The Villeneuve House in Charlesbourg, Province of Quebec (eighteenth century) and the Saucier House in Cahokia, Illinois (ca. 1735) appear as precursors of such well-known southern homes as Parlange in Pointe Coupe Parish (ca. 1750) and Magnolia Mound in Baton Rouge (ca. 1791).

A curious thing happened, however, as the French tradition moved south. Although the essential large bonnet roof and structural frame of widely spaced posts with brick or mud and moss infilling were retained, the roof overhang became wider and galleries were often added on one or more sides of the house. The ceilings became higher, window and door openings were enlarged, and the living floor was raised out of contact with the ground. All of these changes were concessions to the hot, humid climate and ground damp of the lower Mississippi valley.

There are fewer examples left of domestic architecture from the Spanish period, and a clear metamorphosis is not so easy to rationalize as with the French. Perhaps the Spanish were more adaptable. They built heavy adobe houses with small openings and flat roofs in the American Southwest and raised houses with high roofs, galleries, and louvered openings in the West Indies. Most of the southern houses remaining from the Spanish period we now recognize as variants of the West Indies form, a classic example being the Pitot House in New Orleans (ca. 1790).

Eventually, the French and Spanish houses began to look somewhat alike. There is little doubt that one borrowed from the other, and the resulting hybrid was the classic Creole raised cottage— with above-ground basement floor on heavy masonry piers, high-ceilinged second floor with light wooden posts or columns, and steep-sloped hipped roof with at least one full gallery across the front.

The structural materials for these houses came from the land. Brick was burned from local clay. (There are records of brick production in New Orleans as early as 1725.) Timber was cut from local cypress and pine. Shingles were split from cypress. Infilling for the wood frame structure (*colombage*) was either brick (*briquete entre poteaux*) or clay mixed with Spanish moss plastered over split wooden laths (*bousillage*). Since both the brick and the mud infills had a tendency to leak and weather badly, walls were frequently covered with either wooden weather boards or plaster. About the only imported building materials were glass, some hardware, and, in later years, fireplace fronts and slate shingles.

Following the Louisiana Purchase, wealthier planters began to demand the Revival styles that were becoming popular farther east. The earliest examples were, as one might expect, the more or less standard plantation style, with Classical features added. A good example of this transitional style is l'Hermitage near Burnside (ca. 1812). The interiors of Magnolia Mound in Baton Rouge (ca. 1791) are of Federalist styling, though the house itself is fairly typical Louisiana plantation design. It is one of the few domestic examples of Federalist architecture in the state. Rosedown, near St. Francisville (1835) is a stylistic blend of Greek Revival and the English house types found in the Feliciana parishes. The Classical details of this house belie its early date. Later houses, such as Evergreen near Edgard (1840) and Houmas House near Burnside (1840), began to appear more strongly Classical Revival and less regional.

With the emergence of architecture as a profession, and the proliferation of builders' handbooks by Minard LaFever, Asher Benjamin, and others, the plantations and manors of the area entered into the grand era in which each tried to outdo the other. Belle Grove, attributed to Henry Howard, and Nottoway, by the same architect, both near White Castle, both built in 1857, competed for the title of largest house in Louisiana. Nottoway won. Both houses were atypical, eastern-influenced Classical Revival. Another Howard house, Indian Camp near Carville (1850), exhibits the same stylistic influence. Belle Helene near Geismar (1841), attributed to James Gallier, is severe Classical Revival, but on a gargantuan scale, boasting galleries twenty feet wide. There were Gothic examples, too, such as Afton Villa near St. Francisville (1849), San Francisco near Garyville (1850), and Orange Grove near Braithwaite (1850). Because the Civil War effectively put a stop to the construction of large plantation manors in the South, there are practically no examples of decadent Revival styles to be found.

This is a book that visually narrates the development of lower Mississippi valley plantation architecture from its earliest forms to its final flowering just before the war. The photographs are the result of more than fifteen years of concentrated effort by David Gleason. They represent the most comprehensive and sensitive presentation of the subject it has been my privilege to see.

New Orleans
and the
Lower Mississippi

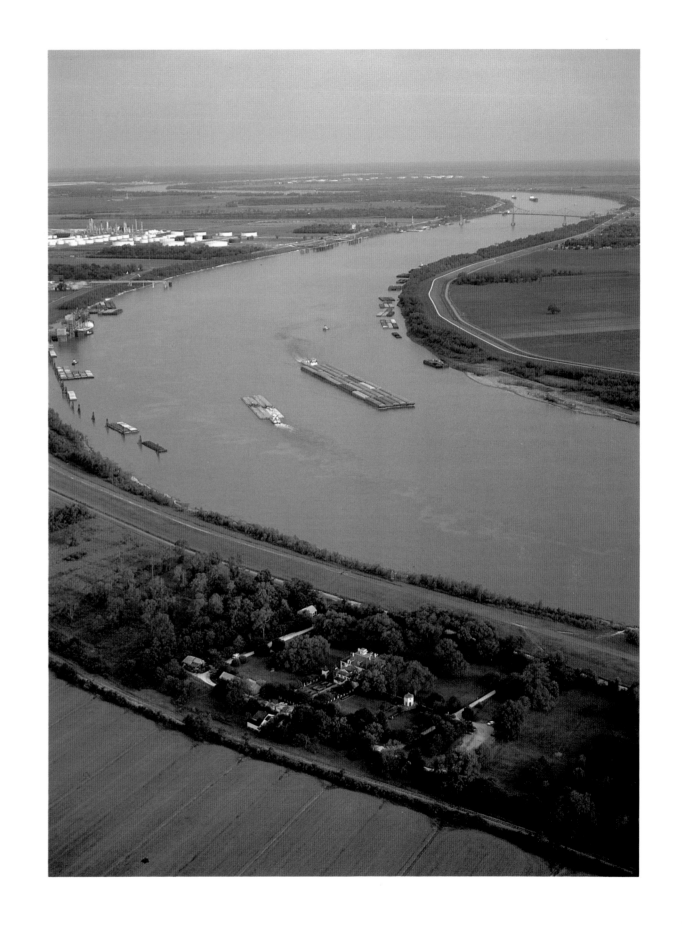

Orange Grove, 1850

Orange Grove, or Braithwaite, stands on private grounds south of New Orleans, on the East Bank near Braithwaite.

One of the antebellum culture's truly unique houses, the great manor house featured a number of innovations, including a below-ground, brick-floored basement, central heating, and hot running water.

Orange Grove was completed in 1850 by a Phila-delphian, Thomas Ashton Morgan, a shipping mag-nate who purchased four miles of river frontage below New Orleans and became a cane planter. At the center of his holdings he built Orange Grove, in the Gothic Revival style.

The main floor had a center hall and four large rooms with 20-foot ceilings, marble-tiled floors, and an ornate spiral stairway leading to the six rooms on each of the second and third floors. Deli-cately ornamented, the windows were of stained glass. The roof was slate.

Orange Grove was gutted by fire in early 1982.

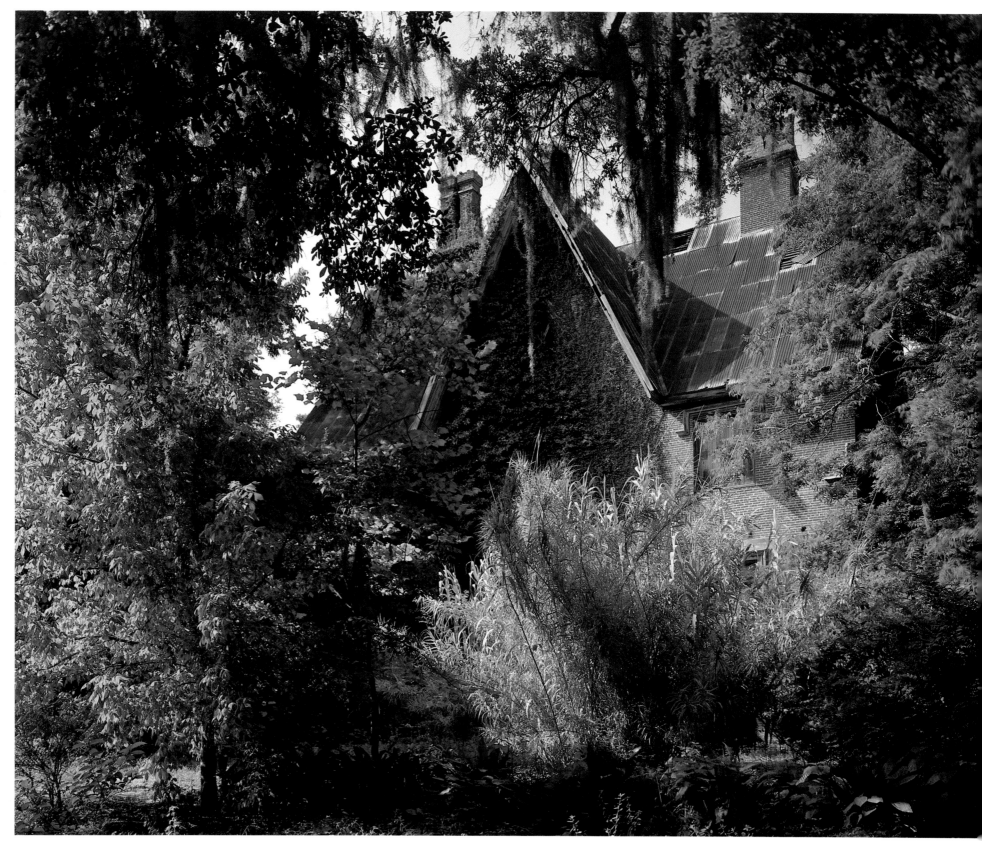

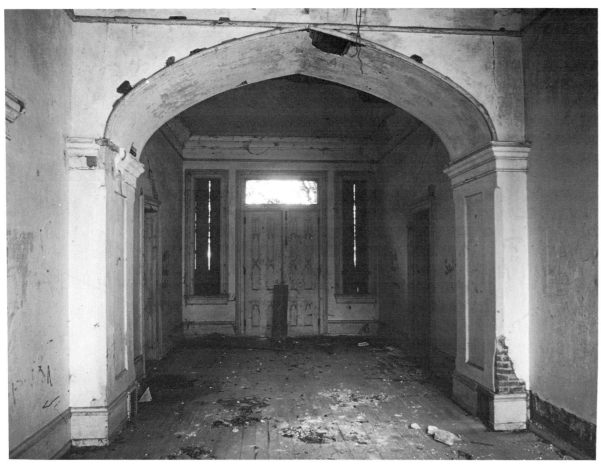

The great hall in Orange Grove originally had a
floor of black and white marble tiles, but before the
fire these were removed by vandals, along with a
great stair climbing three stories, and the doors and
silver doorknobs.

In an aerial photograph, only the rusted roof of
Orange Grove rose above the near-jungle of its de-
serted grounds. (*right*)

Kenilworth, 1759

Lying east and south of New Orleans, about five miles east of Poydras, is Kenilworth, named by the English-educated granddaughter of Pierre Antoine Bienvenu, who came from Canada in 1725 and in 1759 erected the first part of Kenilworth, a one-story Spanish blockhouse. An additional story and a half were added in the early 1800s.

Kenilworth plantation at one time comprised over 12,000 acres, and on its property was fought part of the Battle of New Orleans in 1815. The house, restored by Dr. and Mrs. Val Acosta, is now their family home.

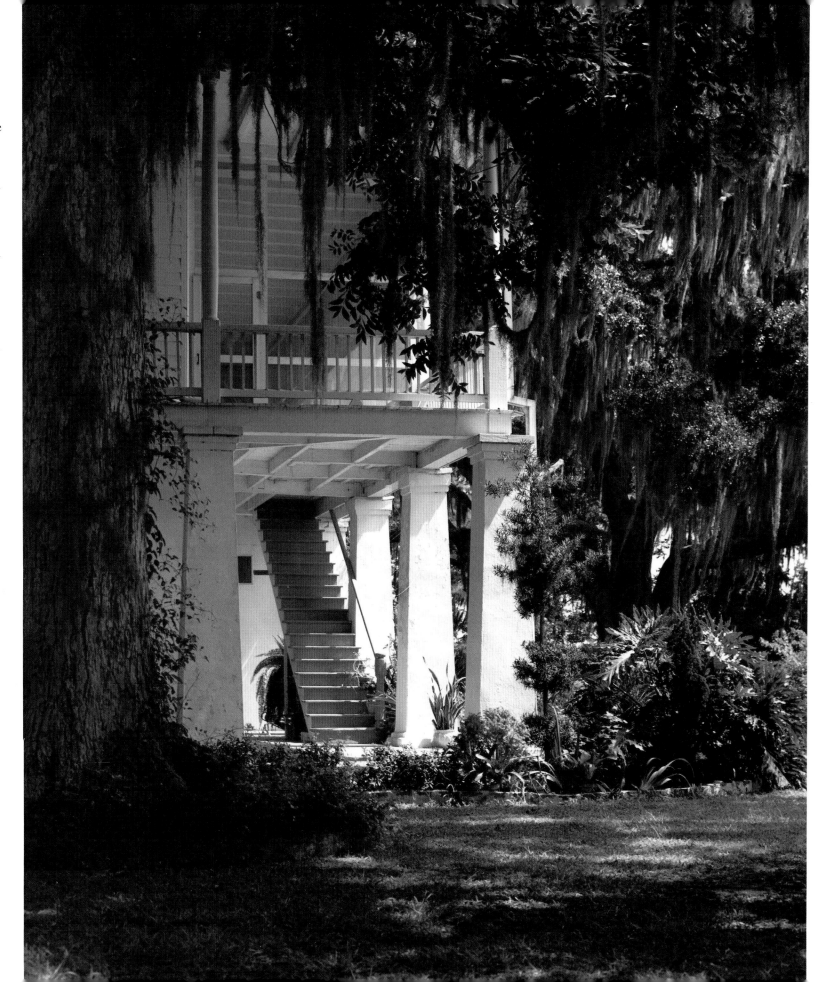

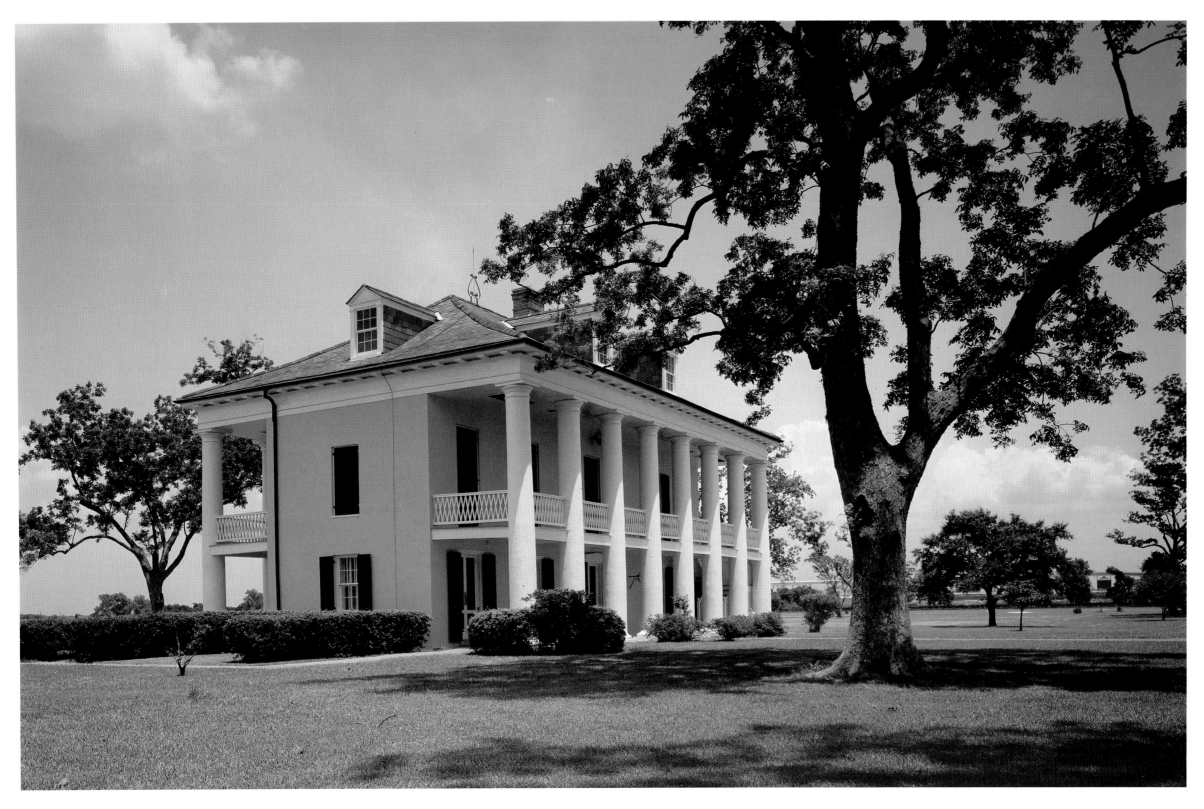

Beauregard House, 1840

Built in 1840, Beauregard House is situated on the Chalmette Battlefield just below New Orleans, where, in 1815, General Andrew Jackson led American forces to an overwhelming victory over the British in the War of 1812.

The house, only one room deep, was later occupied by Judge René Beauregard, son of General P. G. T. Beauregard.

Owned and restored by the National Park Service, Beauregard House now serves as the visitor center for the Chalmette National Historic Park.

Pitot House, 1790

Built by Don Santiago Lorreins about 1790 on the east bank of Bayou St. John near New Orleans, this modest yet handsome structure was acquired in 1809 by James Pitot. A native of France who came to Louisiana via Philadelphia in 1796, Pitot became the first mayor of the incorporated city of New Orleans.

Scheduled for demolition in 1963, the home was donated by the Missionary Sisters of the Sacred Heart to the Louisiana Landmark Society and moved to an adjacent site. Now beautifully restored, Pitot House is open to the public.

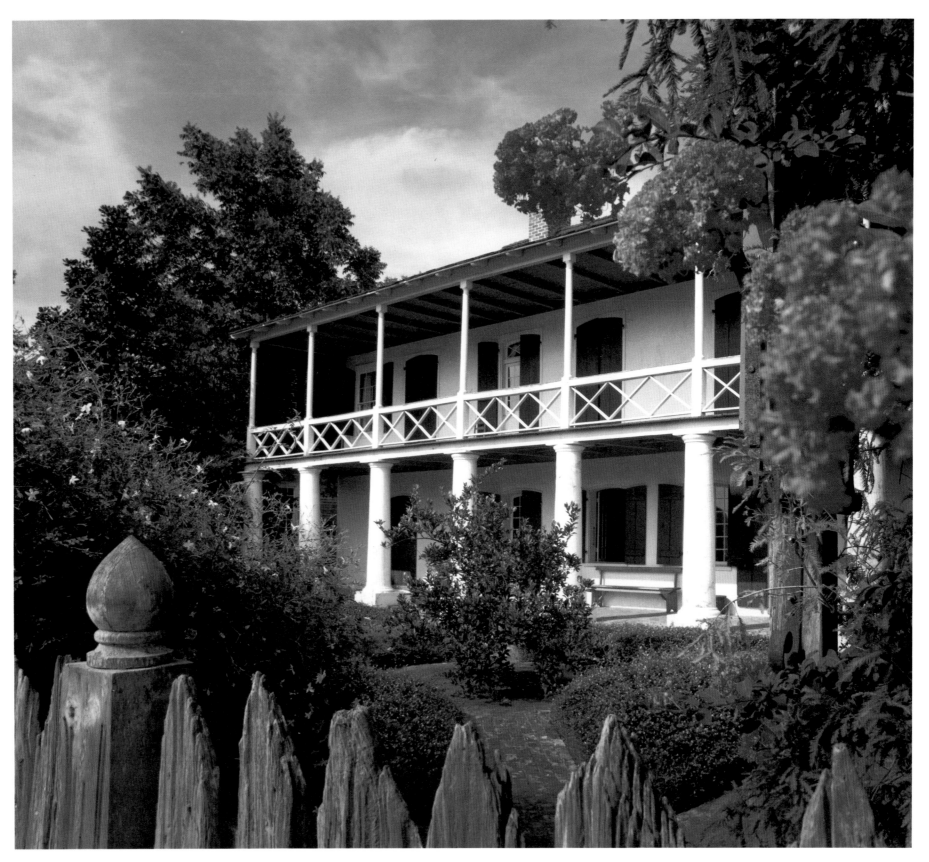

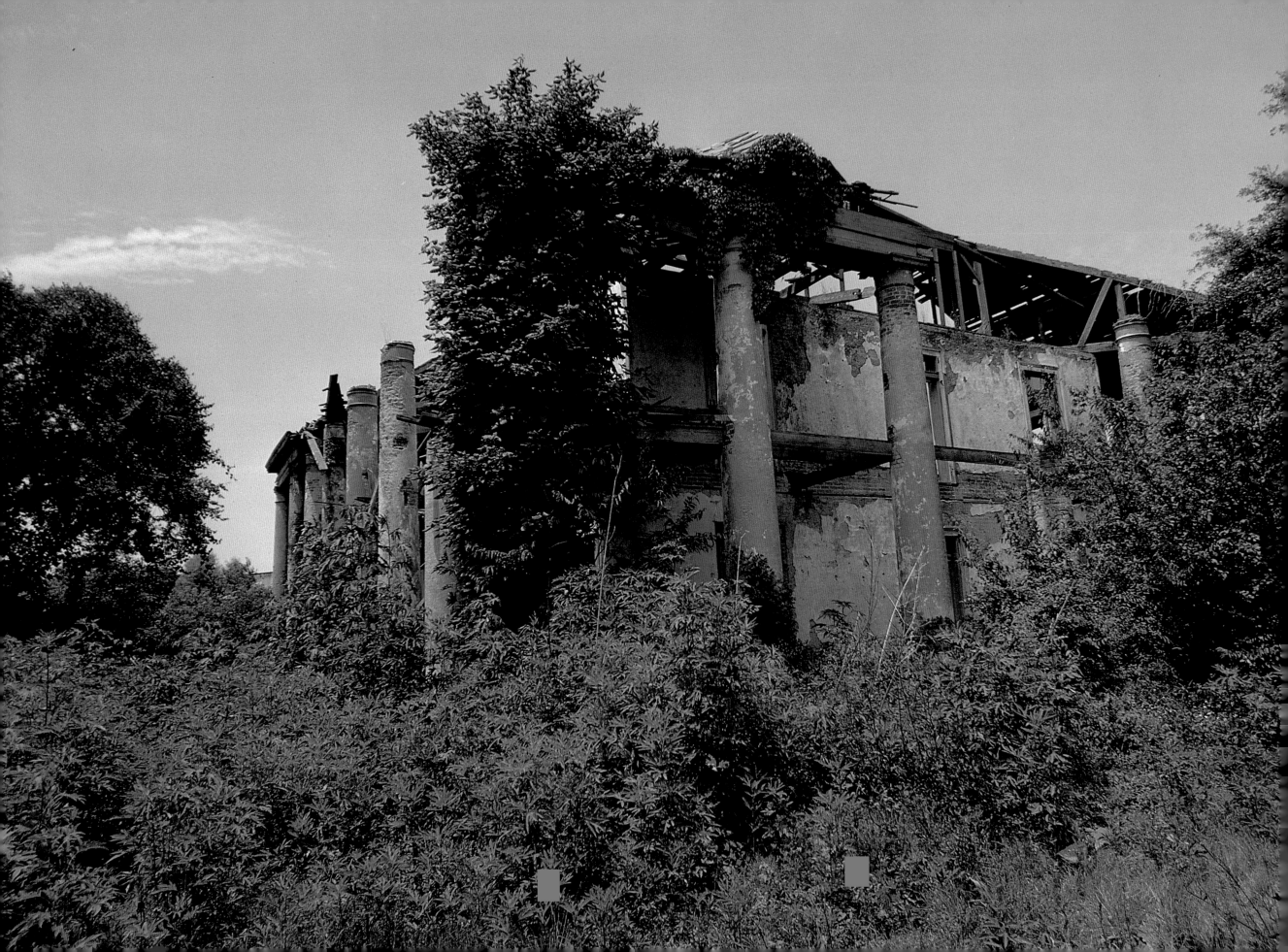

Magnolia, *ca.* 1795

One of the first large plantation homes to be built between New Orleans and the Gulf of Mexico, Magnolia was constructed by two river captains, George Bradish and William Johnson, in 1795.

Rising 2½ stories, the home featured 20-inch-thick brick walls, with all materials except hardware prepared at the plantation.

Mark Twain, who spoke of his visit to Magnolia in *Life on the Mississippi*, mentioned a "fruitful orange grove of 5,000 trees," many of which survived with the house through many years. At the rear of the grove was a large sugar mill, one of the state's first.

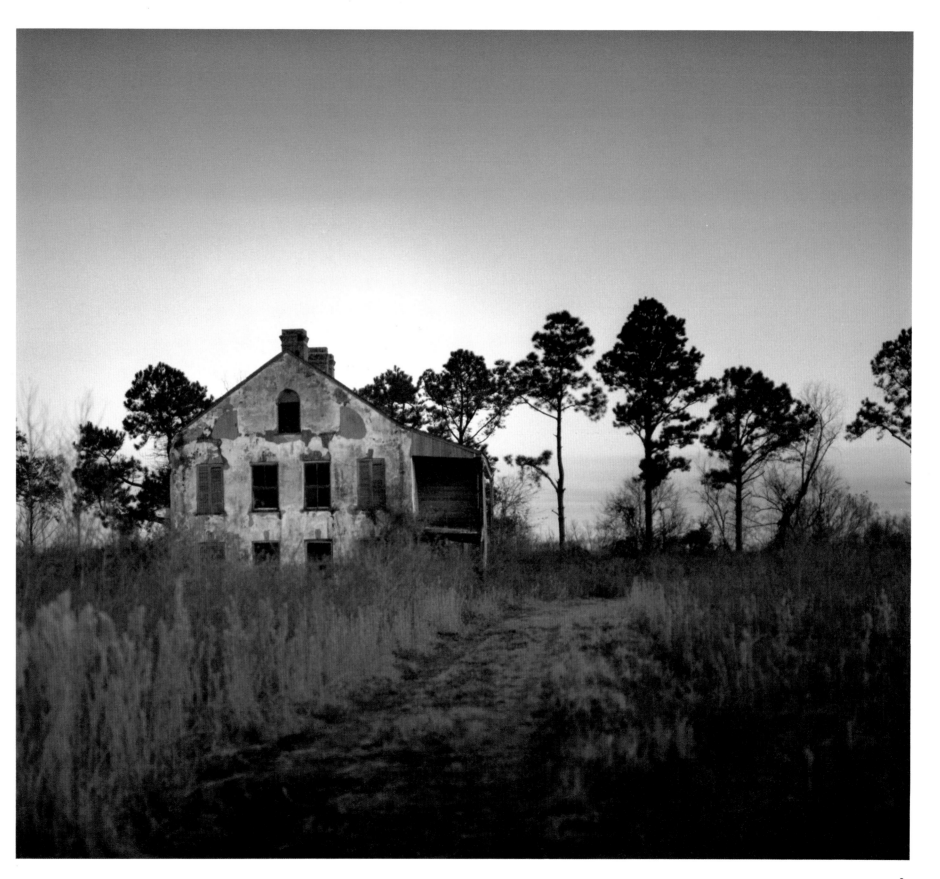

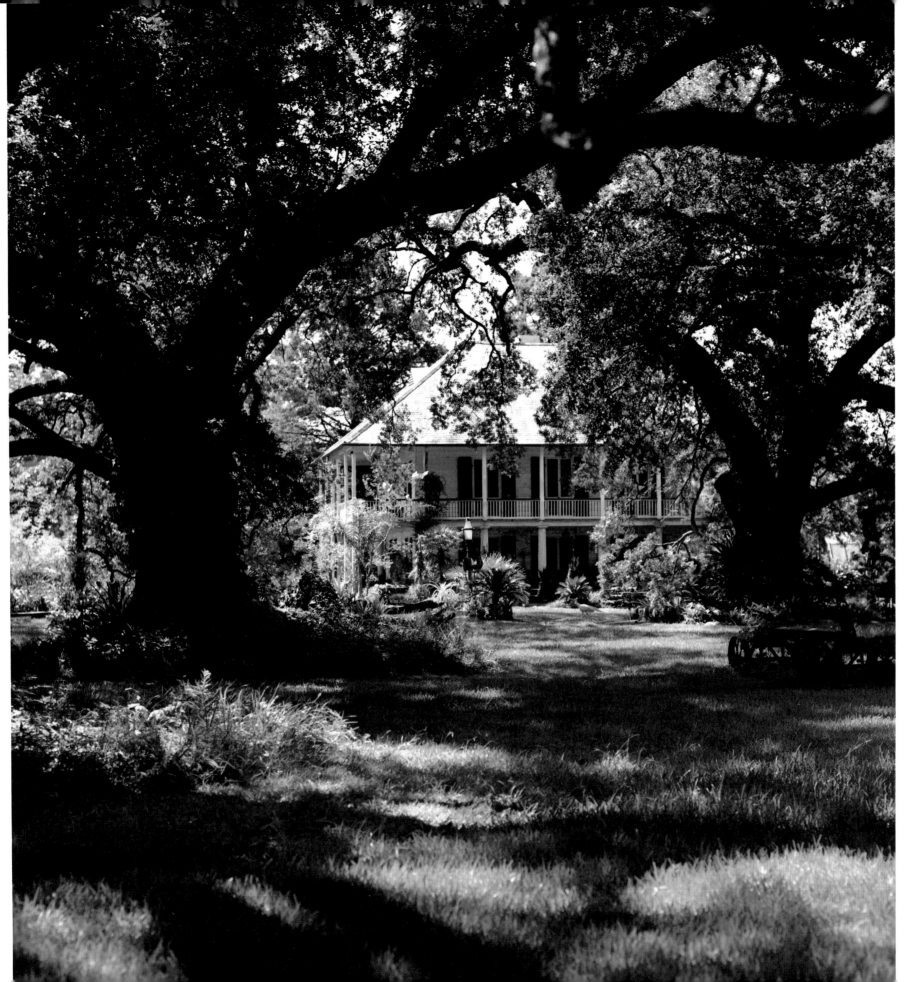

Mary, late 1700s

Located on the River Road at Dalcour, downriver from Braithwaite, is the delightful raised cottage Mary. Restored by Mr. and Mrs. E. R. Knobloch of New Orleans, the house stands on some of the highest ground between New Orleans and the mouth of the Mississippi and, according to the owners, has never been flooded.

The house is small but well proportioned, with four rooms downstairs (originally) and four upstairs. The grounds are spacious and include an extensive collection of bromeliads growing in profusion in the lush semitropical climate.

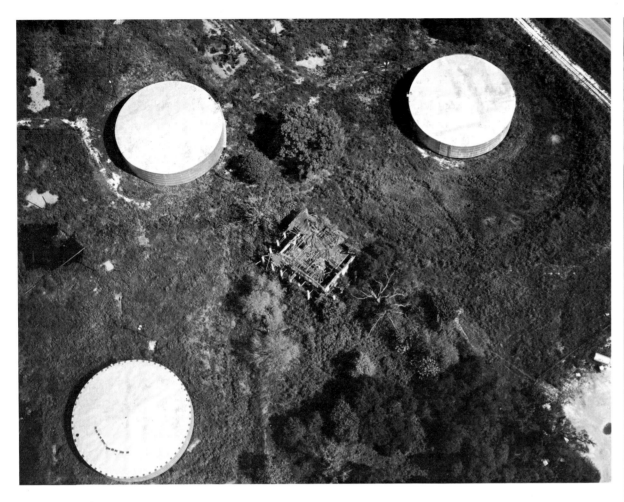

Seven Oaks, 1830

Now settled with its ghosts, the one-time eighteen-room mansion Seven Oaks was located within an industrial tank farm in Westwego across the river from New Orleans.

The majestic house was surrounded by a grove of seven live oaks and was distinguished by twenty-eight Doric columns, seven on each side, and by deep galleries. Through the years the house suffered greatly from neglect and from souvenir hunters and vandals, who stripped the interior of its fireplaces, molding, stairs, and flooring.

The ruins were bulldozed in 1977.

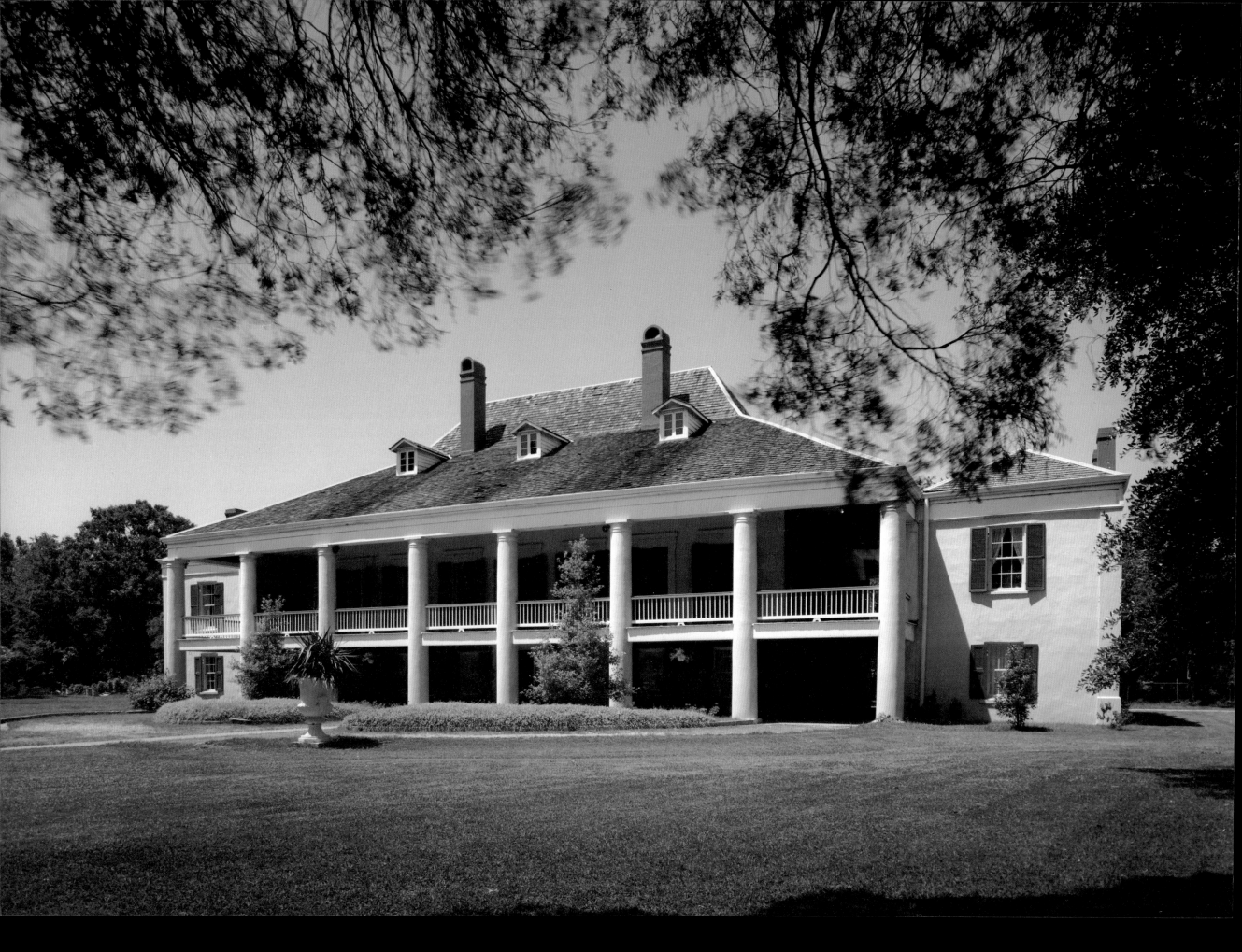

Destrehan, 1787

Destrehan is a unique example of a plantation home outliving the oil refinery that had been built around it.

One of the oldest homes in the Louisiana Purchase, Destrehan's construction was begun in 1787 and completed in 1790. Garçonnières were added in 1812. Robin de Logny contracted with a free man of color, Charles Pacquet, for the house and outbuildings for the grand sum of "one brute Negro," one cow and calf, 100 bushels each of corn and rice, and $100 in cash upon completion.

Twelve years later, de Logny sold the house and land to his son-in-law, Jean Noel Destrehan de Beaupre, who expanded his holdings to 1,050 acres and enlarged the house. Destrehan continued to hold the land until 1910, when it was sold to a syndicate.

In 1914 the Mexican Petroleum Company bought the property and built a refinery. Subsequent owners were Pan American Southern Company and American Oil Company, which closed the refinery in 1959.

The following twelve years brought rapid decay for Destrehan Manor. Vandals and treasure hunters stripped the house of mantels, paneling, and windows, and left gaping holes in the walls.

In 1972 American Oil donated the house and four acres of land to the River Road Historical Society, which through its all-volunteer efforts has raised sufficient funds to halt the process of decay and has begun to bring the house and grounds back to their former beauty.

Home Place, 1801 (right)
(Keller House)

Only a few years before the Louisiana Purchase, the Fortier family built a typical raised cottage on land granted by the Spanish to an earlier ancestor.

Similar in construction to Magnolia Mound, but with a fully usable brick-floored basement, the property was later purchased by the Kellers, after whom it was named. Known both as the Keller House and as Home Place, the structure is now on the National Register of Historic Places.

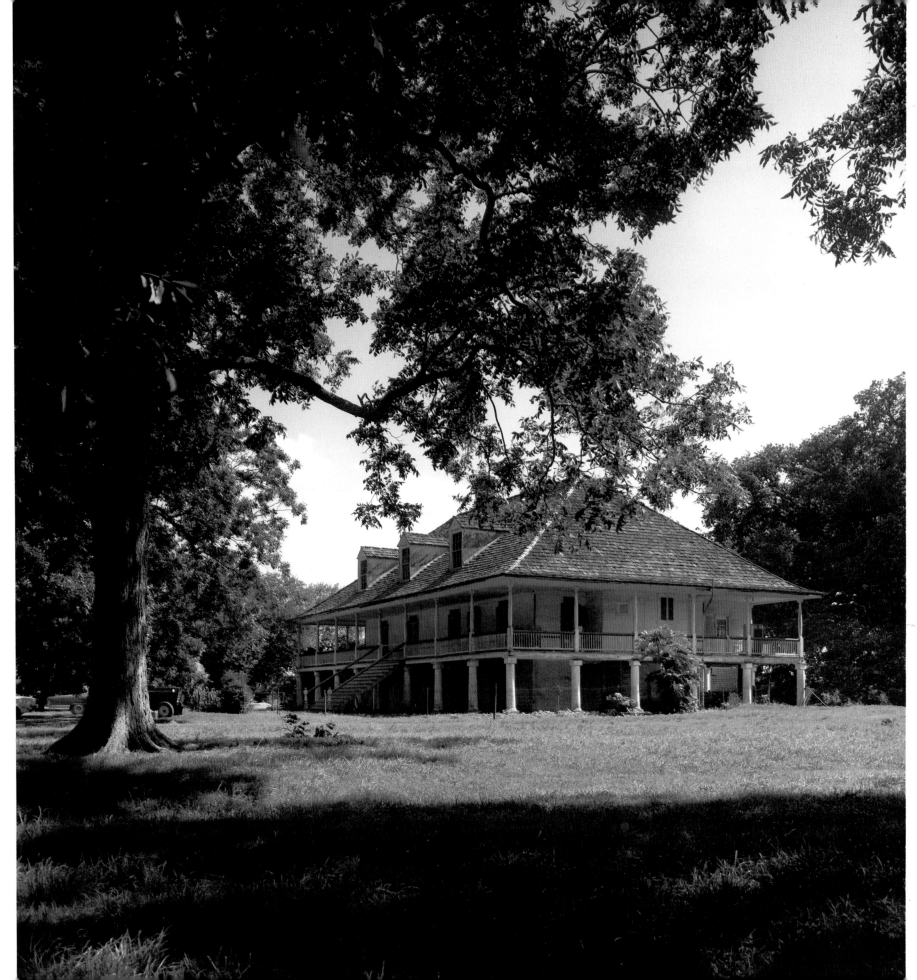

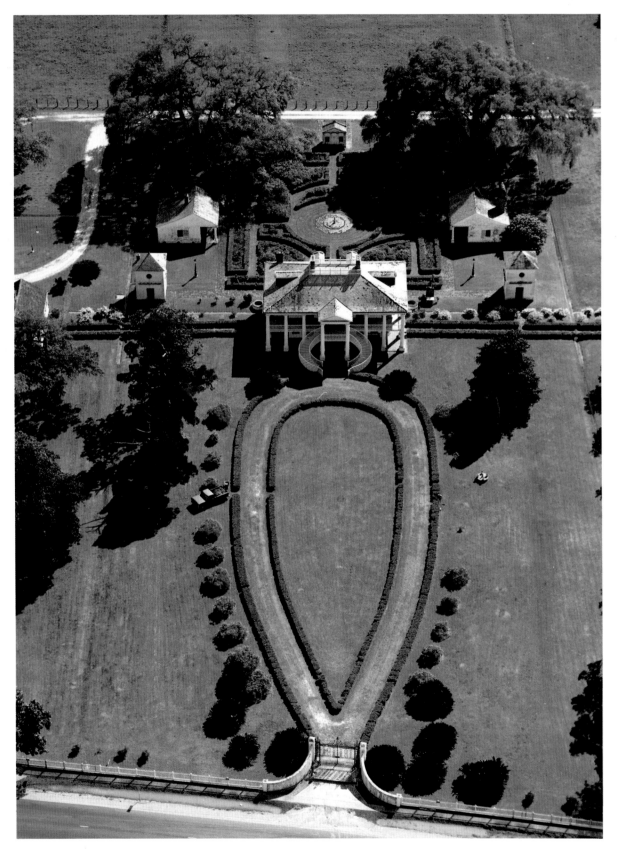

Evergreen, 1840

Also on the West Bank, below Felicity and Oak Alley, Evergreen is one of the last existing great plantation complexes. Built about 1840 and restored by Matilda Gray of New Orleans and Lake Charles, the plantation is owned by Mr. and Mrs. Harold H. Stream and is well maintained.

Behind the house is a formal garden, flanked by Greek Revival outbuildings, including a Greek Revival privy. Originally gardens led to the river, and behind the house on either side was an avenue of oaks, each with slave quarters at the rear. One of the oak avenues still exists, complete with its wooden slave cabins spaced between the trees.

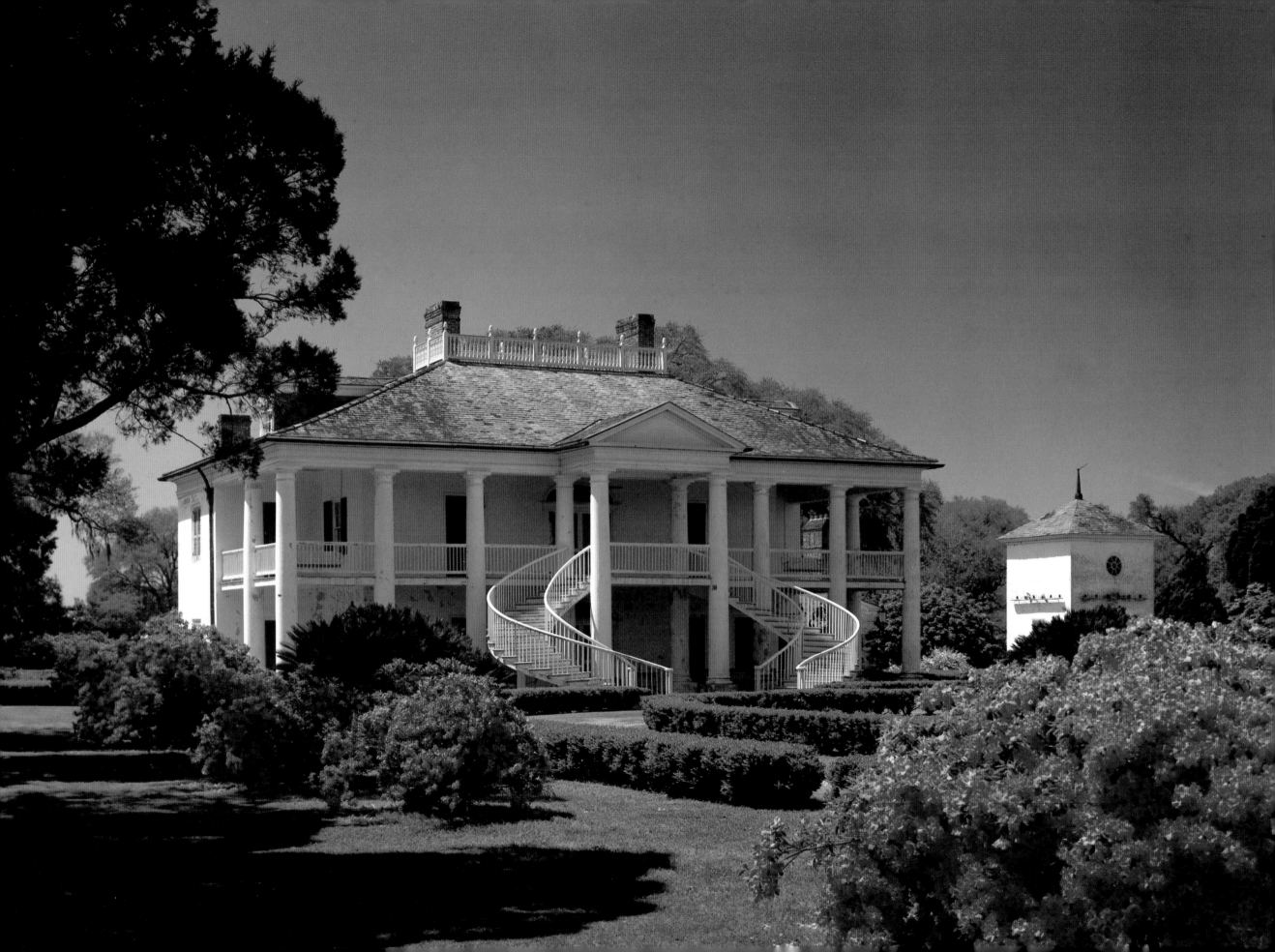

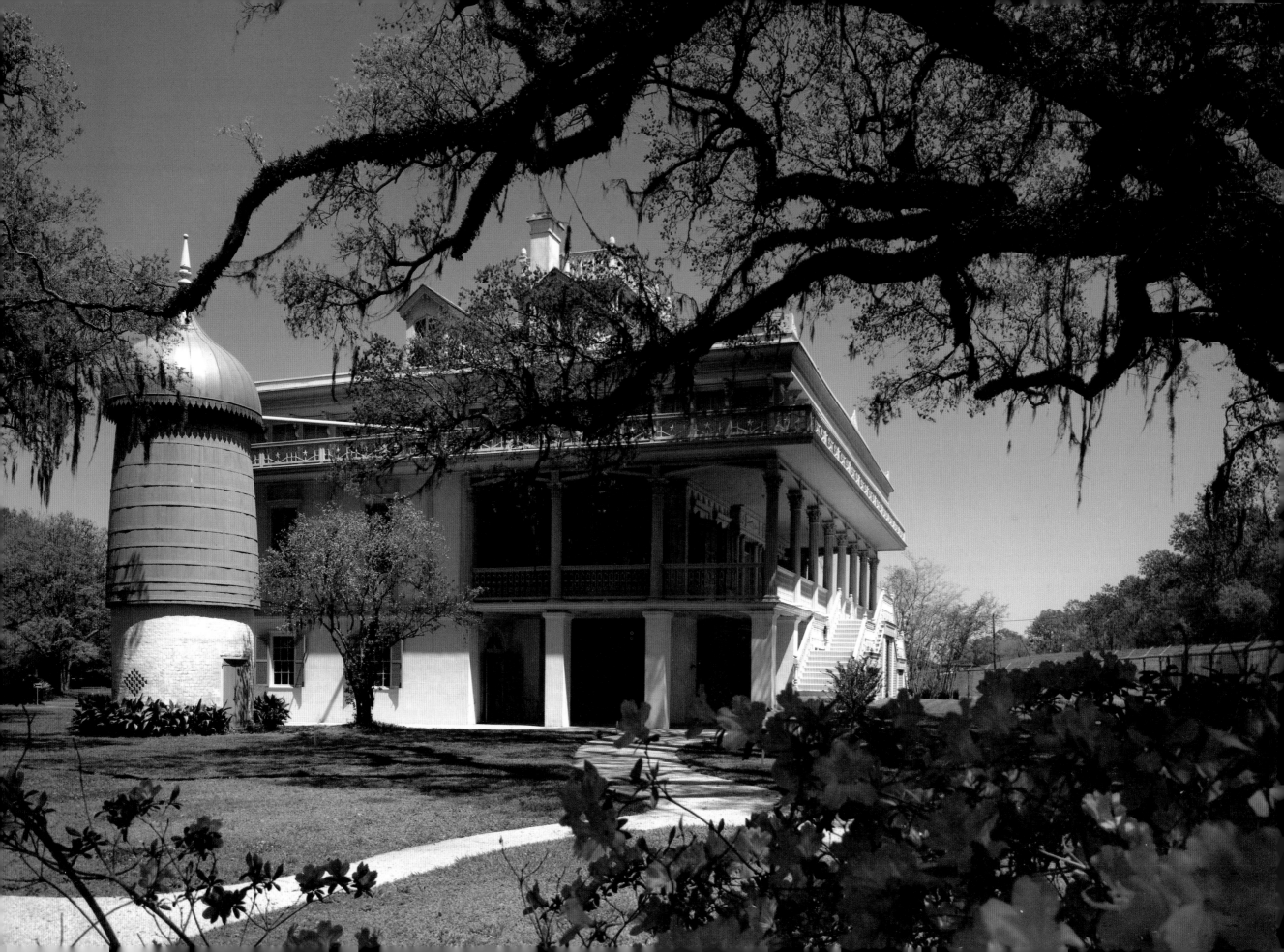

San Francisco, 1853

On the River Road at Reserve, next to the levee, stands one of the most exuberant examples of plantation home architecture, appropriately named *St. Frusquin*, or, translated from the French slang of the day, *One's All*, apparently because of the lavish construction and detail of the great house.

San Francisco has been completely and painstakingly restored and authentically furnished, and is a brilliant example of the life style that ended with the Civil War.

The house was started in 1853 or 1854 and completed in 1856, only four years before the war. That same year the owner, Edward Bozonier Marmillion, died, and his son Valsin continued the interior decoration until just before war broke out.

Originally, formal gardens extended several hundred yards from the house to the river, but the ever-changing Mississippi has demanded successive levee setbacks, which now leave the levee adjacent to the house.

Valcour Aime, 1799 (right)

Although the plantation home of Valcour Aime at St. James was once considered one of Louisiana's most outstanding, it is the parklike setting surrounding the mansion that was acclaimed as Le Petit Versailles. Aime himself was nicknamed the Louis XIV of Louisiana.

An unsightly bog separated the St. James mansion from the river, something Mrs. Aime wanted corrected, and with the help of a landscape architect from Europe, the 12 acres between home and river evolved into Aime's "English Garden." An artificial lagoon fed by the Mississippi River wound through the grounds, under bridges and among summerhouses, a treehouse, greenhouses, past a miniature Napoleonic fort, all viewable from a pagoda built atop a man-made hill.

The decline of Valcour Aime began in 1854 when his only son, Gabriel, died a victim of yellow fever. On the day of Gabriel's death, Aime wrote in his diary, "Let he who wishes continue. My time is done." Within a very few years his wife had also died, and Aime withered away, dying a recluse in 1887.

The plantation never recovered and was abandoned by the turn of the century. The house burned in 1920; the gardens went untended.

In early nineteenth-century England, a garden was far from the intricate, well-manicured geometrically precise design of the 1700s. Eclectic landscape architects preferred to "return to nature" and included ruins—artificial if necessary—with every proposal.

Today nature has all but reclaimed the remnants of the fort, bridges, and grotto. Perhaps it is a fitting, poetic end to the gardens of Valcour Aime.

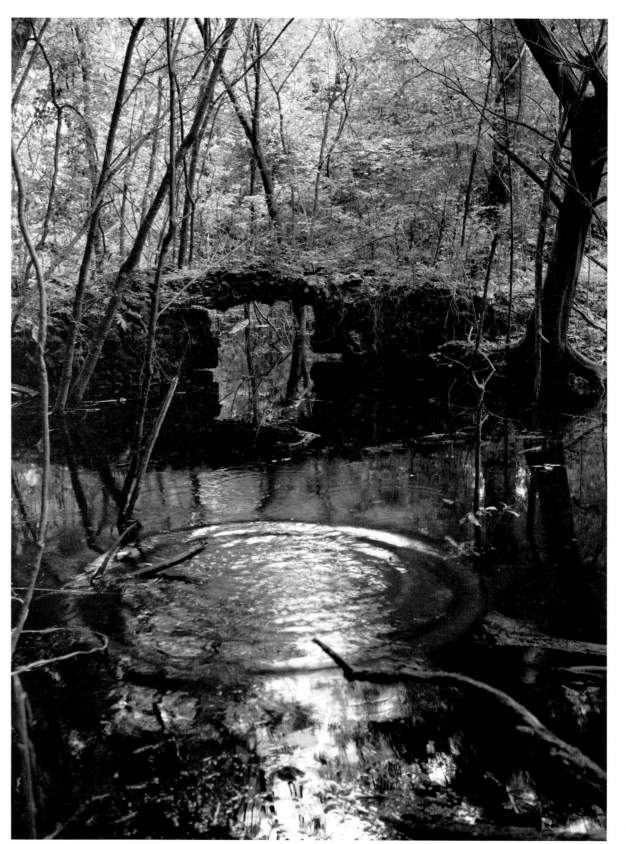

The gardens of Valcour Aime not only had their own artificial, slave-dug river, Napoleonic fort, Roman bridges, and private zoo, but their own "mountain," topped by a pagoda and housing a grotto within. It is obvious that the grotto, built rather like a large brick igloo, was constructed first and then covered with earth to create a hill. After standing untended for over a hundred years, the grotto is still in astonishingly good condition.

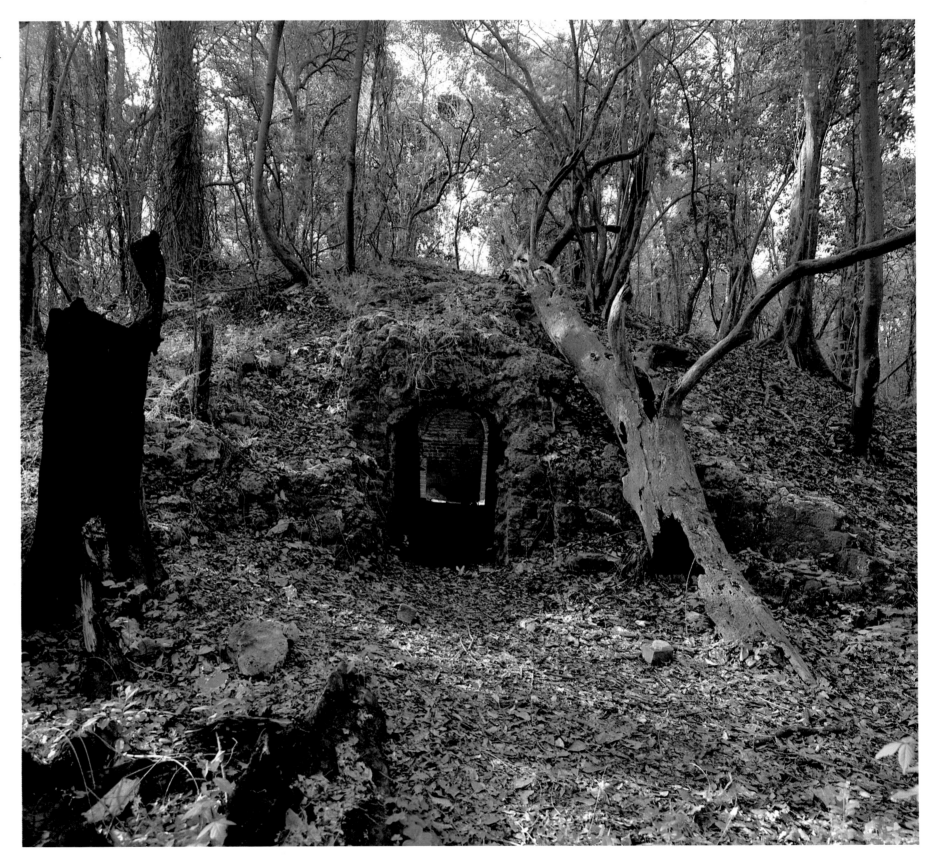

Felicity, 1850

Built as a wedding present for his daughter, Felicité, by Valcour Aime, Felicity was begun in 1847 and completed in 1850. Divided by a center hall with two large rooms on either side on both floors, the house has 14-foot ceilings and red Italian marble fireplaces in the living and dining rooms.

Felicity is part of a 2,400-acre working plantation owned by the St. Joseph Planting and Manufacturing Company.

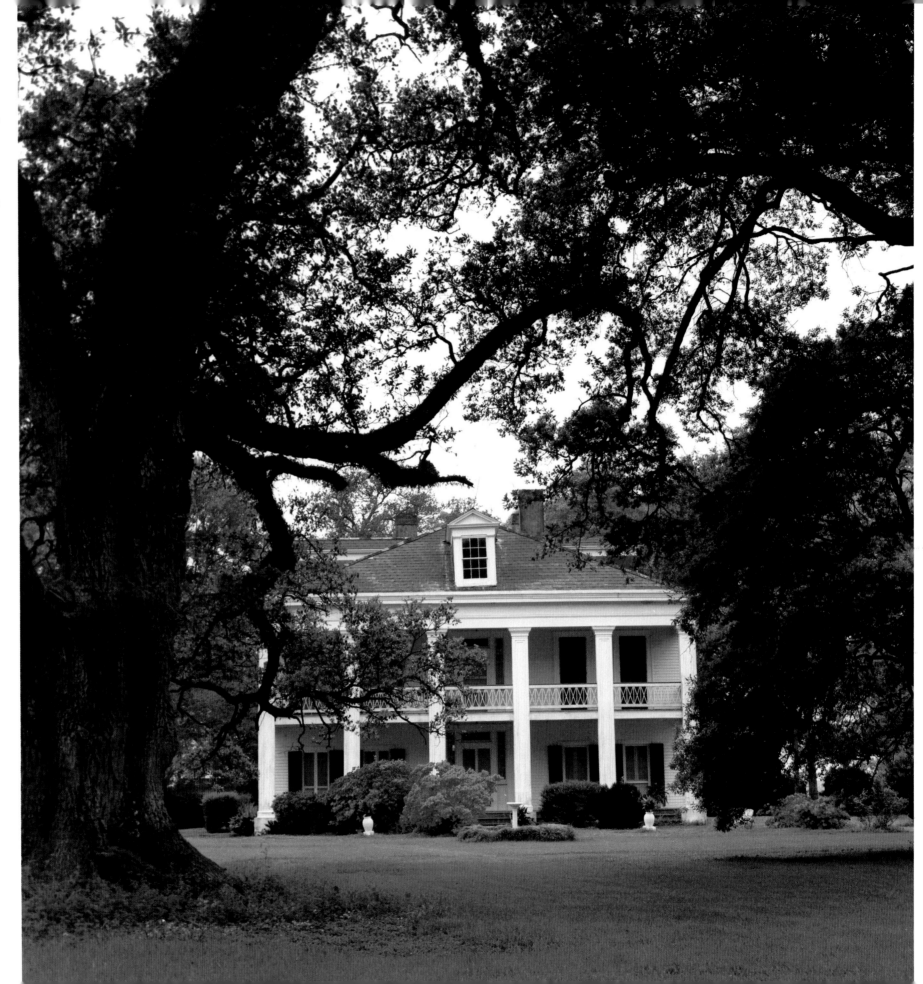

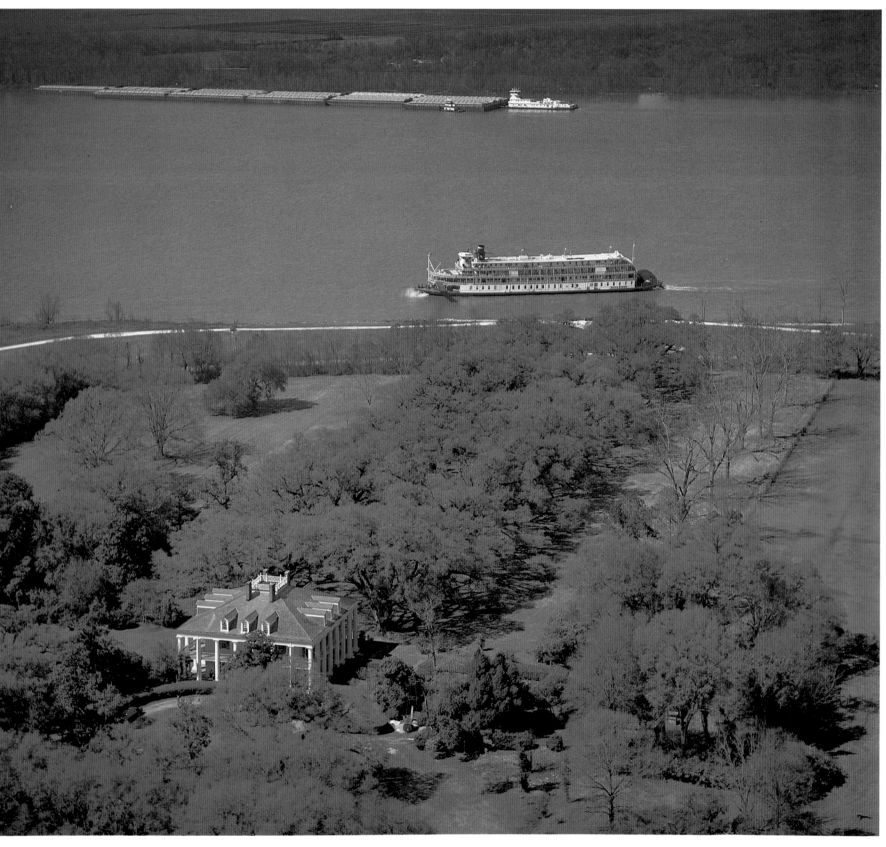

The *Delta Queen* docks at Oak Alley. *(left)*

Oak Alley, 1839

Probably the best-known plantation home in Louisiana, Oak Alley is 70 feet square, surrounded by 28 Doric columns, and stands at the end of a spectacular avenue of 28 oak trees that are at least a hundred years older than the house.

The oaks were planted, eighty feet apart, by an unknown French colonist in the early 1700s, who placed his own house at the end of the avenue. In 1839 Jacques Telesphore Roman III replaced the simple dwelling with the existing mansion, naming it Bon Sejour, meaning Good Rest. Travelers on the Mississippi steamers, however, gave it their own name, Oak Alley, and that name has endured.

Restored by Mr. and Mrs. Andrew Stewart, Oak Alley has been assured a serene future by Mrs. Stewart's establishment of a nonprofit foundation for the continued preservation and maintenance of the house and grounds.

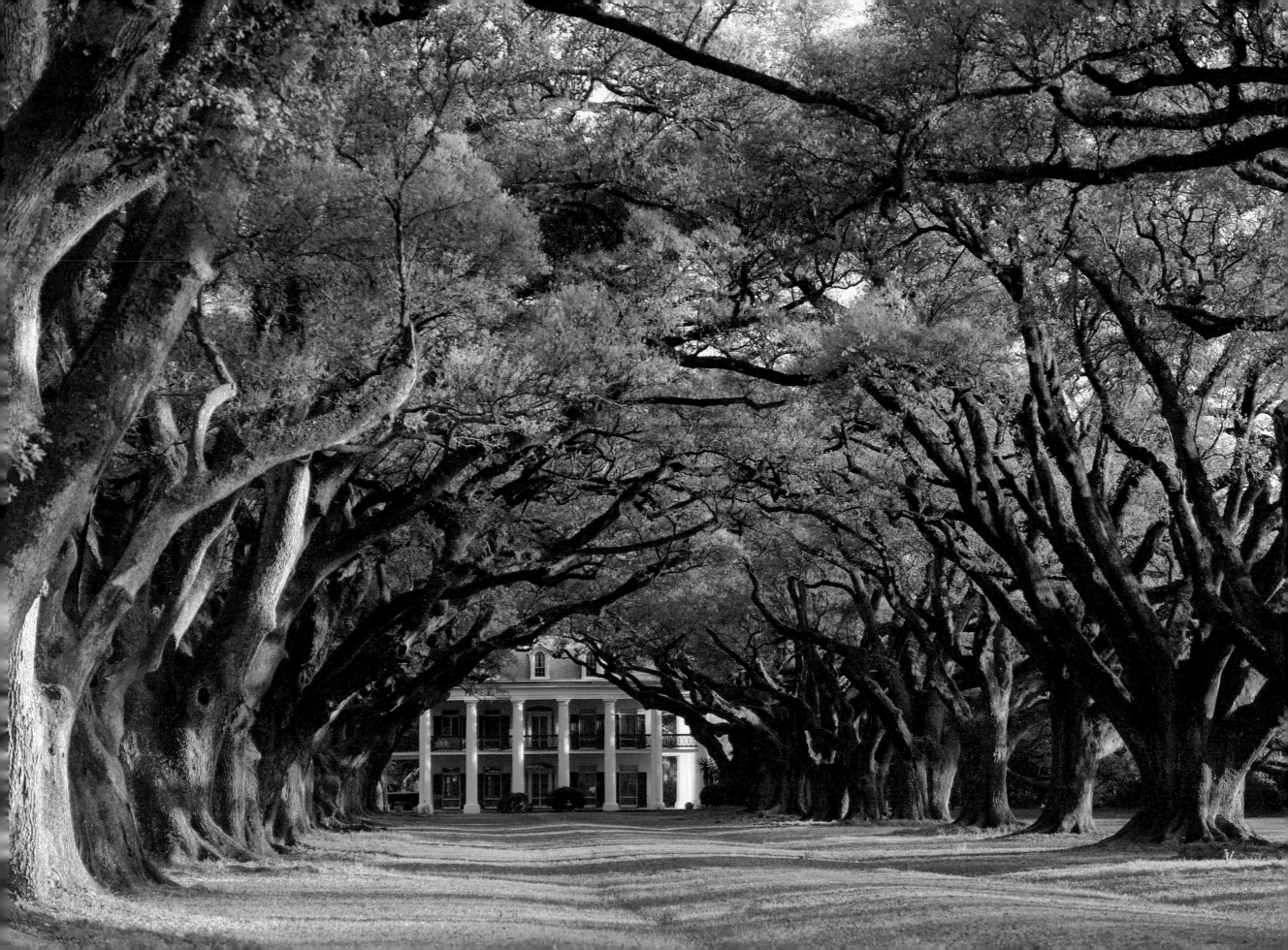

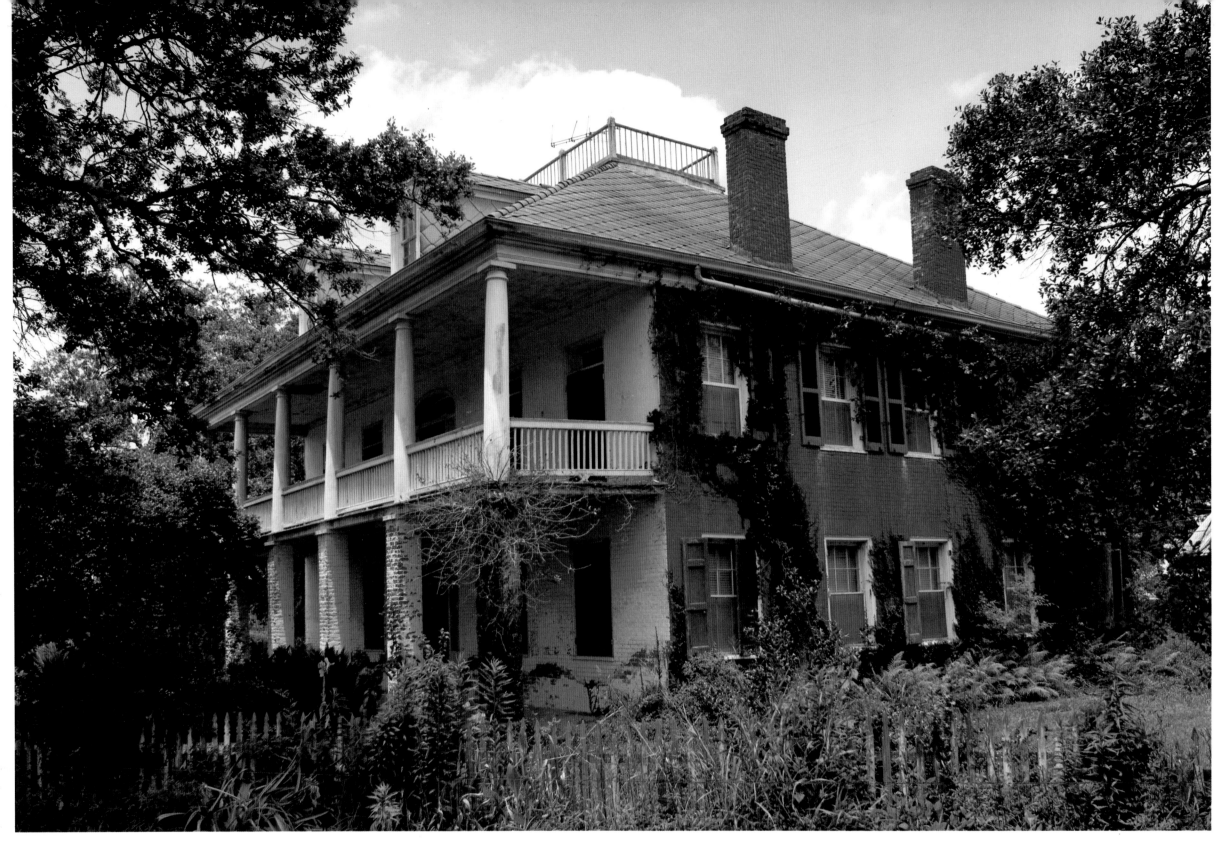

Welham, 1835

Crowded against the levee on Louisiana Highway 44 at Hester, Welham once had spacious gardens and an avenue of live oaks between house and river. Constructed in 1835, Welham's plantation acreage was constantly enlarged by William Peter Welham until his death in 1860. His widow, Riene Theriot Welham, continued buying adjoining tracts until the plantation's holdings included 2,300 acres in 1866.

The property remained intact during the past century, although it changed hands several times. Welham was purchased in 1975 by Marathon Oil Company, and in 1979 the company demolished the house.

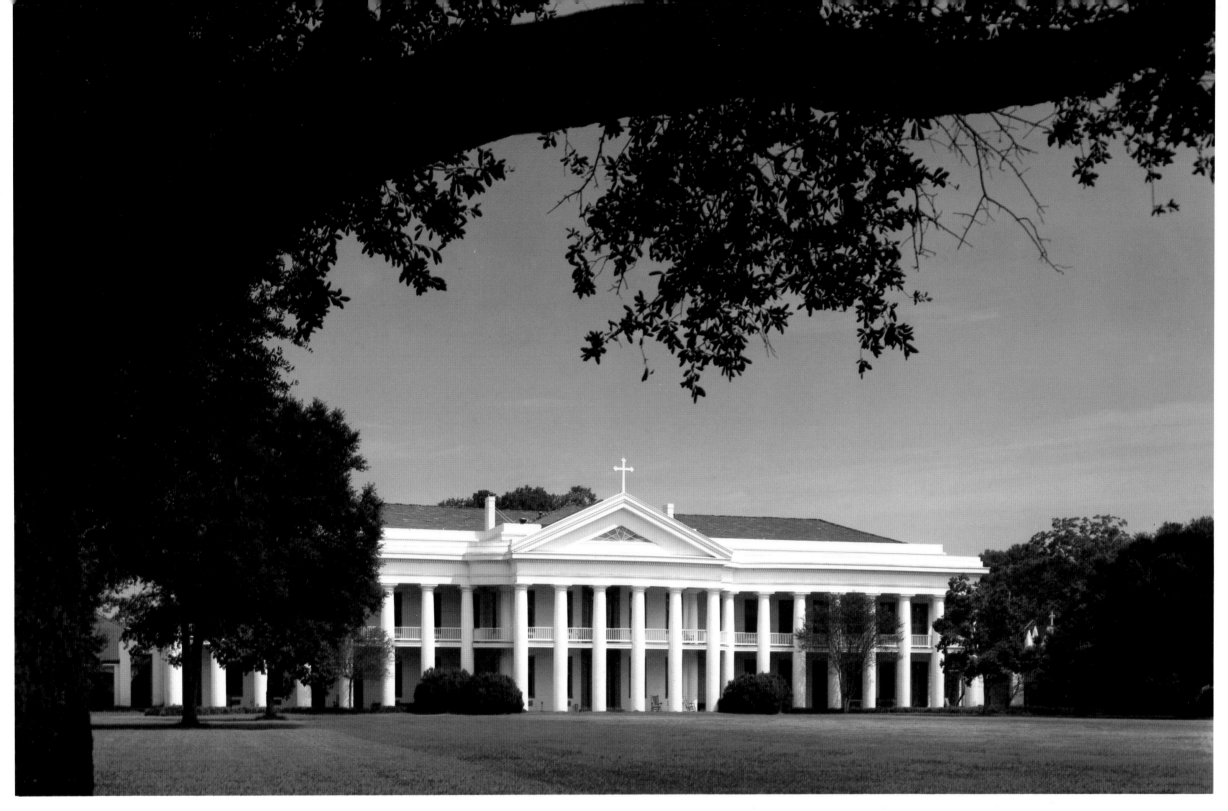

Jefferson College, 1834
(Manresa Retreat House)

The creation of Jefferson College in St. James Parish recalls the trying times once experienced between French and American factions in Louisiana. Soon after the state legislature had approved the forma-tion of the College of Louisiana at Jackson in the strongly English section of the state, the French in the southern regions clamored for such an institu-tion for their sons.

The result was the College of Jefferson, chartered by the legislature in 1831 and built on 65 acres en-tirely by subscription.

Troubled times, however, were ahead. In 1847 it closed, reopened as the College of Louisiana, and closed again. To save it, West Bank planter Valcour Aime bought the entire facility, reorganizing the school in 1859. Between 1862 and 1864, Union troops used the institution as a barracks.

In 1864 Aime gave the school to the Jefferson College Corporation, which soon turned the place over to the Marist fathers, who ran it as a boarding school. By 1927 Jefferson was forced to close. Pur-chased in 1931 by the Jesuits, the former college has since been renamed Manresa Retreat House where the Jesuit Order holds retreats for men throughout the year.

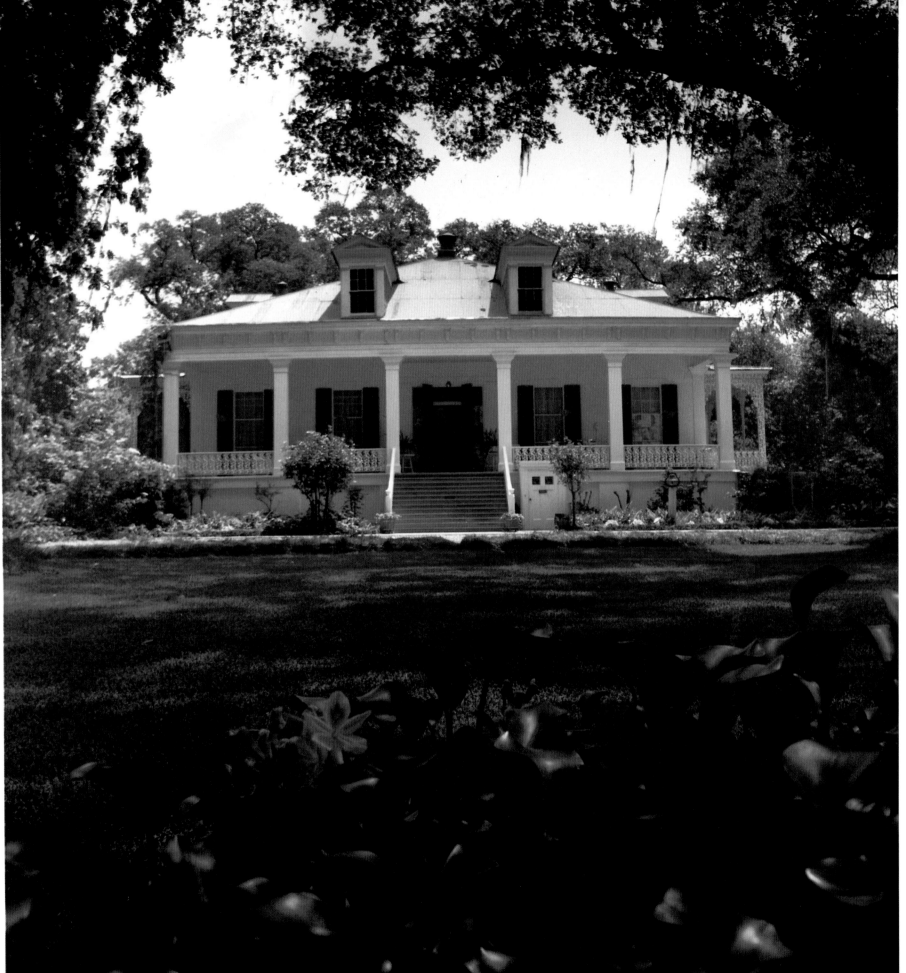

Tezcuco, 1855

Framed in an impressive avenue of live oaks, Tezcuco (Resting Place in Aztec), was constructed in 1855 by Benjamin Tureaud, whose wife Aglae was the daughter of the owner of l'Hermitage, Michel Douradose Bringier.

Dr. and Mrs. Robert H. Potts, Jr., acquired the property in 1950. They restored the house and furnished it with their antique furniture of the same period. Tezcuco was purchased in March of 1981 by Major General and Mrs. O. J. Daigle of Gonzales and at that time was slated for extensive restoration. General and Mrs. Daigle also own the Governor Holmes House in Natchez, the home of the last territorial governor of Mississippi.

Both General and Mrs. Daigle have strong ties to the plantation culture. Mrs. Daigle, a Songy before marriage, is a descendant of Alfred Songy, who built Evergreen, and General Daigle's family includes descendants of Valcour Aime.

Tezcuco is distinguished for the meticulous execution of its interior detail. Referred to as a "raised cottage," its front corner rooms are 25 feet square, with 15-foot ceilings.

Houmas House, 1840 (*right*)

Named after the Houma Indians, this 2½-story mansion has been completely restored and refurnished to reflect the period before 1840. Saved from neglect and nature by Dr. George B. Crozat in 1940, Houmas House is furnished with museum pieces of early Louisiana craftsmanship.

Surrounded on three sides by Doric columns, the house is connected to an original four-room dwelling in the rear. On either side of the house is a two-story hexagonal garçonnière of brick and plaster, each a traditional bachelor's quarters, consisting of a sitting room downstairs and a bedroom above.

At the right of the house is one of two cisterns designed to hold rainwater, plentiful in Louisiana's humid, semitropical climate.

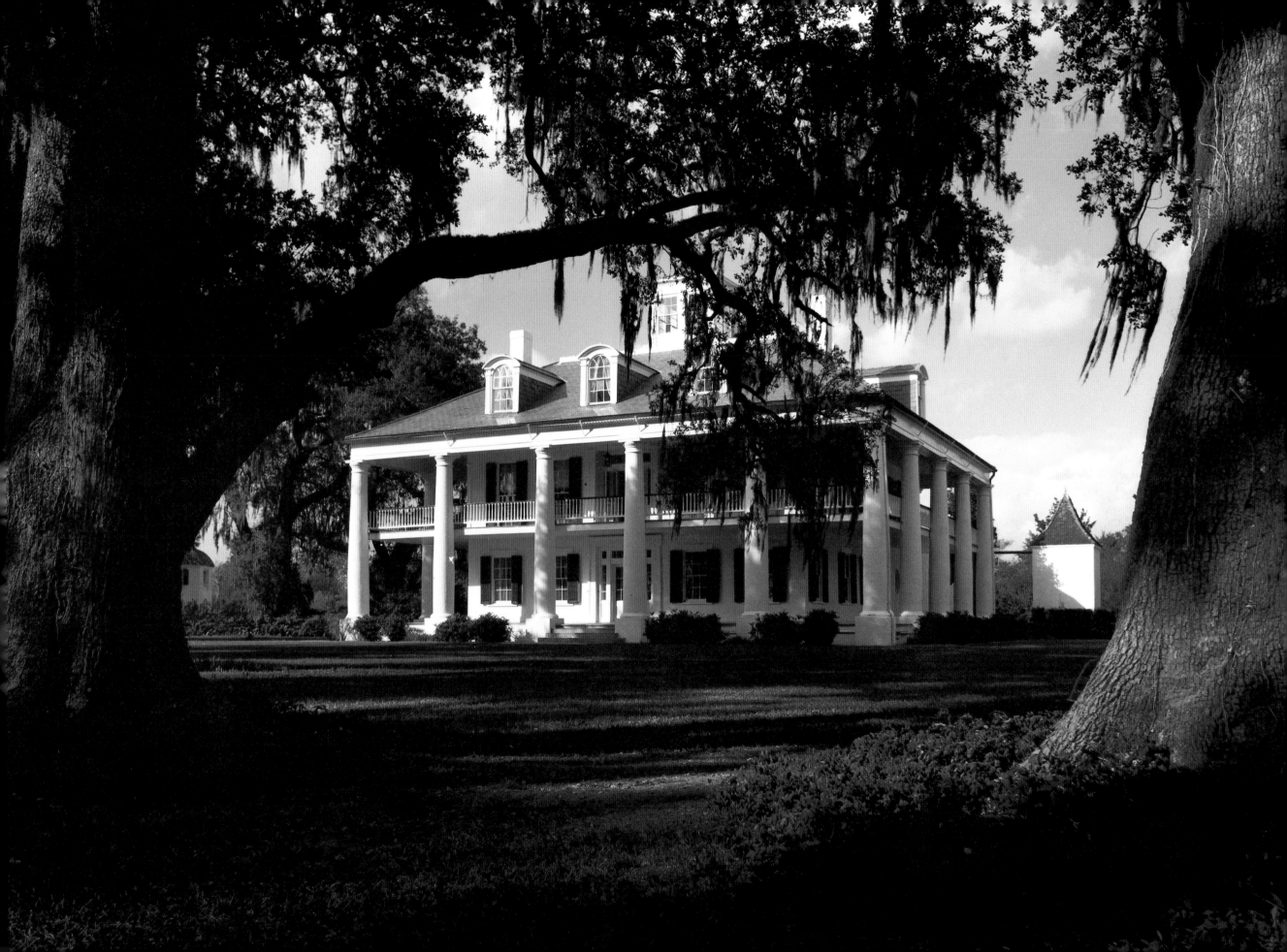

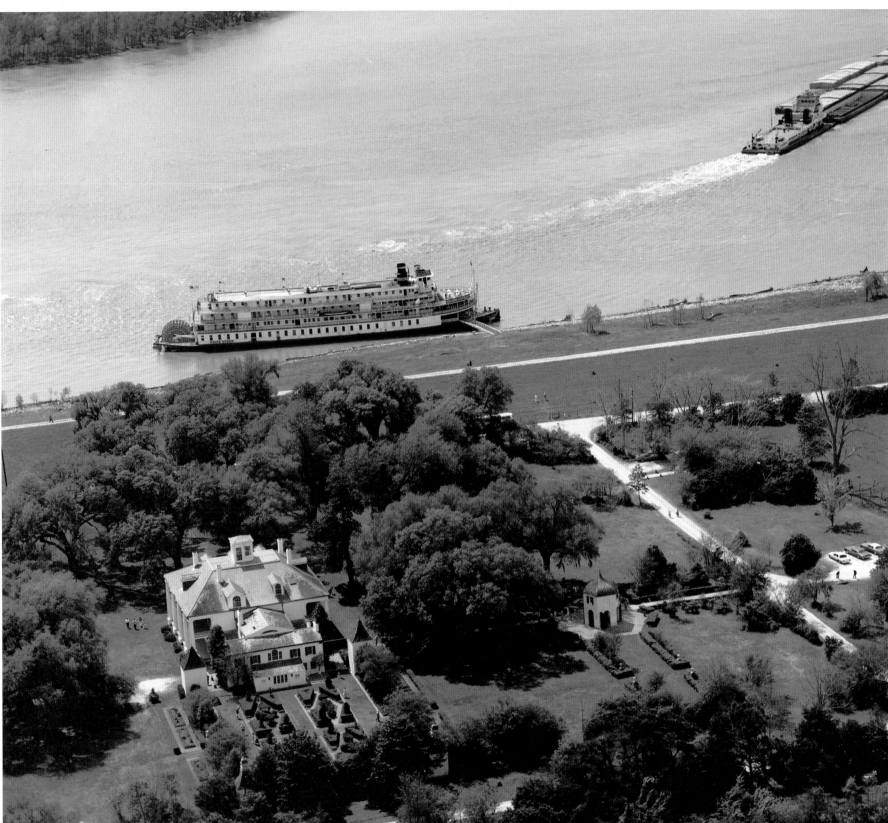

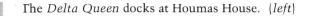

The *Delta Queen* docks at Houmas House. (*left*)

Bocage, 1801

Built in 1801 by Emmanuel Marius Pons Bringier as a wedding gift for his daughter, Françoise, Bocage, like Bringier's wedding gift of l'Hermitage to his son Michel, is not the same house as first built. James Dakin, famous for the old Louisiana State Capitol, is said to have remodeled the house in the 1840s, giving the structure a heavy pediment that completely conceals the roof.

With a unique treatment along the front colonnade, the home's first floor, still influenced by the raised cottage attitude, is short and squatty. The second level's ceilings are much higher.

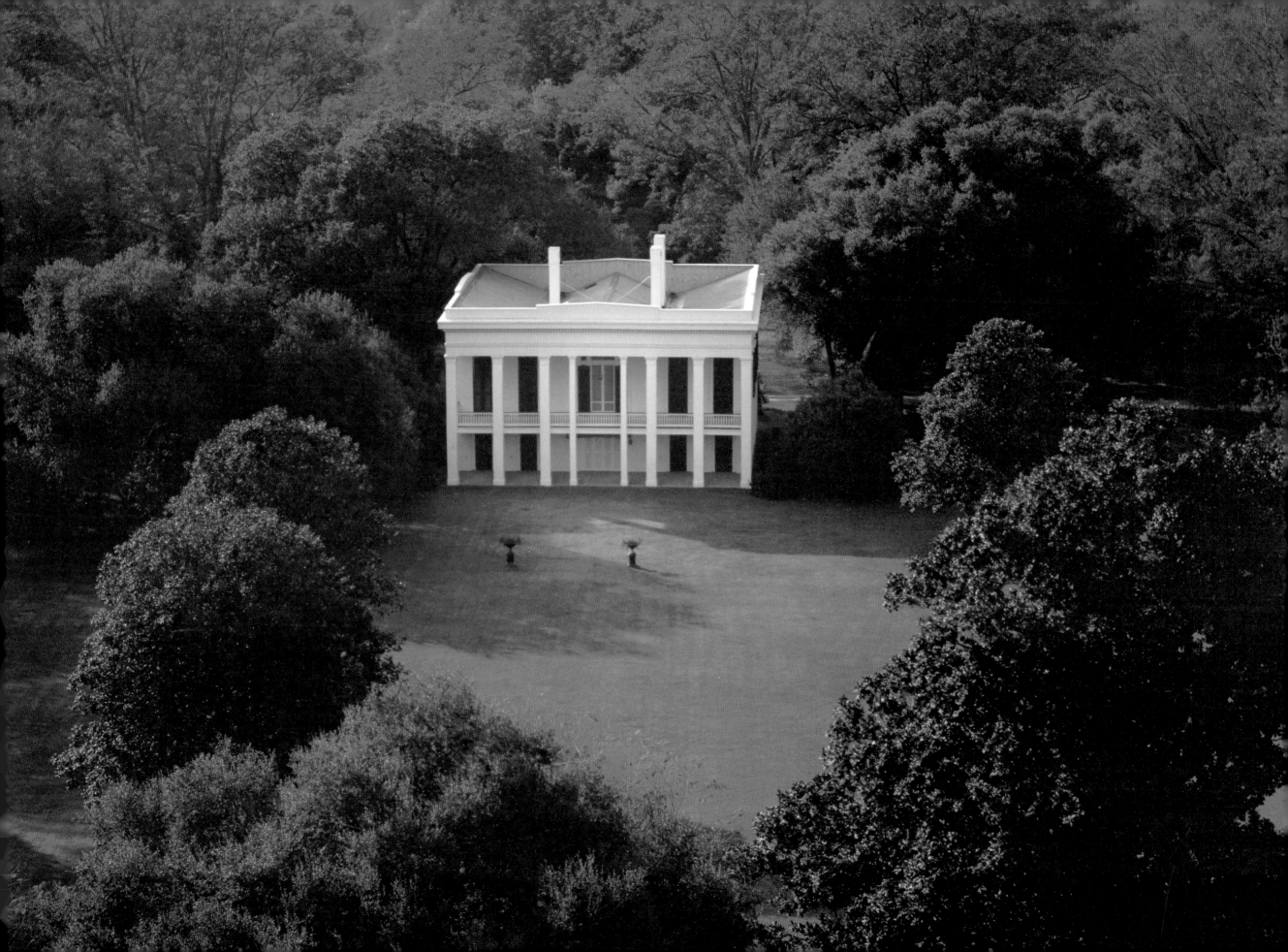

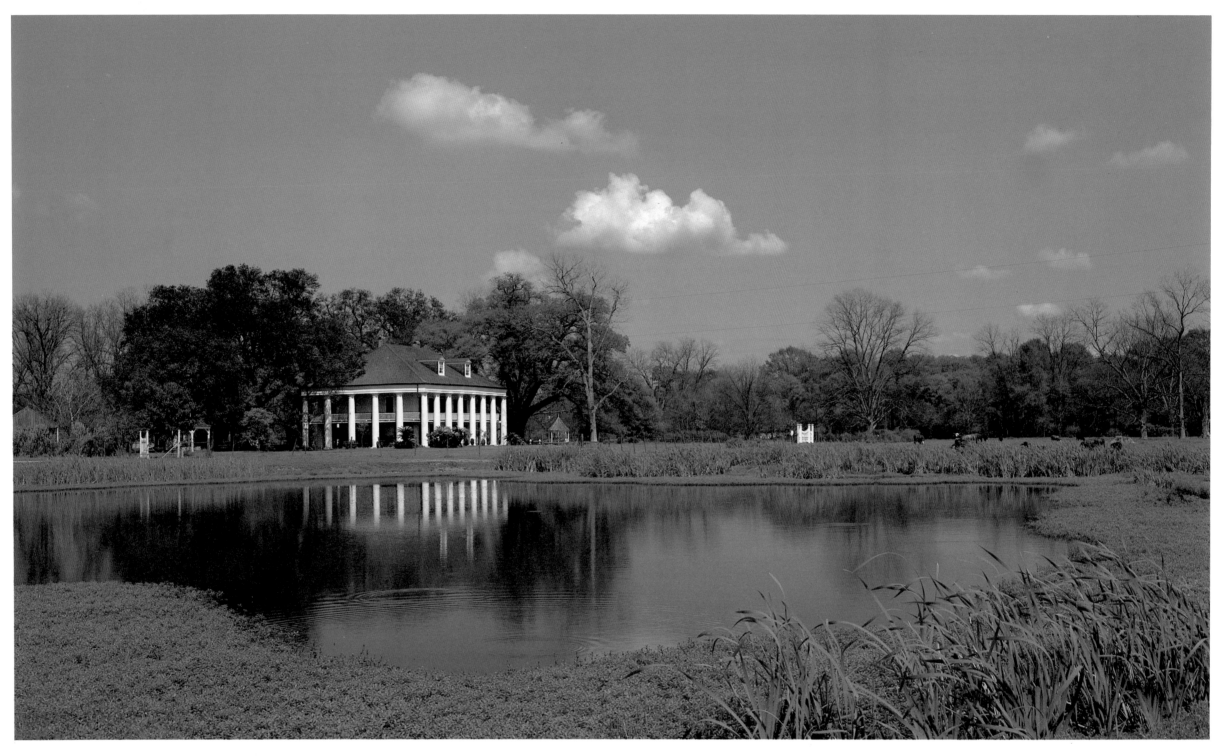

L'Hermitage, 1812

A majestic Greek Revival mansion, l'Hermitage was named after the Tennessee home of Andrew Jackson following his defense of New Orleans in 1815. Built in 1812 by Marius Pons Bringier as a wedding gift to his son, Michel Douradose Bringier, who was among the Creoles who fought beside Jackson on the plains of Chalmette, the two-story house consists of walls of brick-between-posts construction and Doric columns surrounding broad galleries.

Unoccupied during the 1950s, l'Hermitage was acquired in 1959 by Dr. and Mrs. Robert C. Judice of New Orleans, who then embarked upon a twenty-year period of restoration.

That restoration now complete, the future of l'Hermitage seems assured. The interior has been furnished in the pre–Civil War style, a period during which the house and plantation were at their prime.

Along the Bayous

Belle Alliance, 1846

In 1846 a Belgian aristocrat, Charles Koch, built Belle Alliance about five miles south of Donaldsonville on the east bank of Bayou Lafourche. The manor combined a classic Greek Revival of the 1830s with the airiness of the French Quarter, and was surrounded by majestic formal gardens.

The plantation remained in the family until 1915. Tenants then allowed livestock to roam freely over the grounds, and when Mr. and Mrs. C. S. Churchill bought the plantation in 1927, the gardens had been completely demolished. The Churchills restored the house and began a careful landscaping.

Today the 33-room, two-story manor house is complemented with mature plantings of flowers and greenery.

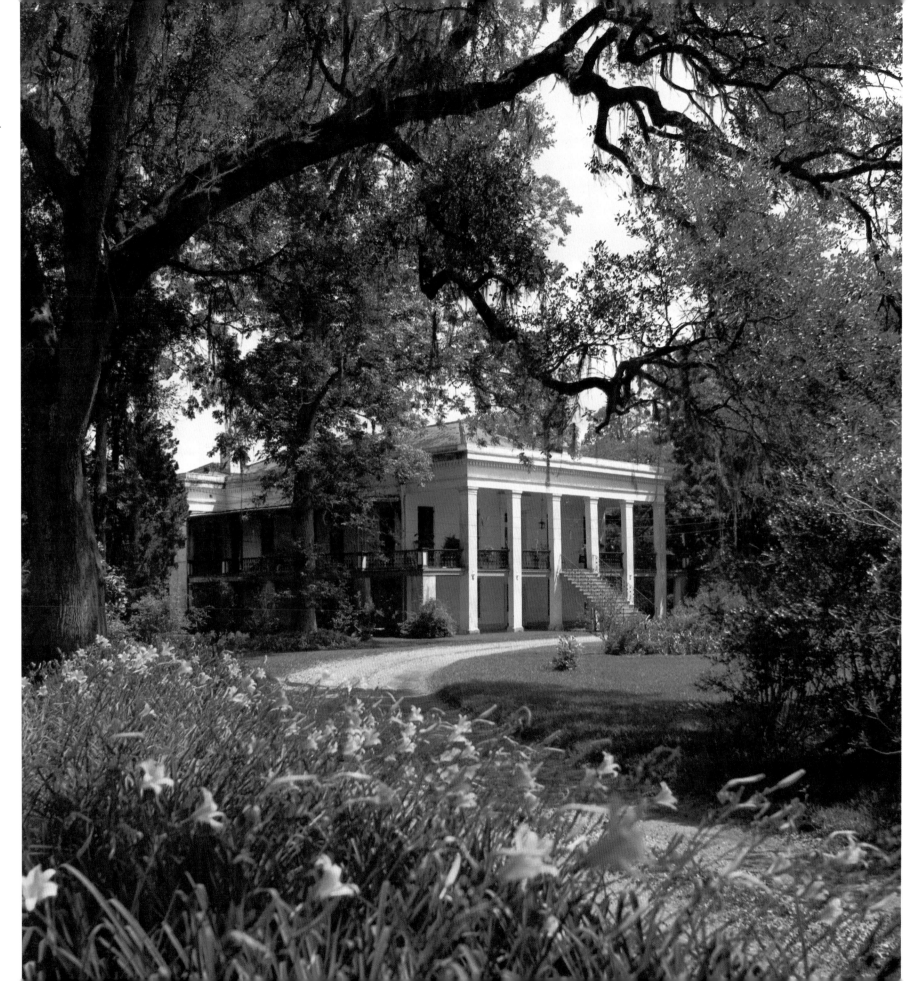

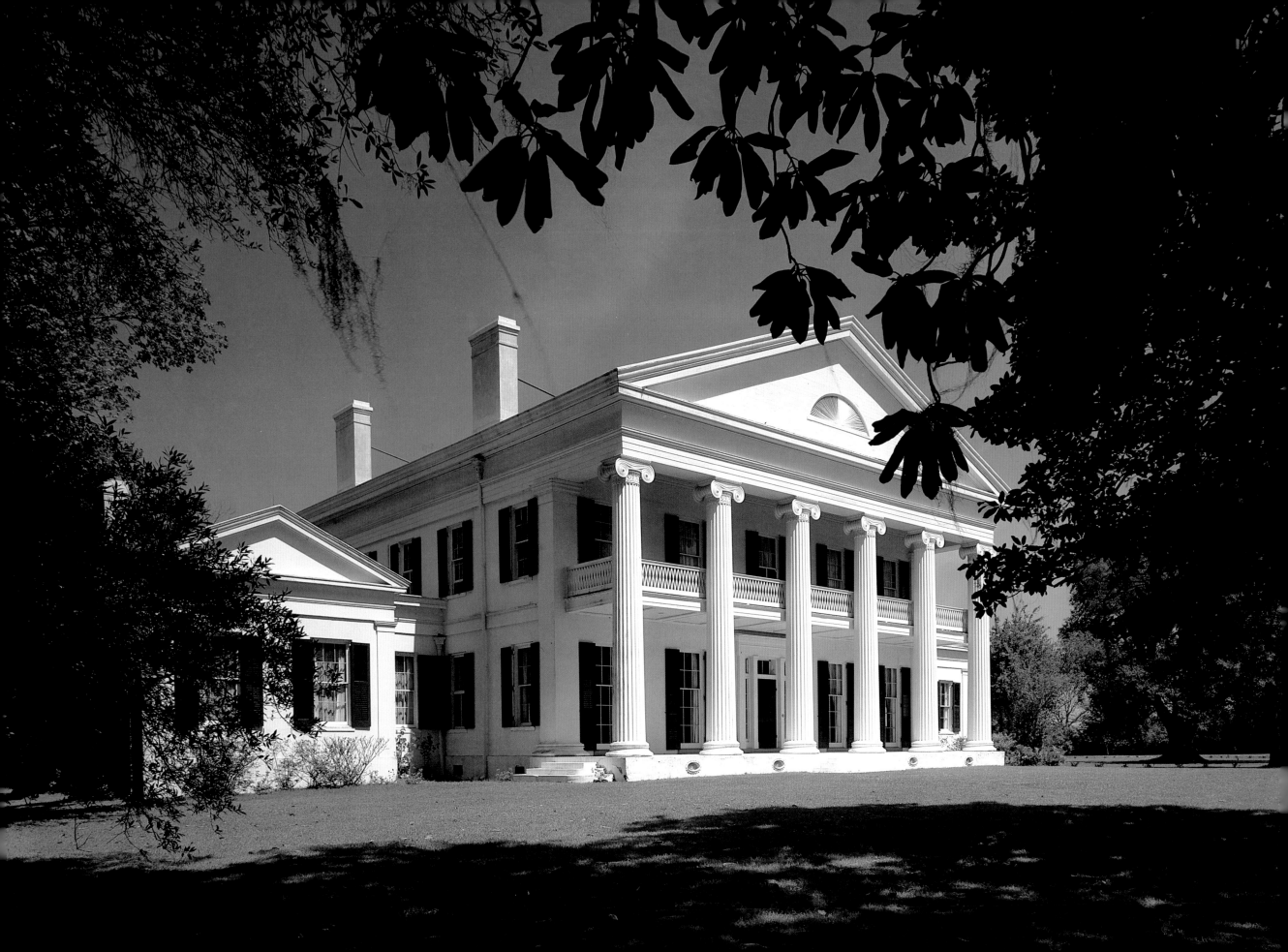

Madewood, 1848

Madewood acquired its name because, along with 60,000 slave-made bricks, the home was constructed with wood from the grounds of the plantation. The timbers were seasoned for four years before the house was built near Napoleonville, on the east bank of Bayou Lafourche.

One of the most palatial homes in the state, the house was eight years in construction by a North Carolinian, Colonel Thomas Pugh, who did not live to see it finished. Madewood was completed by Colonel Pugh's widow, who added a seventy-foot ballroom to the left wing.

The house is well constructed, with interior walls about 18 inches thick and outside walls of about 24 inches. The sturdy construction stood well when in 1965 Mrs. Harold K. Marshall, the current owner, used a power hose, in the Augean manner, to clean out the 25-year accumulation of litter from the unoccupied main hall and east wing.

Ducros, 1835 (right)

Thomas Villanueva Barroso was granted 4,400 acres on Bayou Terrebonne near Thibodaux in 1802, but the present structure was not started until at least 1834, when the plantation was purchased by Pierre Ducros. Enlarged or rebuilt by later owners, Ducros was used as a hospital during the Civil War. It was purchased in 1909 by Samuel Polmer, whose son Irwin Polmer related memories of frequent visits to the house by Huey Long.

With 18-foot ceilings and plaster medallions, Ducros is said to be modeled after Andrew Jackson's Hermitage near Nashville.

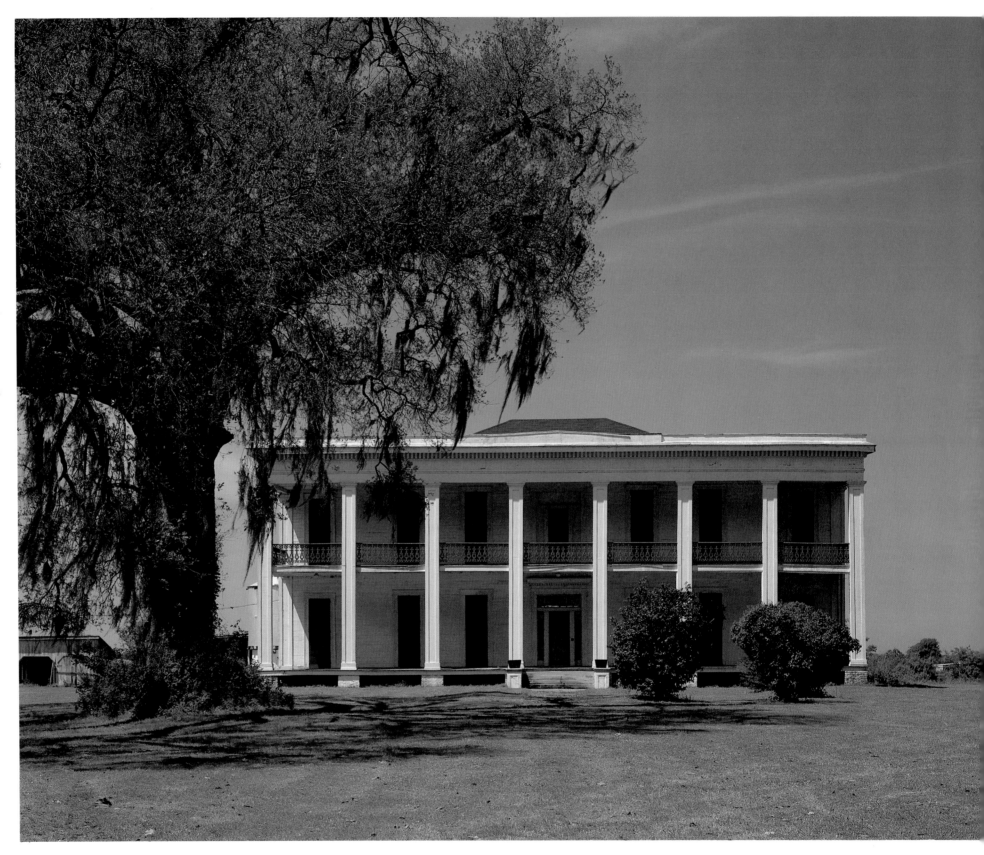

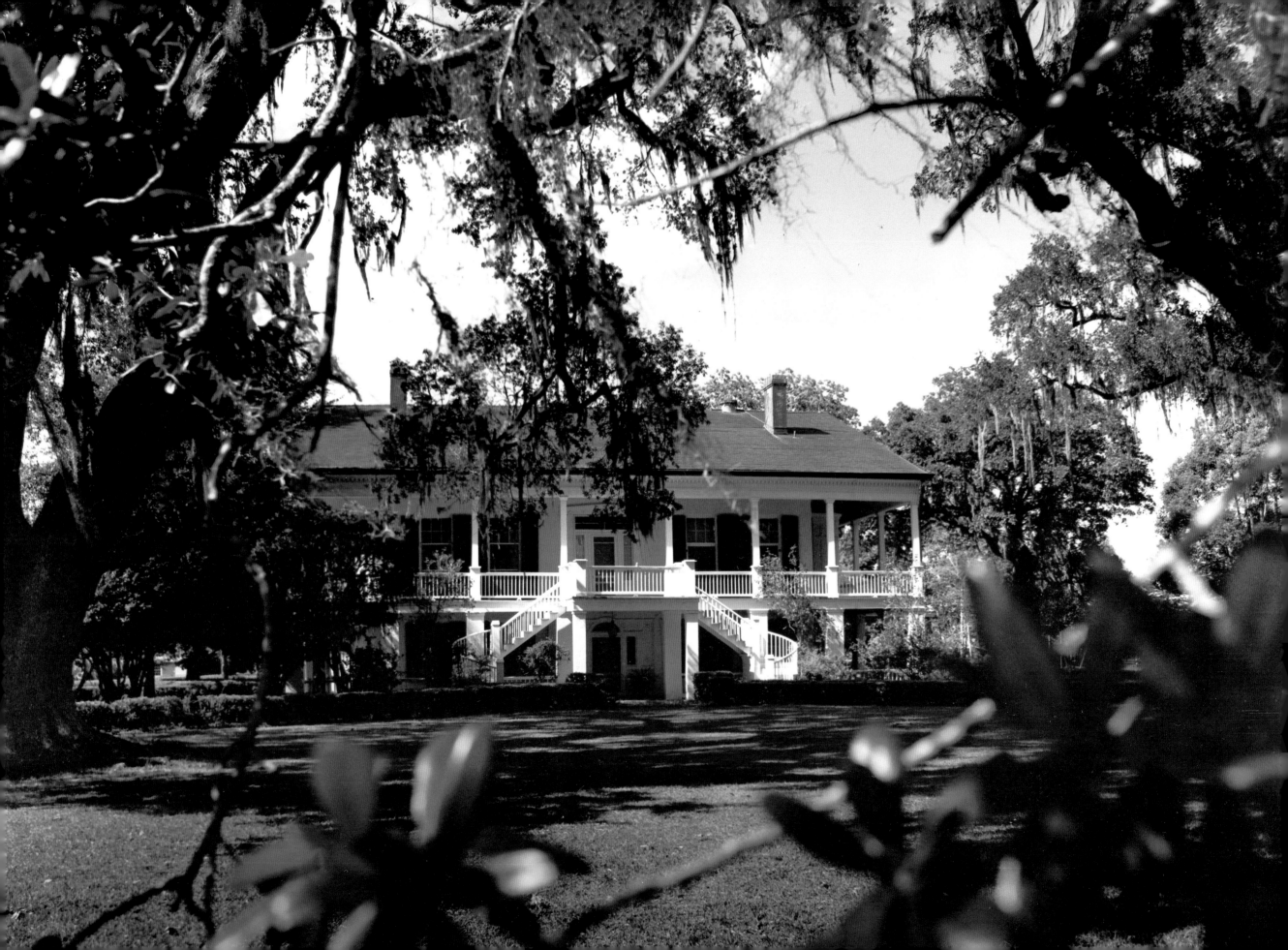

Rienzi, 1796

Once believed to have been built as a refuge for Queen Maria Louisa in the event of the defeat of Spain in the Napoleonic wars, Rienzi was constructed about 1796.

The entire bottom floor was originally open and used to stable horses. In about 1850 it was walled into four rooms. The four upper rooms adjoining a cross-shaped hall and the elaborate interior woodwork are Spanish in flavor.

Rosella, 1814 (*right*)

Constructed of hand-hewn cypress lumber and home-baked bricks, Rosella was completed in 1814 and has remained in the same family of its Acadian builders, Jean Baptiste Thibodaux and Natalie Martin.

Enlarged several times, and renovated in 1956 by the present owners, Dr. and Mrs. Ben Ayo, the plantation consists of over 350 acres devoted to the cultivation of sugarcane.

Just prior to the Civil War, Rosella's holdings included 74 slaves, two sugar mills and about 1,200 acres. On the grounds are the remains of the antebellum kitchen (a separate structure), the slave quarters, and the sugar mills.

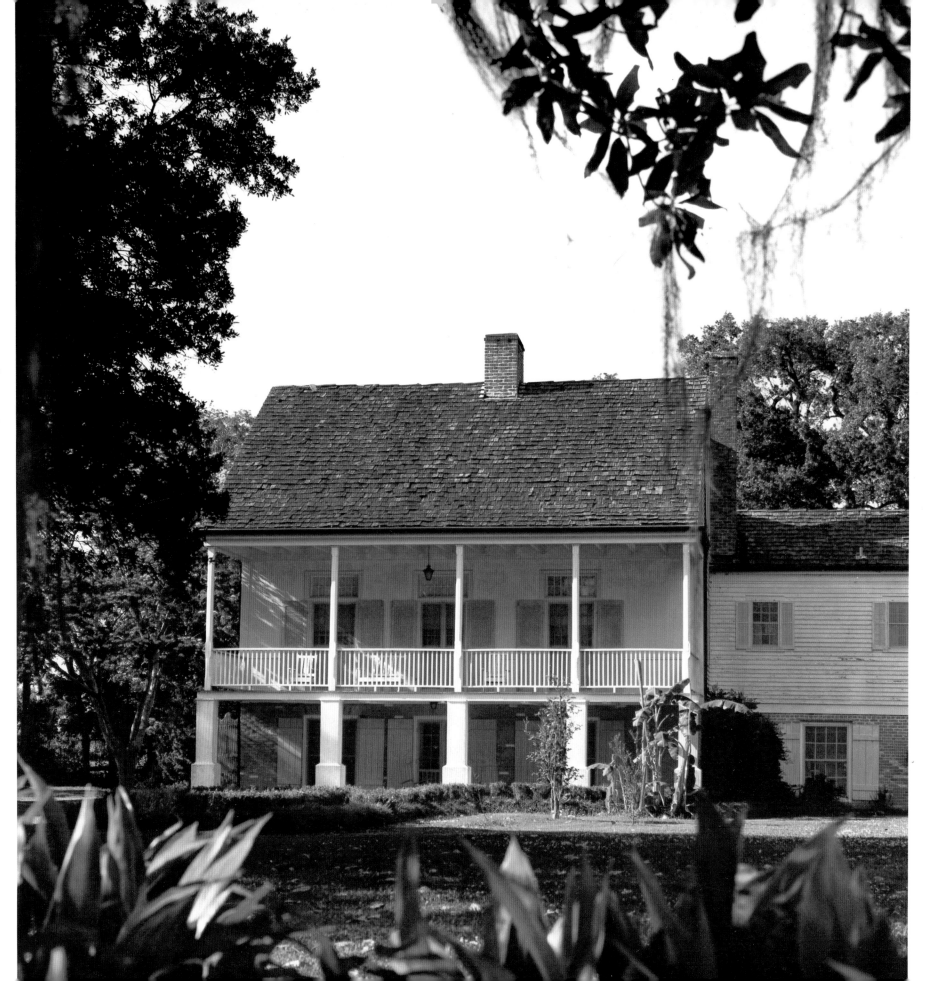

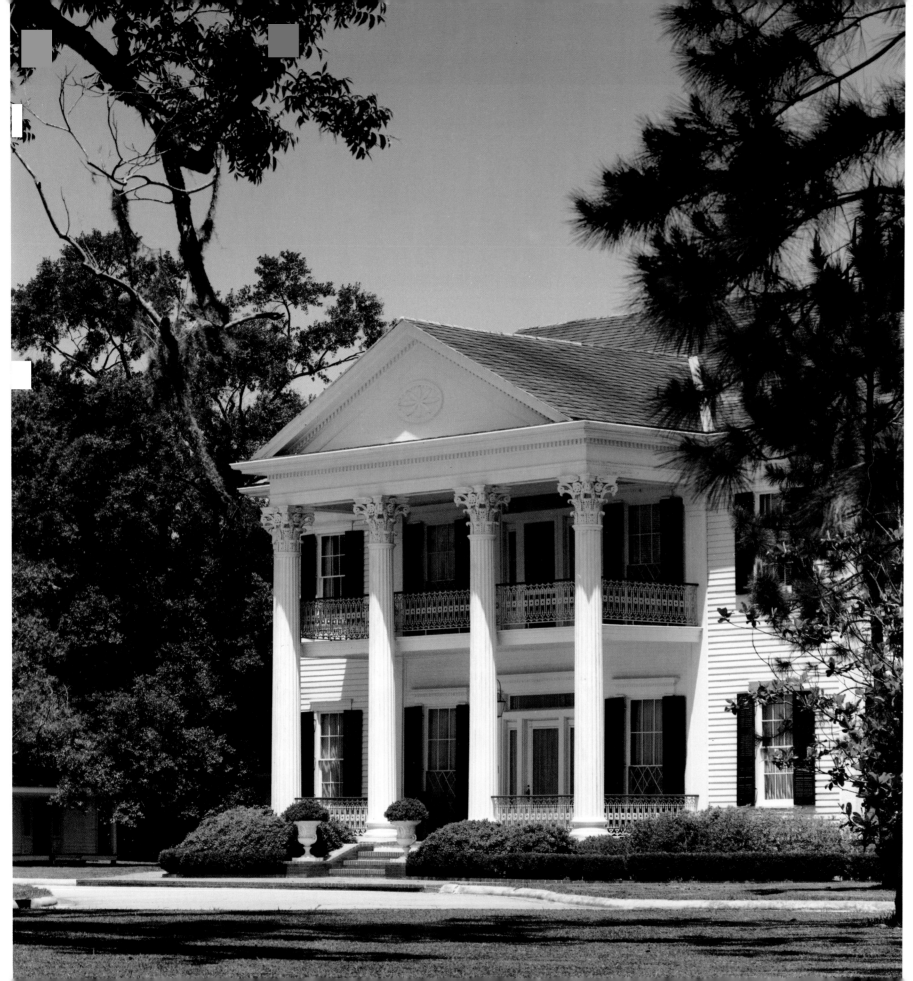

Arlington, 1855

Arlington Plantation once lay on both sides of the Teche. The builder of the mansion was Euphrasie Carlin, whose forebears received land grants from the Spanish, and is said to have been the owner of 2,000 slaves.

Later owners added a small wing to each side of the house. These were demolished in 1965 by Mr. and Mrs. Carl Bauer, who restored the Greek Revival home to its original character in 1965.

A tastefully furnished mansion on spacious grounds, Arlington is distinguished by its elegant millwork, fluted Corinthian columns, and 14-foot ceilings.

Oaklawn Manor, 1827 *(right)*

Like a giant resting in a large garden of 135 live oaks, Oaklawn Manor dominates the Irish Bend of Bayou Teche near Franklin.

The great manor house was built by Louisiana Supreme Court Judge Alexander Porter in 1827. After the Civil War the house fell into disrepair and was purchased in 1927 by a steamboat captain, C. A. Barbour, who had fallen in love with the plantation as he viewed it from his paddlewheeler on the Teche.

Captain Barbour, who had made his fortune in the oil fields of Texas, began a much-needed restoration of the great house, but just before it was completed, it all but burned to the ground, leaving only the great columns and brick walls. Undiscouraged, Captain Barbour reconstructed the home, building it "better than ever."

In 1960 Oaklawn and its extensive grounds and gardens were given a second restoration by Mr. and Mrs. George Thompson.

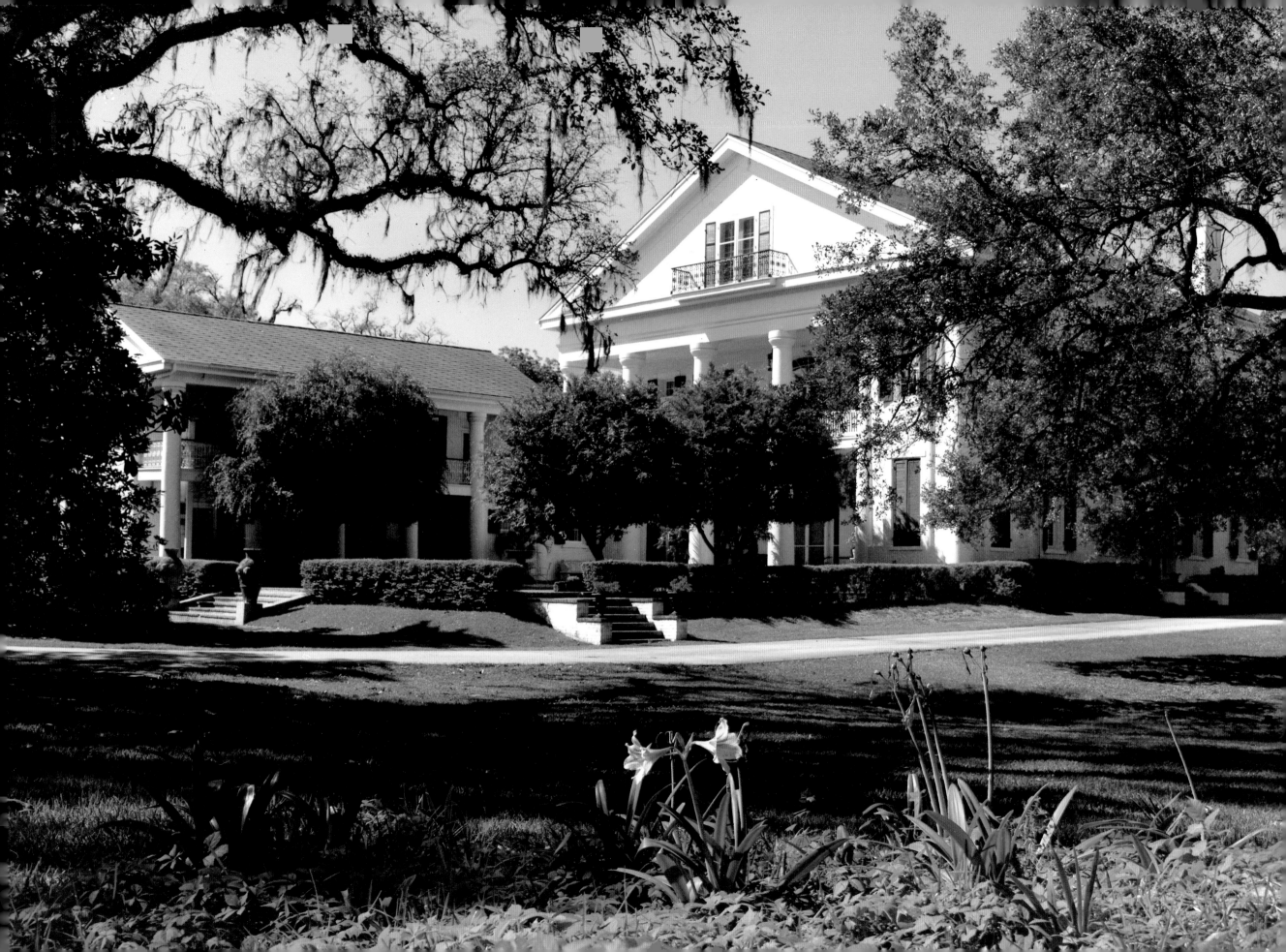

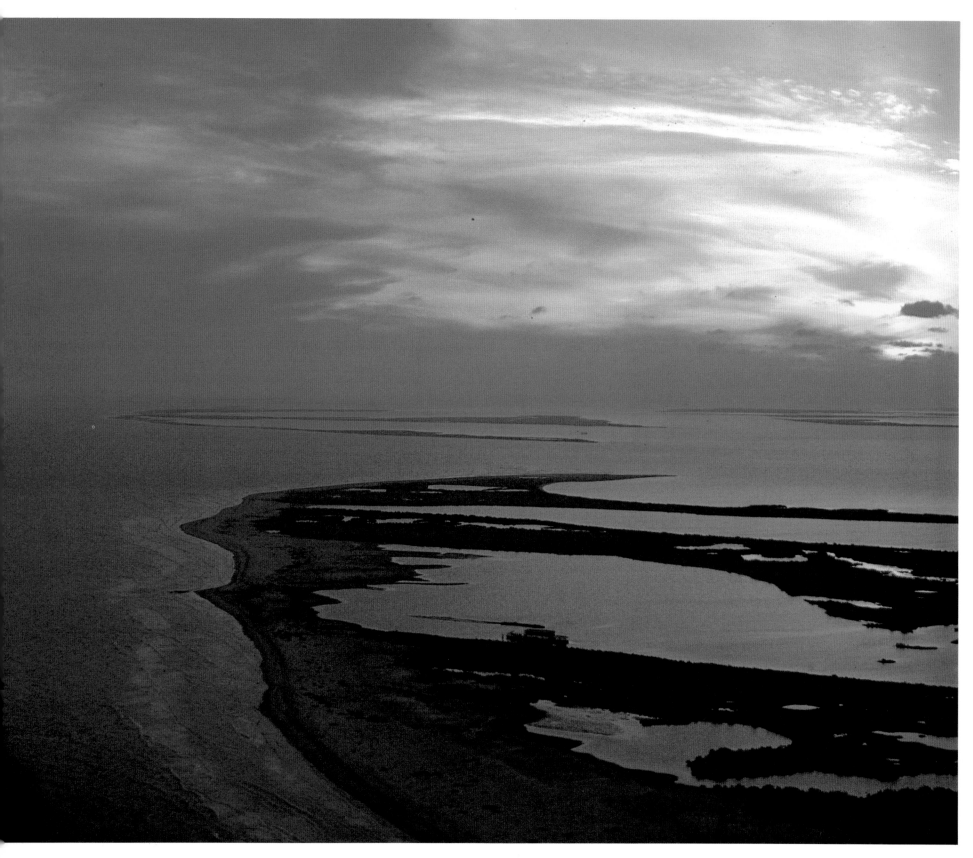

Last Island

Due south of Rienzi and Rosella, off the coast of
Louisiana, are clustered five islands, the Isles Der-
nières, which were one before the Civil War. Last
in a string of barrier islands proceeding westward
from the mouth of the Mississippi, the 20-mile-
long isle was appropriately called Last Island, or Isle
Dernière.

Although accessible only by steamboat, the is-
land rapidly acquired popularity as a seaside resort
before the Civil War, attracting planters and their
families from the lower Mississippi valley, particu-
larly from those areas most vulnerable to outbreaks
of yellow fever, since it was well known in ante-
bellum days that the fever "didn't like salt water."

Wealthier planters built summer homes, and
those who didn't were housed at the island's one
hotel. Another hospice, still larger, was to be called
the Trade Winds, and in the summer of 1856 was
on the drawing boards of the two owners of the St.
Charles Hotel in New Orleans.

The beginning of August, 1856, was a busy time
on Last Island. The hotel was crowded, and cottages
were packed. Vacationers remembered the fierce
yellow fever outbreak in New Orleans only a few
years earlier, and were determined to stay near salt
water.

Even the increasingly threatening breakers on
August 6 and 7 were ignored, and by the time a ma-
jor hurricane struck on the night of the tenth, it
was far too late to leave.

The island was swamped, overrun by the great
storm, and literally broken in pieces. Over 500 died,
and the few survivors told harrowing tales of drift-
ing in the marshes for days on bits of wreckage, tor-
mented by the sun by day, and swarms of mosqui-
toes by night.

The destruction of the South's economy that fol-
lowed the Civil War marked the end of hope to re-
vive the resort. To this day Last Island, now five
islets, four not much larger than a sandbar, remains
deserted, although a few camps can now be seen on
the easternmost island.

Irish Bend

From about 5,000 feet, it is easy to see the tenuous relationship between land and water in South Louisiana. Below us is Bayou Teche, near Franklin, whose great loops indicate the bayou itself may once have been a bed of the Mississippi. Beyond the land, to the south, are the waters of the Gulf of Mexico.

In the foreground, on Irish Bend, so named because of the Gaelic immigrants who settled there before the Civil War, are the cane fields of Oaklawn Manor plantation. The grounds of the manor house itself lie on the south side of the bayou. At the rear, toward the southeast, is the town of Franklin, while closer, on the north side of the bayou, is the plantation's sugar mill.

During the Civil War, on those cane fields was fought the Battle of Irish Bend, part of the North's effort to bring the rest of Louisiana under control after the fall of New Orleans.

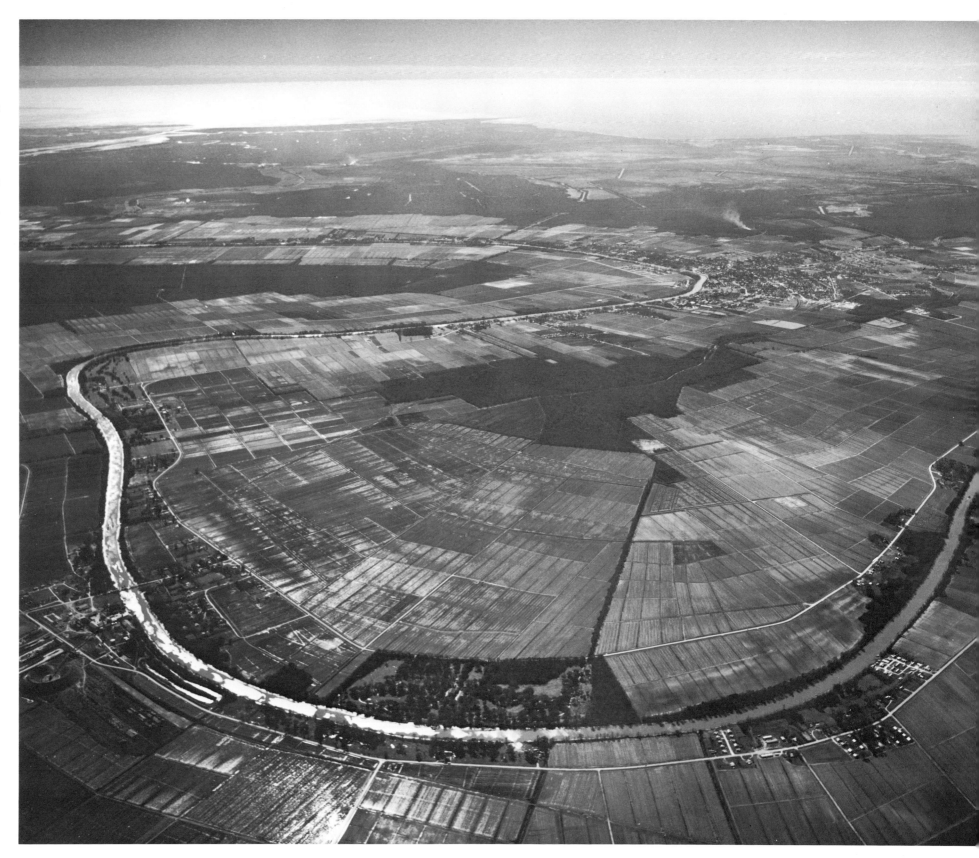

Shadows-on-the-Teche, 1831

Constructed as a townhouse central to four plantations owned by David Weeks along Bayou Teche, Shadows-on-the-Teche was bequeathed by his great-grandson, Weeks Hall, to the National Trust for Historic Preservation in 1958.

Returning to Louisiana after the First World War, Weeks Hall found the Shadows abandoned and showing signs of decay. He devoted his life to restoring the mansion and its gardens, and during the twenties and thirties he re-created the sparkle and gaiety of antebellum hospitality at the Shadows.

Upon Hall's death in 1958, the house and $400,000 were passed to the Trust for care. Open to the public, Shadows-on-the-Teche stands as a memorial of Weeks Hall, who said of the stately house, "No place is more tranquil nor more ageless."

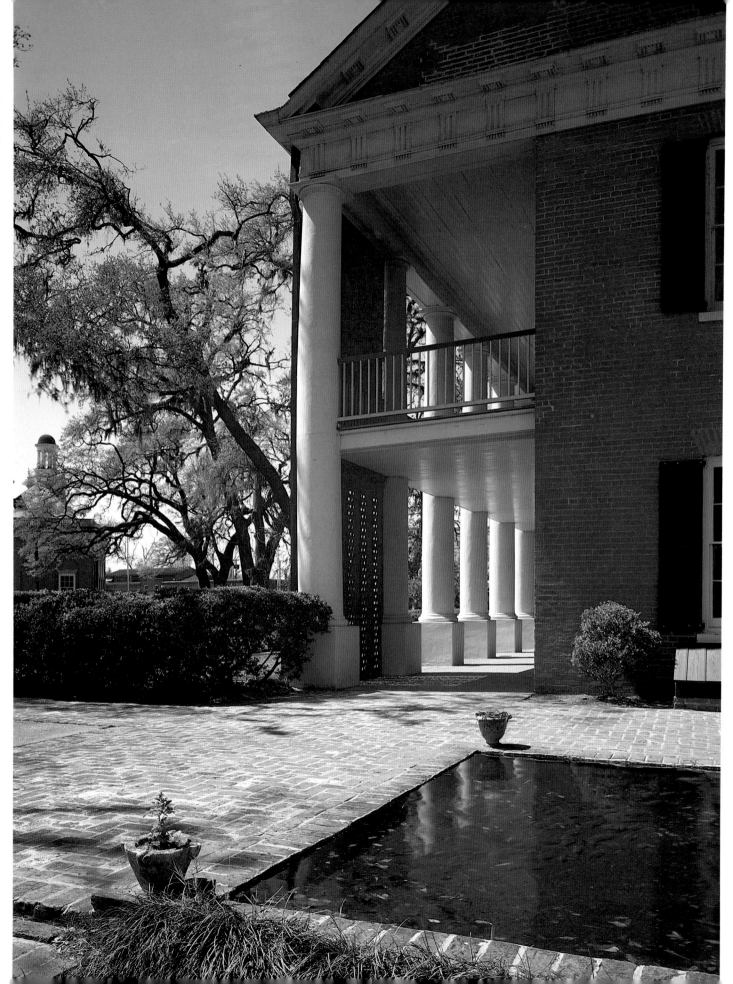

Bayside, 1850

Two-and-a-half-story Bayside is situated on the north side of Bayou Teche in Jeanerette. The mansion has 10½-foot ceilings on the first floor and 14-foot ceilings on the upper floor.

Bayside was built in 1850 by a friend of Edgar Allan Poe, Francis D. Richardson, and got its name from the large bay trees on the site.

Currently owned by Mr. and Mrs. Robert Roane, Jr., the house and grounds are excellently maintained. Bayside is a working plantation.

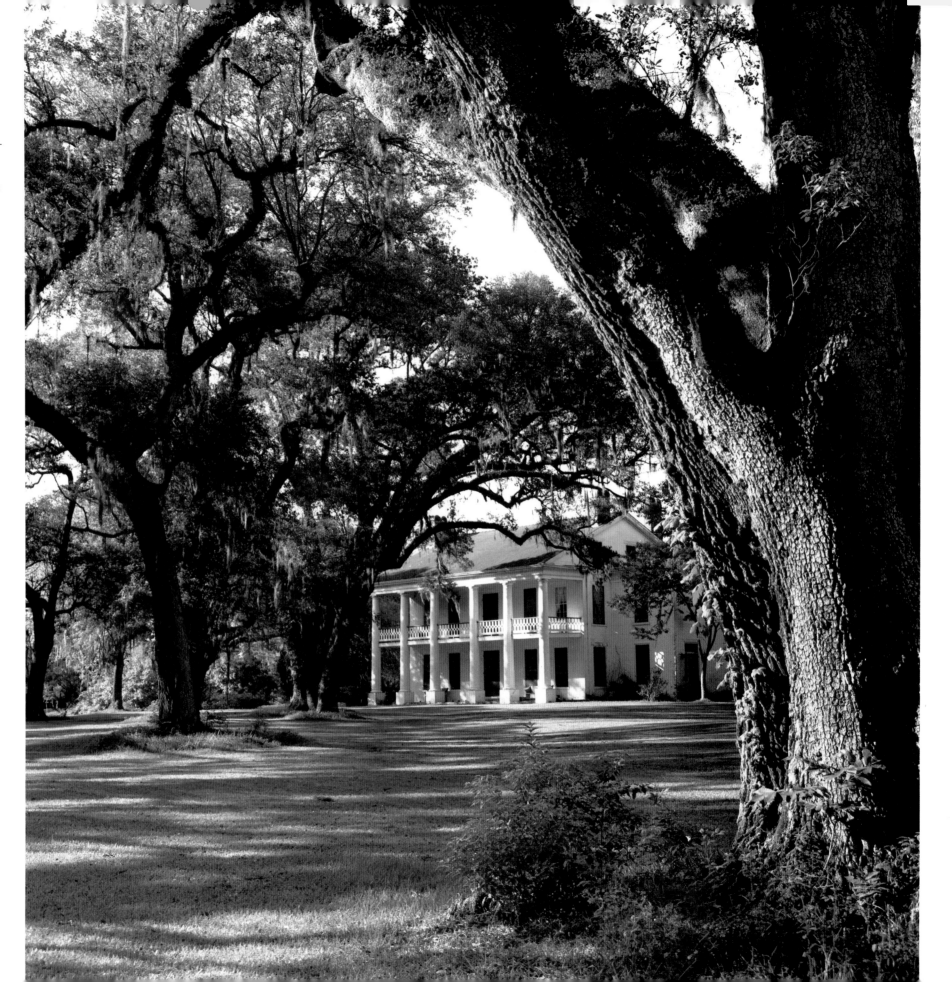

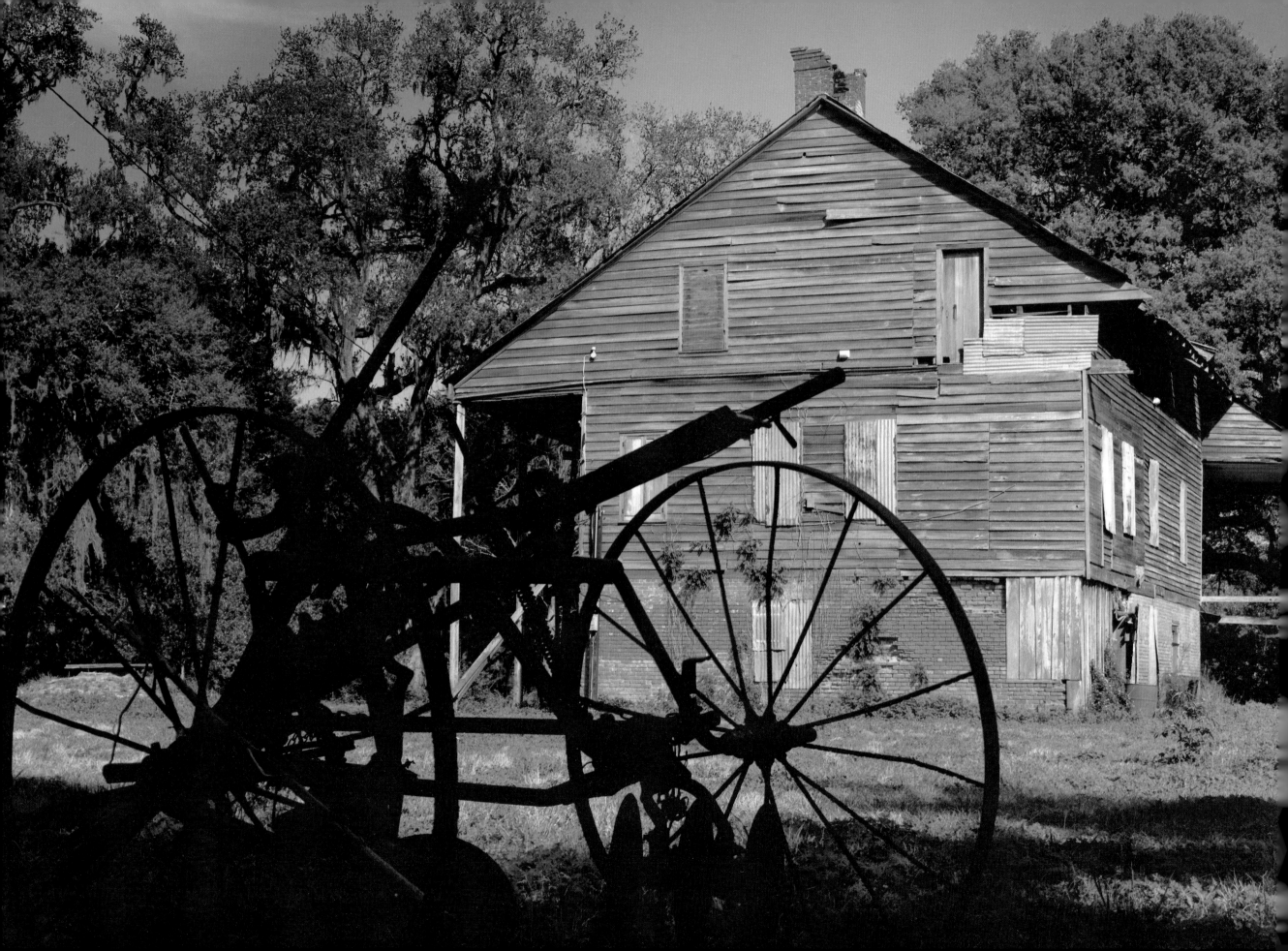

Darby House, 1820

Darby House was built in 1820 by François St. Marc d'Arby, as a wedding gift to his son and daughter-in-law.

The house never recovered from the Civil War when Union troops rode horses through it smashing furniture and fixtures. The d'Arbys, once among the wealthiest families in the South, were impoverished by the war, and their home fell into decay.

Two brothers continued to live in the house well into the twentieth century. One brother existed by selling milk, from a pushcart, to the townspeople of New Iberia, and the other, vegetables from his garden.

In a state of ruin, the property was acquired in the late 1970s by a local preservation society and was scheduled for restoration. Fire, however, brought an end to that dream, and now, of Darby, nothing remains.

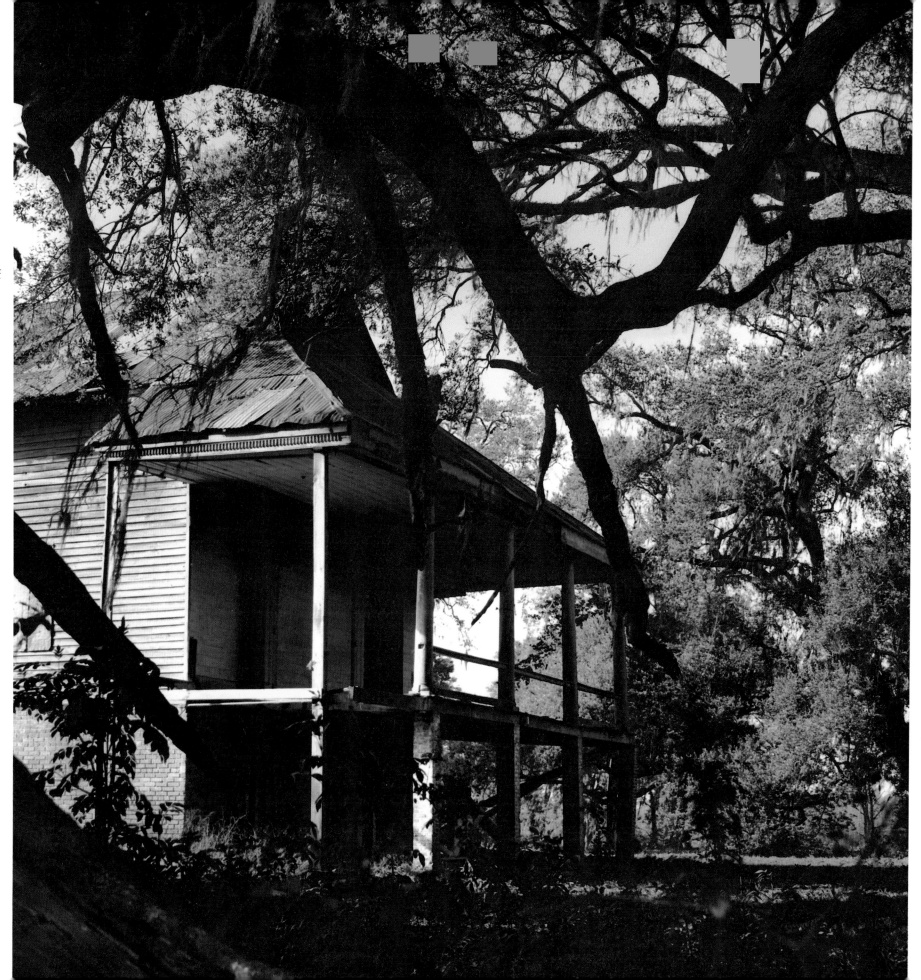

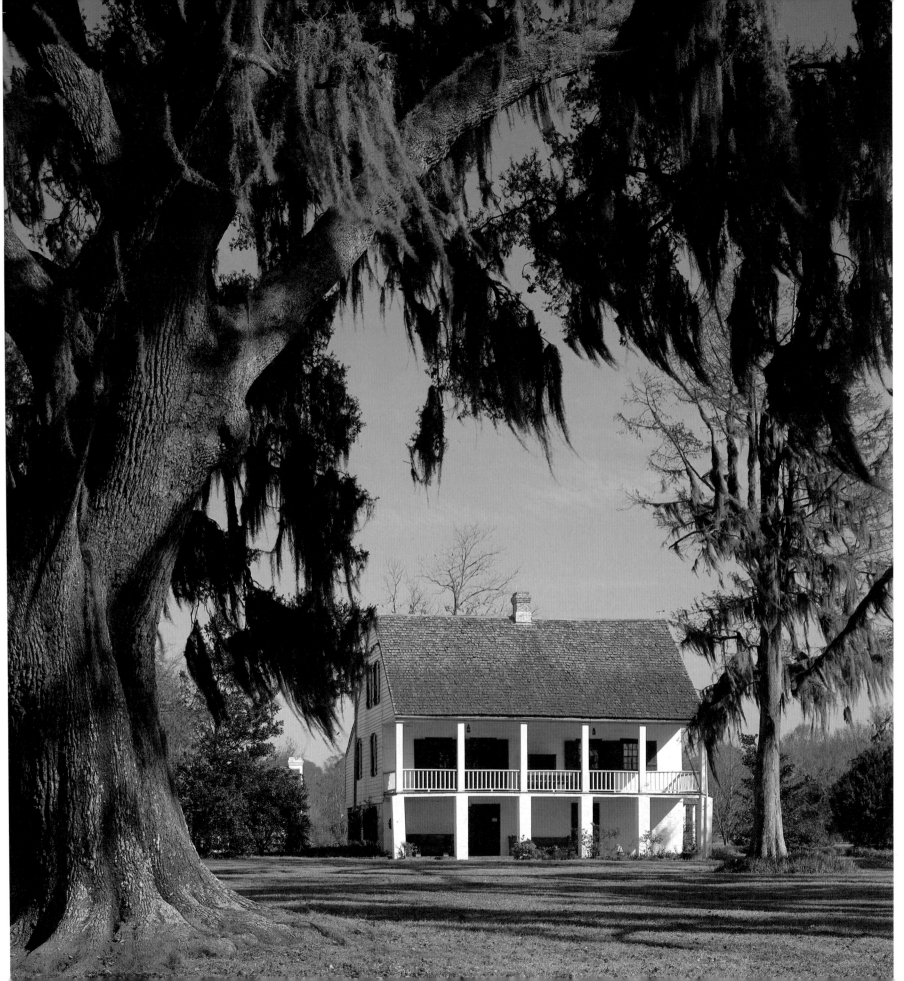

Acadian House Museum, late 1700s

Standing in the shadow of the 500-year-old Gabriel Oak, the Acadian House museum is owned by the state of Louisiana and is part of Evangeline State Park. Its furnishings reflect the life style of the early Acadian settlers.

The house was built before 1800 by a French chevalier, Paul Augustin le Pelletier de la Houssaye, who bought the original estate from a man named D'Hauterive, who came to the banks of the Teche near St. Martinville, then known as the Poste des Attakapas, in 1763 or 1764.

Although legend has it that this was the house that Gabriel of Longfellow's *Evangeline, a Tale of Acadie* built, other researchers have pointed out that the Acadian refugees did not at that time have the financial resources to build a structure of this scale. A replica of the simpler type of cottages the refugees built has been erected on the park grounds.

Lady of the Lake, late 1700s *(right)*

Once overlooking a much larger Spanish Lake, near St. Martinville, Lady of the Lake was built on a 3200-acre Spanish land grant by Despanet de Blanc at about the time of the American Revolution.

Built over a raised basement, floored with imported hexagonal tile, the house was one of the most delicately detailed in the area, with slim colonnettes on the second floor, marble fireplaces, and gracefully proportioned fanlights over every doorway.

Although ransacked by Federal troops during the Civil War, and later by vandals, the house survived, unattended, overlooking a shrunken lake turned pastureland, until the early 1970s, when it was ordered bulldozed by absentee landlords.

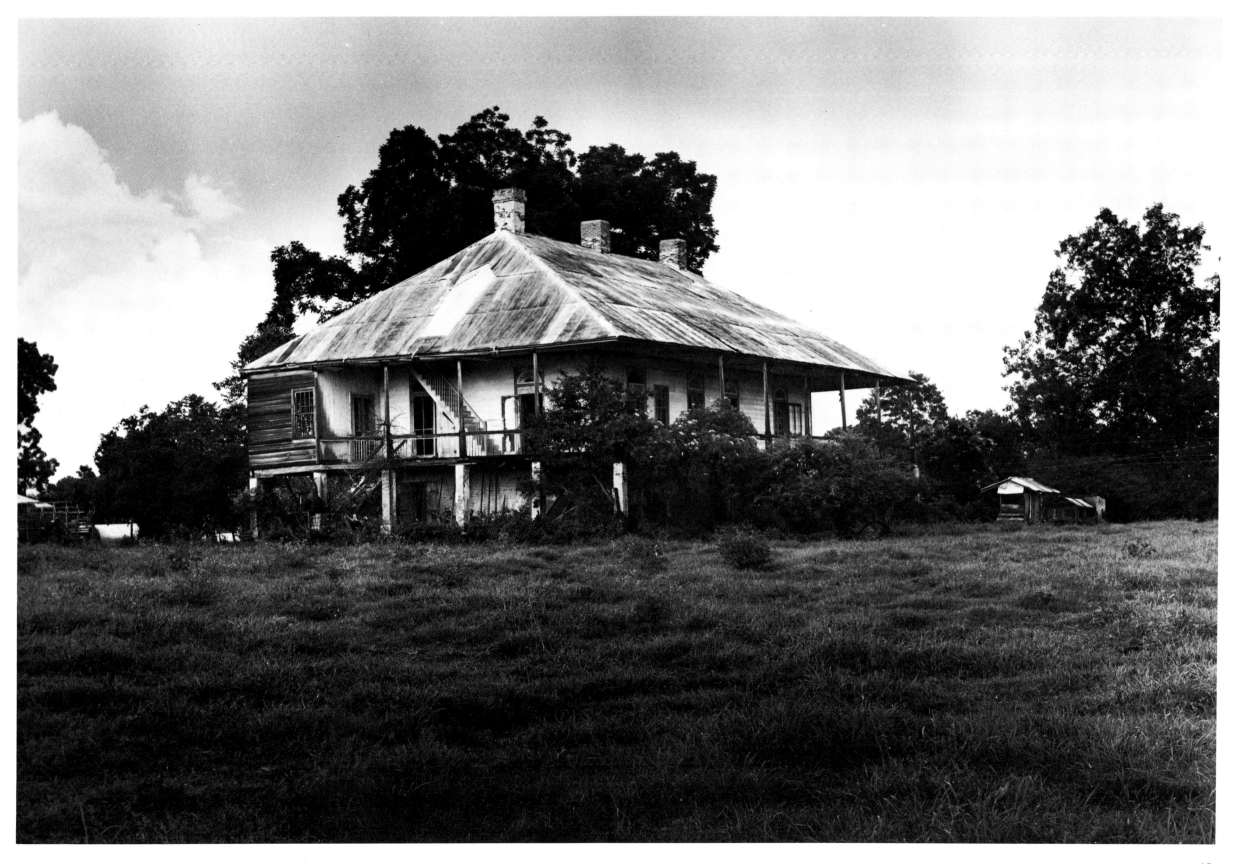

Chretien Point, 1831

Under construction for nearly four years, Chretien Point was begun in 1831 by Hypolite Chretien II on land that was a wedding gift from his father.

Upon Chretien's death by yellow fever shortly after the mansion was finished, his wife Felicité assumed management of the plantation. A daring poker player, Felicité traveled alone to New Orleans, behavior that was unheard of during that time, to confer with bankers. Eventually, the plantation passed on to her son, Hypolite Chretien III, who saved the house from destruction by Union troops by giving a Masonic sign, which the Union commander, also a Mason, recognized. However, the commander did destroy the outbuildings and crops, and confiscated the livestock and slaves.

Chretien Point then passed on to Hypolite III's son Jules and later was deserted. Today the mansion, located on Bayou Bourbeau just west of Sunset, has been restored by Mr. and Mrs. Louis J. Cornay of Lafayette.

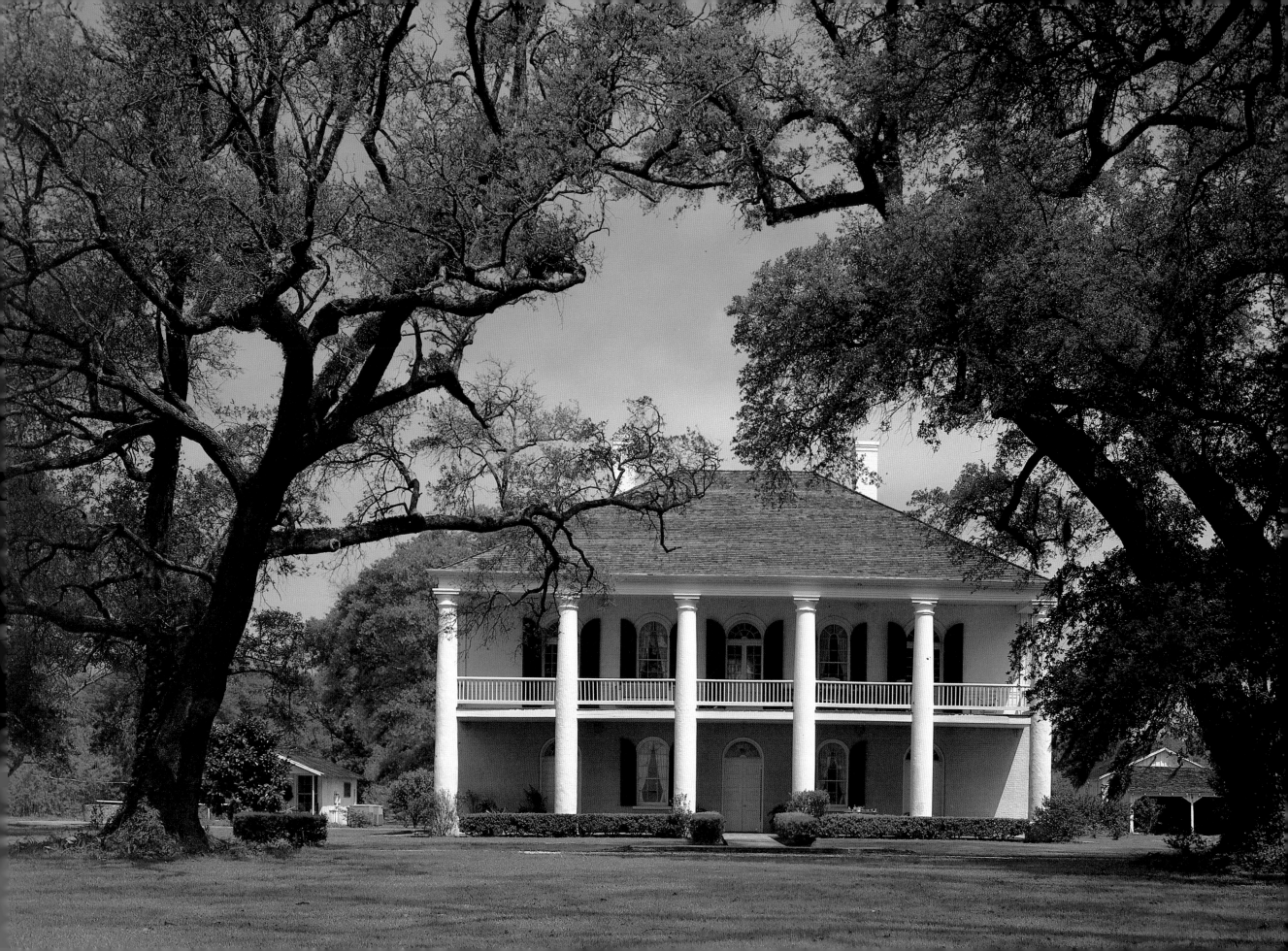

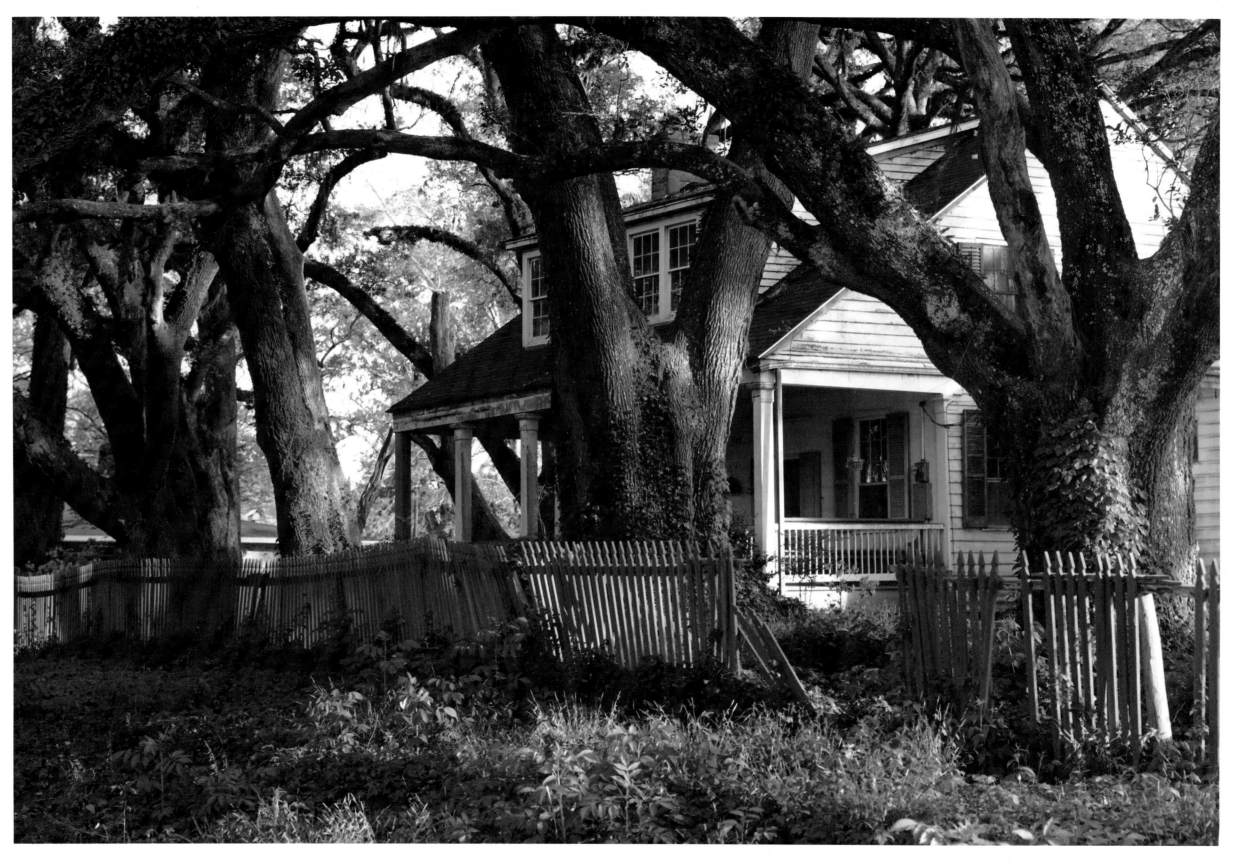

Hinckley, early 1800s

Built in the early 1800s by Asa Norton on a Spanish grant that ran from Bayou Courtableau to Bayou Carron near the port city of Washington north of Opelousas, Hinckley has remained in the same family line since its construction.

Oramel Hinckley was a young apprentice engineer on a steamboat plying Bayou Courtableau when he met and married the granddaughter of Asa Norton. In the ensuing years before the Civil War, Oramel became a steamboat captain and ultimately owned five vessels.

Washington, incidentally, was the western terminus for steamboat traffic. Passengers and freight heading west changed to stage and overland freight lines, while goods and passengers heading up Bayou Boeuf toward Alexandria transferred to *pull boats* towed by oxen and mules against the slow-moving current. Cotton and cane from plantations along the bayou were floated down on those same craft and stored in warehouses in Washington until they were transferred to steamboats, which carried them across the Atchafalaya swamp to Plaquemine, on the west bank of the Mississippi below Baton Rouge.

After the war, Oramel Hinckley lost his fortune, commenting that he had only $150 "in good money."

The house is still occupied by Hinckley descendants, Mr. and Mrs. Arthur Hinckley, Jr., and is furnished with the heirlooms of generations of the same family.

Magnolia Ridge, 1830 (*right*)

Magnolia Ridge was built by Judge John Moore who began construction in 1820 and completed it ten years later. Eleven years after the death of his first wife, Judge Moore married Mrs. David Weeks, widow of the builder of Shadows-on-the-Teche. This marriage was childless, and Judge Moore gave the property to his daughter by his first marriage, who had married William Marshall Prescott.

The home was occupied by the Prescott family for many years. One of its occupants, Captain Lewis D. Prescott, commanded Company A, 2nd Louisiana Cavalry during the Civil War. They were the last organized group to surrender in late 1865.

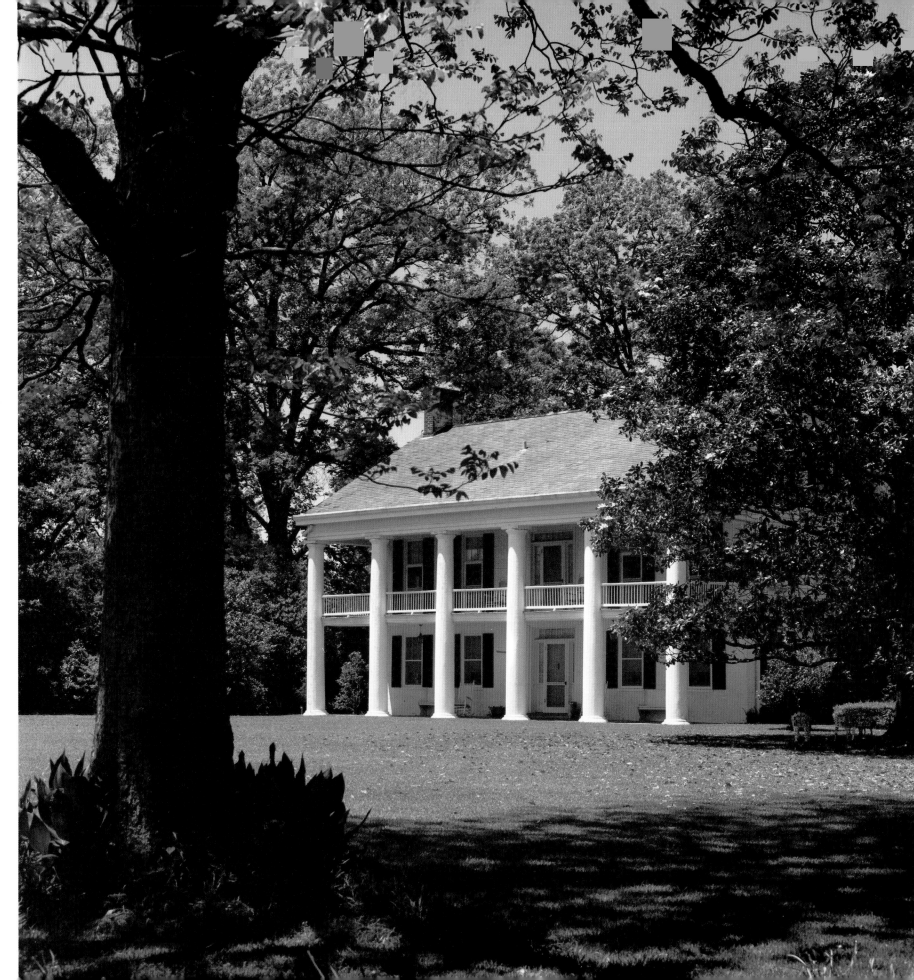

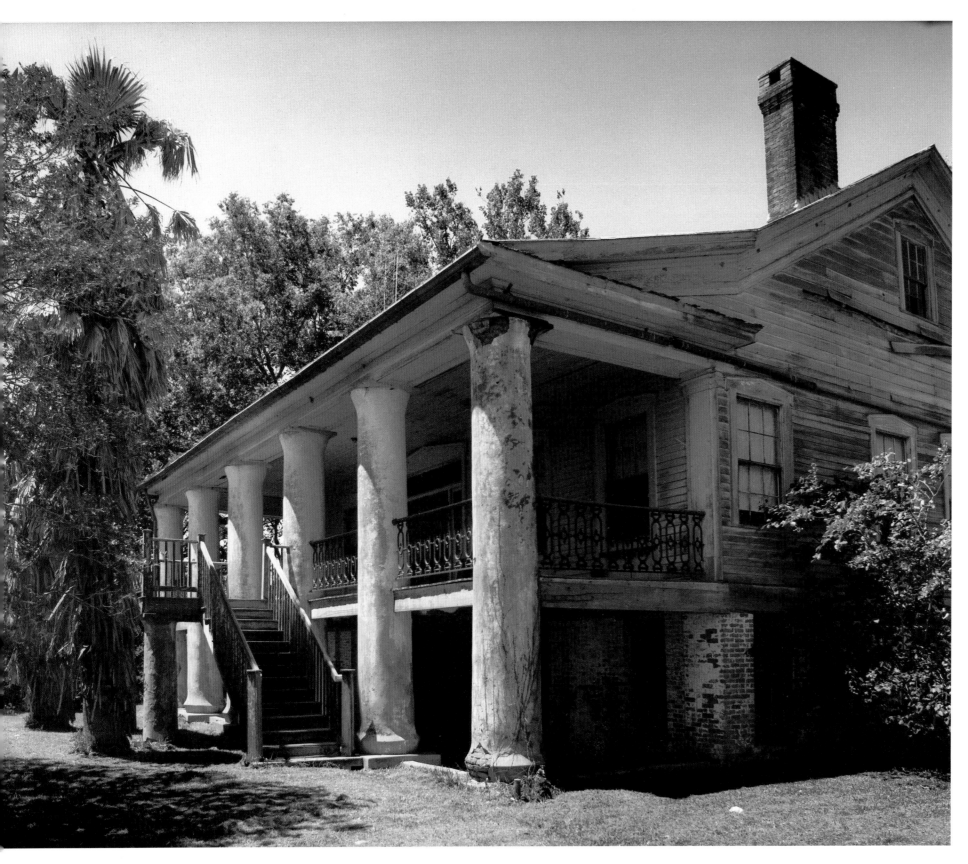

Macland, 1849

Macland, also known as the Payne House or the Thistlewaite home, was originally named Woodland and is located on Louisiana Highway 10 north of Washington near Bayou Boeuf. It is distinguished by its unique columns and by the carriage-way that runs through the raised basement from the front to the rear of the house. Originally, a quarter-mile avenue of oaks led from the house to Bayou Boeuf. Woodland Plantation is said to have comprised 5,000 acres and 110 slaves.

Macland was built by a wealthy Washington physician, Dr. Lewis Archibald Webb, who went to Virginia with his bride, Amelia, and purchased three slaves, sisters, for house servants shortly before the Civil War. The daughter of one of the slaves lived near the house into the 1970s.

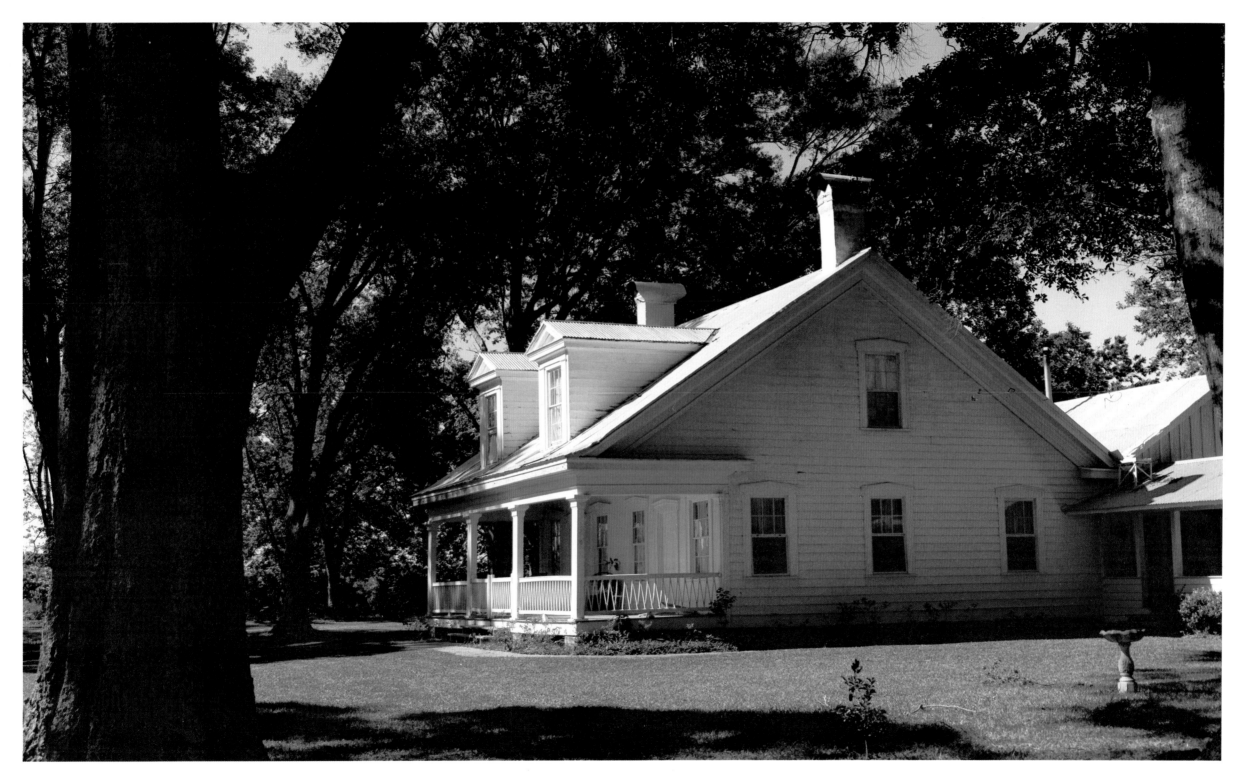

Homeplace, 1826

Dr. François Robin, a native of Bourg St. André in France, and a doctor of both medicine and law, built Homeplace on the banks of Bayou Boeuf north of Washington on a Spanish land grant given him in 1791.

Resting in a grove of oaks, Homeplace is sometimes referred to as the Wikoff House. It was once occupied by one of the original owners of the Opelousas Steamboat Company, Stephen W. Wikoff.

In 1911 the Stephenson family acquired the property, and it has remained in Stephenson possession since that time. Homeplace, now on the National Register, is furnished with heirlooms of the Stephenson and Quirk families.

Sunflower, 1839

Sunflower was built in 1839 by Marshall and Aaron Prescott, who, in 1829, had brought their slaves with them from Georgia and bought 11,000 acres of land along Bayou Beouf below Bunkie, at a price of $4.50 per acre.

The plantation complex included a double row of brick slave cabins, a sugar mill, and a cotton gin. Brick cisterns, looking like huge beehives, and extending ten to fifteen feet below ground, held an ample supply of rainwater year-round.

A Prescott descendant sold her share, 172 acres, to T. T. Sandefur in 1917, whose children still own the property.

Sunflower, although unoccupied since 1925 when the family moved nearby to a newly constructed house, remained in good condition until 1957 when Hurricane Audrey blew a huge pecan tree across the center of the house.

Oakwold, 1835

Just three miles east of Bunkie, on Louisiana Highway 29, is Evergreen, once a thriving steamboat town at the junction of Bayou Huffpower and Bayou Rouge.

Two of the earliest settlers in the area, William Pearce and his son-in-law, S. M. Perkins, founded Evergreen and built Oakwold (an Old English name for oak grove), starting in 1832 and finishing by Christmas of 1835, just in time for a visit by Sam Houston.

Ravaged by Union troops, Oakwold was repaired and enlarged following the Civil War, and has remained in the same family since its construction. It is now owned by Mr. and Mrs. Porter B. Wright.

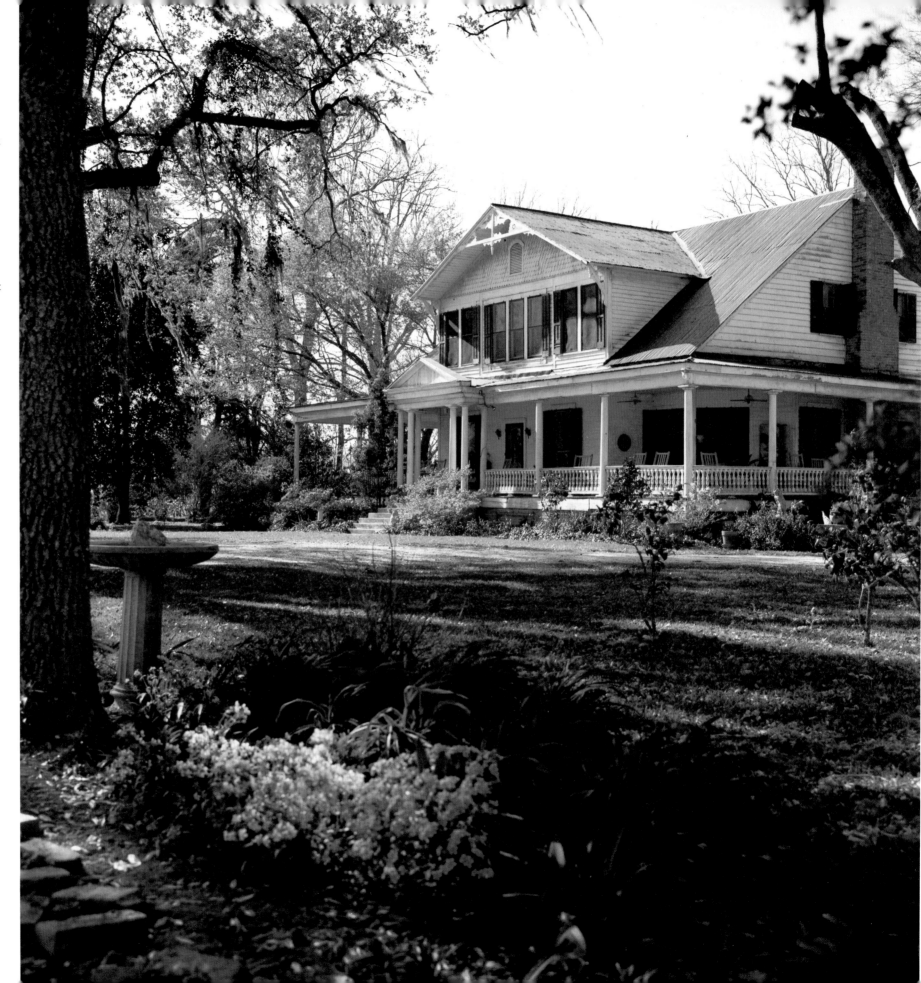

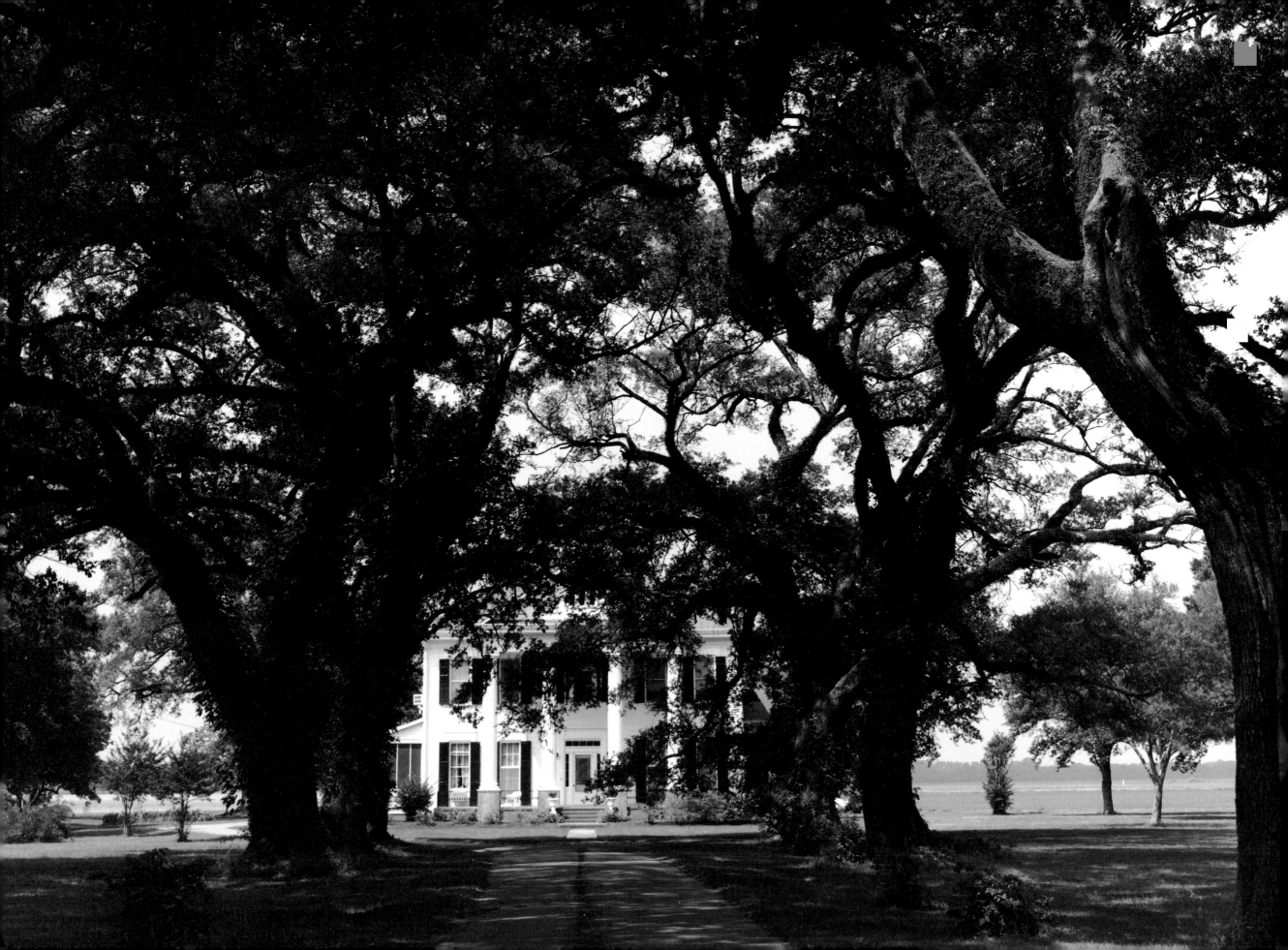

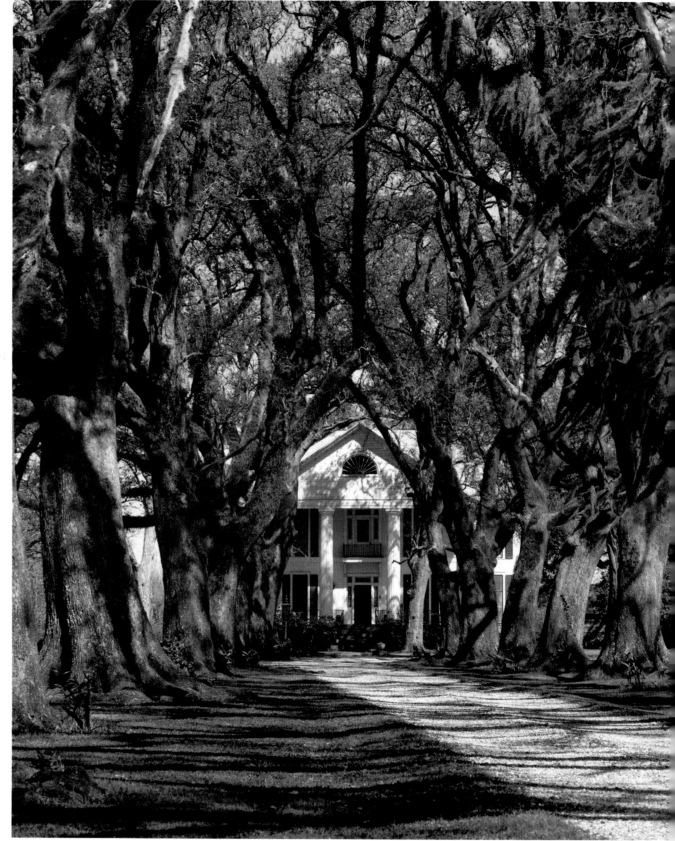

Bubenzer, 1850 (left)

Built for Mary McCoy in the 1850s, Bubenzer enjoyed the life of a manor house for only a few years before Union General Nathaniel Banks made it his headquarters during part of his campaign along Louisiana's bayous.

Located on the west bank of Bayou Boeuf just north of Bunkie, the house originally had columns on three sides and a belvedere on the roof.

Still a working plantation, which has been owned by three generations of Bubenzers, the house is well maintained and preserved.

Wytchwood, 1814

Overlooking Bayou Boeuf near Cheneyville is Wytchwood, completed in 1814 by Robert Tanner, and built on land grants that were signed by Martin Van Buren and Andrew Jackson.

The 1,000-acre working plantation is still owned by Tanner descendants, Mr. and Mrs. Robert J. Munson, and is planted in sugarcane and soybeans.

The 2½-story, 14-room house with floored attic has been remodeled a number of times, but still has the original log cabin standing next to it, which housed the Tanners while the great house was under construction.

Loyd's Hall, 1810

The 2½-story Loyd's Hall was built about 1810 and remodeled around 1830. Constructed of slave-made bricks with six square cypress columns on brick pillars, the Georgian house features 18-foot ceilings and well-preserved trim and plaster medallions.

Tradition holds that the house was owned by one of the Lloyd's of London family, who was given his inheritance on condition that he leave the country and change his name.

Mr. and Mrs. Frank Fitzgerald bought the plantation in 1948 and restored the great house. Overlooking Bayou Boeuf near Cheneyville, Loyd's Hall is still the center of a working plantation.

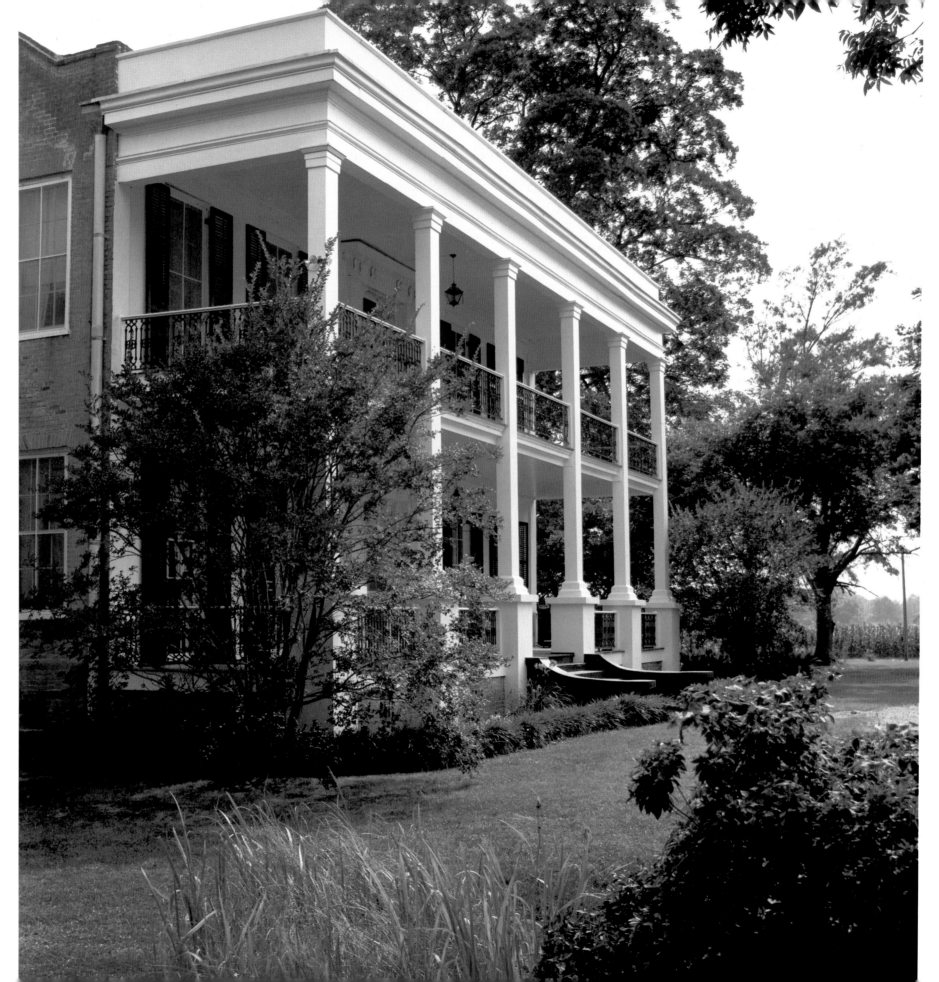

Cane River Country and North Louisiana

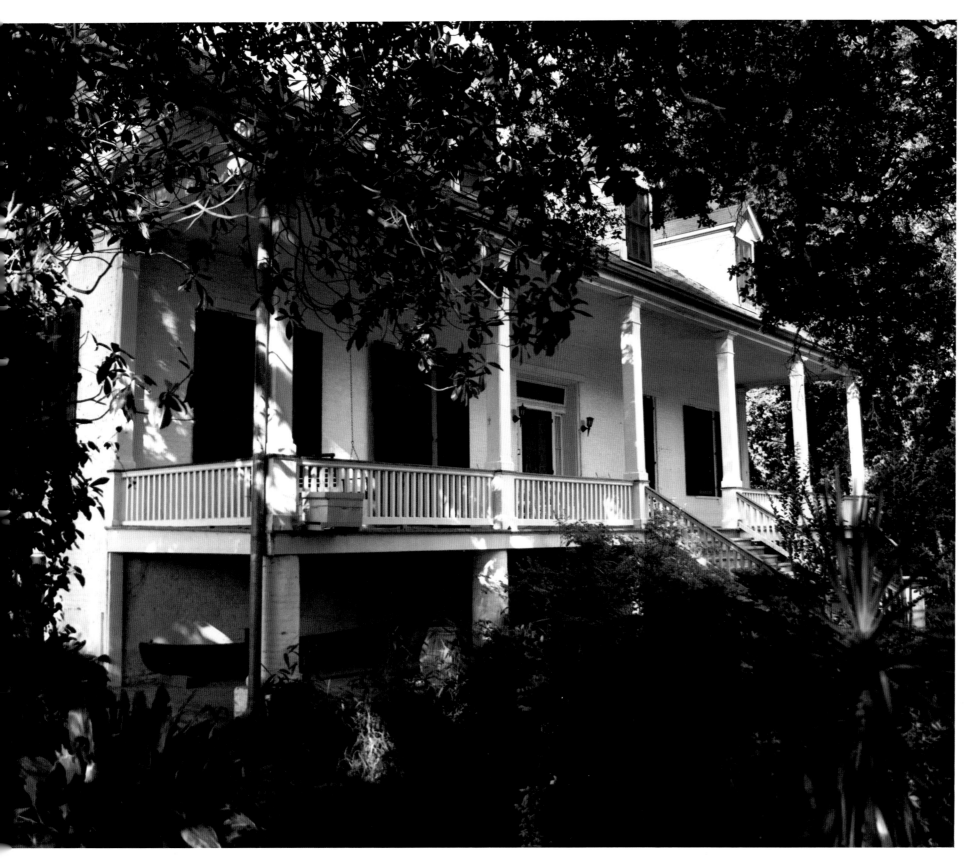

Magnolia, 1840

Surrounded by ten acres of live oaks and magnolias, the "Big House" of Magnolia Plantation was constructed about 1840 by Ambrose Lecompte II and burned by Union troops in 1864.

Following the Civil War, Magnolia was rebuilt to its original specifications, using the raised brick basement's 18-inch-thick brick walls and brick pillars.

The plantation complex included 27 brick slave cabins, still in existence, as well as the cypress cotton press, the first in the area.

Magnolia Plantation is still owned by descendants of the founder, who, in the late 1970s ceded the plantation's cotton gin and double row of brick slave cabins to the city of Natchitoches.

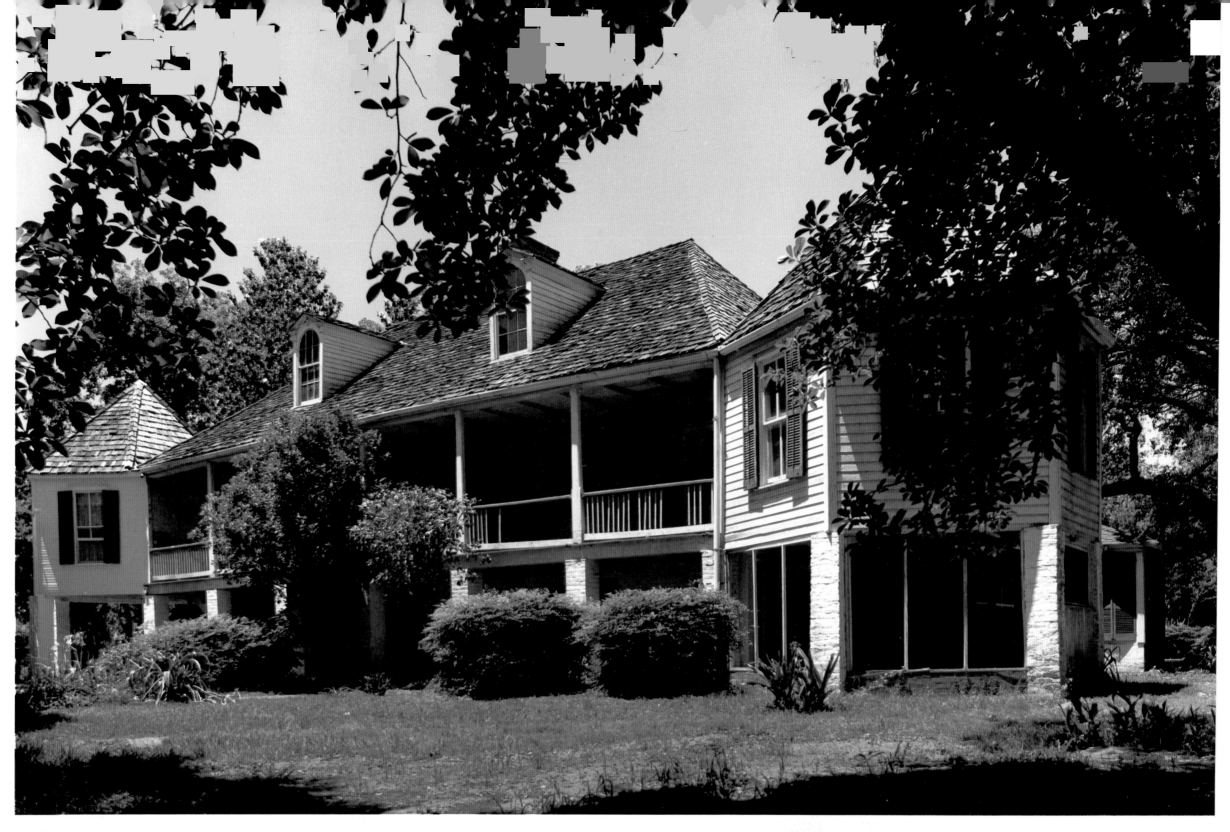

Melrose, 1833

Built by the child of a slave, Melrose became one of the outstanding plantations in the Cane River area (then the Red River) below Natchitoches.

Marie Therese Coincoin, a freed slave, acquired title to the property now known as Melrose Plantation, and before the end of the colonial era, she and her sons held over six thousand acres in the vicinity. In the process, Marie Therese achieved freedom for her ten children sired by a French planter, Claude Thomas Pierre Metoyer, as well as the first four by another slave.

By 1832 the clan held over 12,000 acres, and the family, on a per-capita basis, owned more slaves than did their white counterparts on the other side of the river.

The plantation house, Melrose, is said to have been built by Marie Therese's son, Augustine Metoyer, in 1832. The octagonal garçonnières on either side were constructed later.

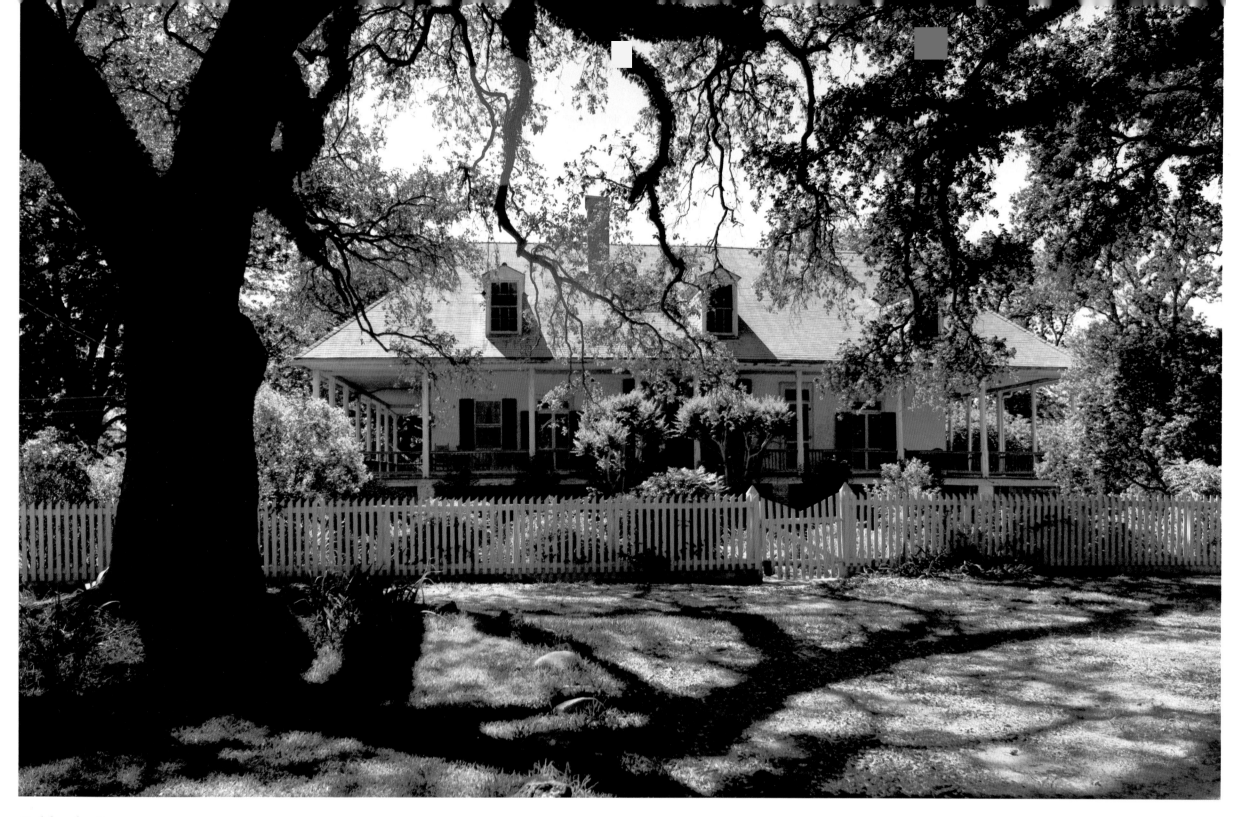

Oakland, 1821

Owned and occupied by the fifth generation of Prudhommes, Oakland was constructed in 1821, although the acreage had been in the family for two previous generations.

Consisting of 15 rooms over a raised basement, the 12-foot-ceiling rooms open on to the 10-foot-wide gallery that surrounds the house, 80 feet in front and back, and 70 feet on the sides. Each of the rooms is interconnected within the house, except for the "stranger's room" which opens only onto the porch.

Downstairs, the basement rooms have been converted into a museum, which features early farm tools, physician's equipment, and hand-turned drilling tools found on the plantation.

Oakland, with its avenue of live oaks, was the scene of *The Horse Soldiers* featuring John Wayne.

Located ten miles south of Natchitoches, it has one of the most complete collections of outbuildings of any plantation in Louisiana.

Oakland has a rare collection of its own original antebellum outbuildings, including the chicken house which has stood to the rear of the manor house for generations. (*left*)

St. Maurice, 1826

Located high on a bluff overlooking a major crossing of the Red River east of Natchitoches, St. Maurice was also near the junction of El Camino Real and the Monroe-Natchitoches Military Highway. Hence the house was as well known for its hospitality to antebellum travelers as for its cotton.

Built in 1826 by Dennis Fort, on a Spanish land grant purchased from Jacques Paillette in 1819, St. Maurice was visited by Sam Houston, Jim Bowie, Stephen F. Austin, and Davy Crockett, among others. In 1846 William Prothro, from South Carolina, became the new owner, who, in addition to operating the plantation, ran a trading post, ferry, and riverboat landing, and built guesthouses for travelers.

Following the Civil War, St. Maurice changed hands repeatedly. One owner was Luther Small, whose ancestors are said to have been slaves on that plantation. In 1980 the stately old home changed hands for the last time and, after renovation, was destroyed by fire in March of 1981. Only the chimneys and columns remain.

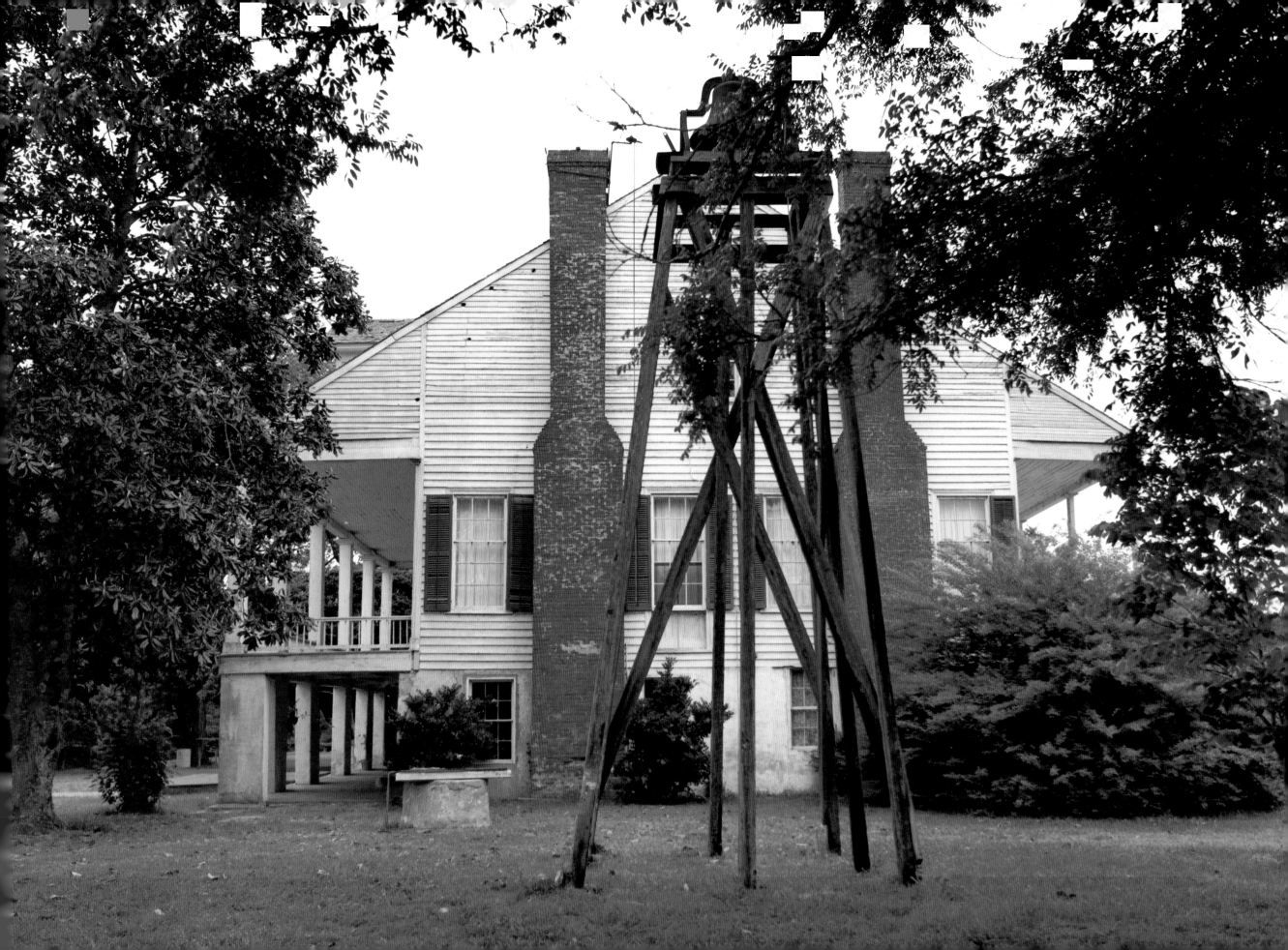

Land's End, 1857

Although the manor house was not constructed until 1857, Land's End Plantation has remained in the same family for seven generations, since Henry Marshall of South Carolina moved to the Red River country below Shreveport in 1837 and acquired approximately 10,000 acres and over 200 slaves.

The plantation house, said to have been built on an old Indian campground, still has its original furnishings, bills of sale for materials, and some of the tools used in its construction.

The name Land's End was applied to the plantation by Colonel Marshall's mother-in-law, who, coming with her daughter to the remote area, complained that she had been brought to "the end of the earth."

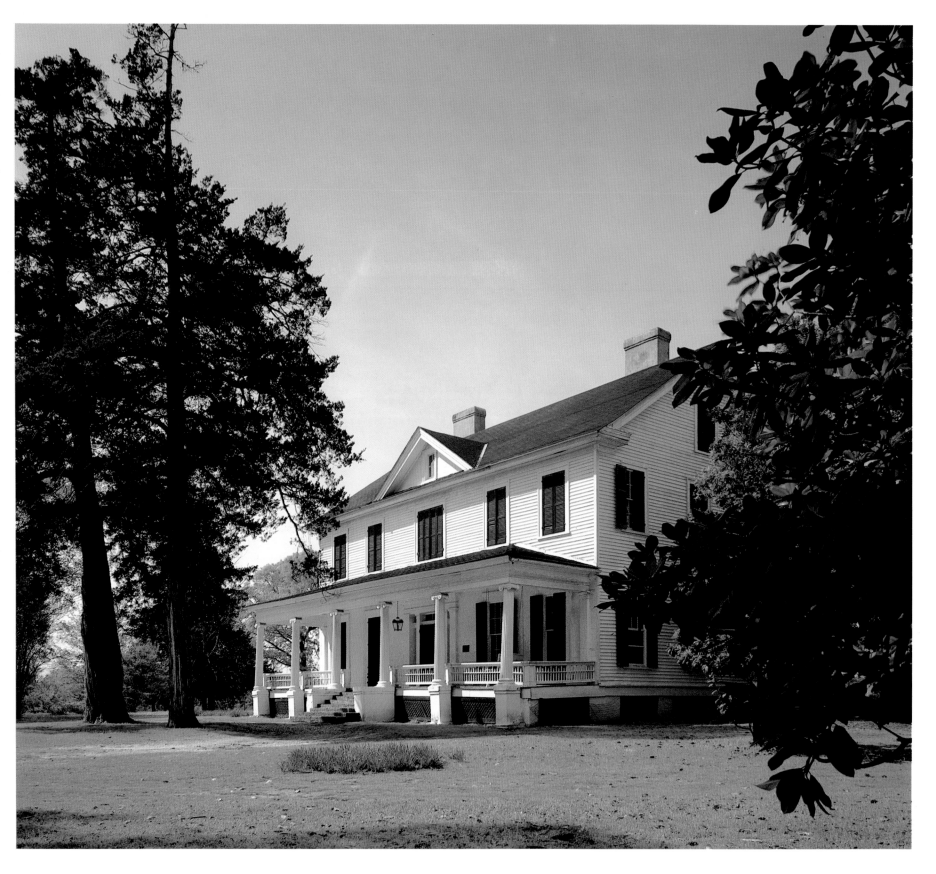

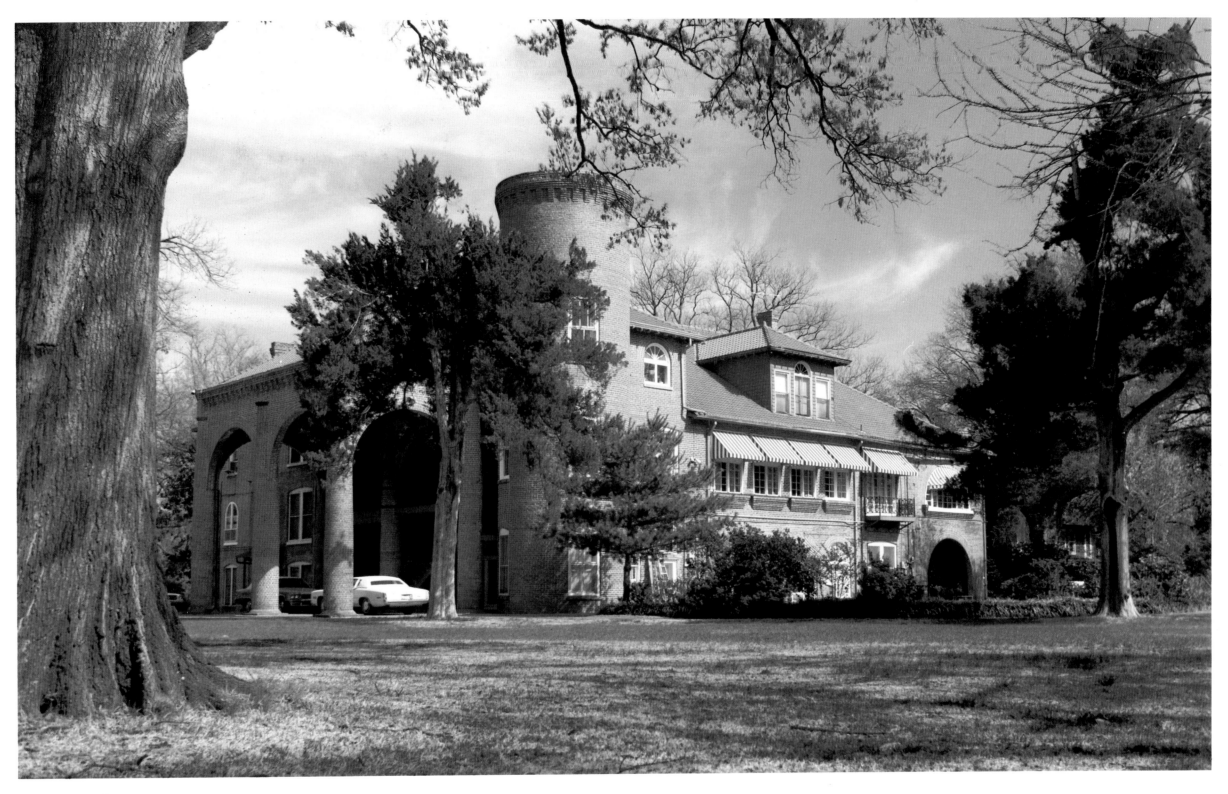

Layton Castle, 1810, 1910

Within the walls of Layton Castle is incorporated part of the Old Bry House, built about 1810 by an early settler on the Ouachita River in north-central Louisiana, Judge Henry Bry.

Judge Bry led the delegation that welcomed the *James Monroe*, the first steamboat to make its way *up* the Mississippi to Fort Miro, as the area then was known, in 1819. They then renamed the settlement Monroe to commemorate the event.

Layton Castle was constructed in 1910 to surround the earlier house by the widow of Judge Bry's grandson, Robert Layton II, and is distinguished by a tower reminiscent of feudal Europe.

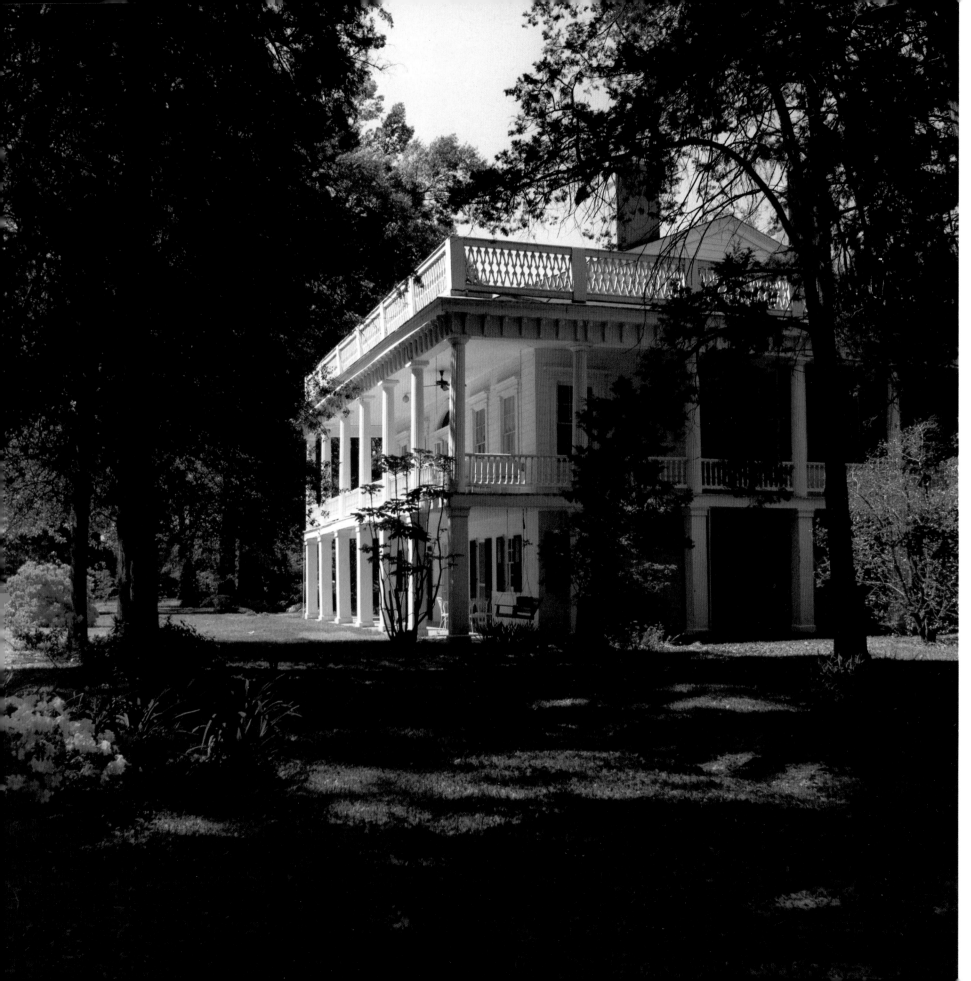

Arlington, 1832

Situated on spacious grounds overlooking Lake Providence, an old bed of the Mississippi, stands Arlington, a two-story structure of brick on the first floor and cypress on the second.

Arlington figured as Union Army headquarters during parts of the Vicksburg campaign, since it is near "Grant's Canal," a futile effort by Grant to bypass the Vicksburg defenses. Union officers using the house included Macpherson, McMillan, and MacArthur, and, according to tradition, Grant himself visited there.

Built as a single-story house in 1841 for Mrs. T. R. Patten, the house was later raised and converted into a two-story manor house by General Edward Sparrow, who later became Louisiana's senior senator in the Congress of the Confederacy.

The Natchez Area and Downriver

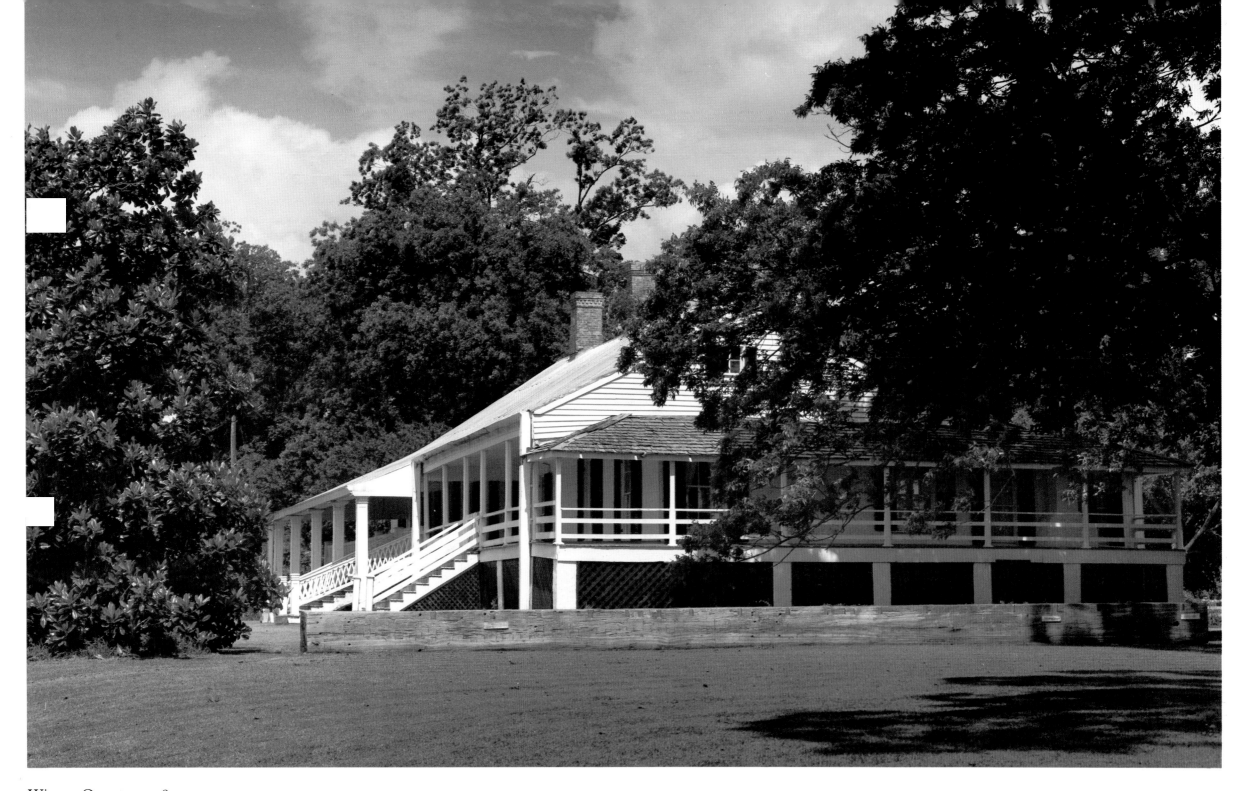

Winter Quarters, 1803

Although Winter Quarters is listed at having been built in 1803, it is actually three houses, each built by different owners, and of course at different times.

Job Routh, an early Natchez planter, was the first to erect a three-room cabin on his 800-acre Spanish land grant, and used it primarily as a hunting cabin in the winter. His daughter and her husband later expanded the cabin by adding six rooms plus a gallery. Then in 1850 Dr. Haller Nutt, who later built the magnificent but unfinished Longwood in Natchez, added the last two-story wing for his expanding family of eleven children. Under Dr. Nutt's guidance, Winter Quarters plantation grew to about 2,300 acres worked by 300 slaves.

During the Vicksburg campaign, General Grant made the house his headquarters for a short period, perhaps the only reason the house was not burned by Federal troops. They did destroy the barn, cotton gin, and other outbuildings, as well as fourteen other great houses along Lake St. Joseph, across the Mississippi between Vicksburg and Natchez.

Winter Quarters was the hub of Dr. Nutt's cotton plantations (he owned four, on both sides of the Mississippi River), and today is operated by the Louisiana State Department of Culture, Recreation, and Tourism as a commemorative area. It was purchased from the heirs of E. R. McDonald, who restored Winter Quarters in 1965 and opened it to the public as an example of a working plantation owned by one of the South's most innovative planters.

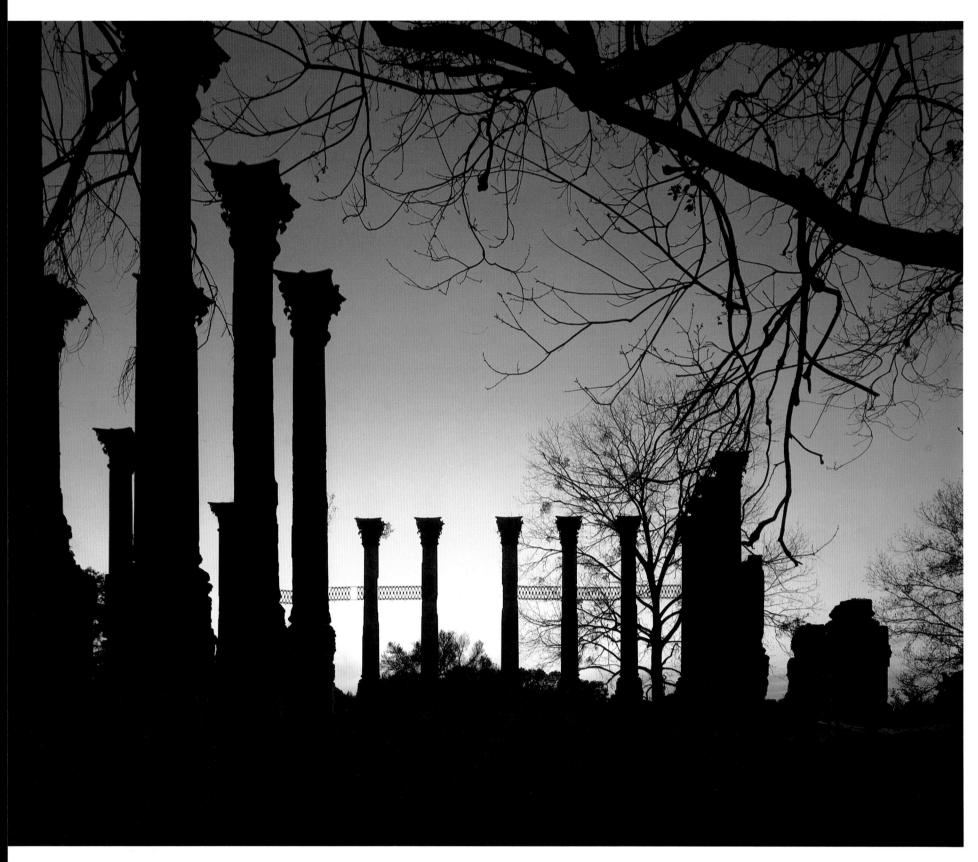

Windsor Castle, 1860

Begun just before the Civil War, in 1859, by Smith Daniell II at the center of his 3,211-acre Claiborne County plantation west of Port Gibson, Mississippi, Windsor Castle was one of the largest and most elegant plantation homes in the South. Built in only one year, at a cost of $175,000, the four-story mansion required the services of approximately 600 carpenters, artisans, masons, and laborers during its construction.

On the ground floor were offices, dairy, schoolroom, and storerooms; the second floor was the main level, with 16-foot ceilings, custom-made furnishings, double parlors, the library, and the master bedroom. In the first parlor was a huge crystal chandelier, floor-to-ceiling gold-framed mirrors, red brocaded rosewood chairs and divans, and red velvet draperies with white silk linings, tied back with tasseled gold rope.

On the third floor were seven bedrooms, a sewing room, and bath; on the top floor was the grand ballroom, and two bathrooms with marble tubs to which water was piped from two 20 × 7 × 5-foot cisterns under the eaves. Crowning the house was a glass-enclosed cupola, from which Daniell could see three of his nine plantations, on both sides of the Mississippi. Daniell owned a total of 21,780 acres and 800 slaves.

The great house survived the war, serving as a temporary Union hospital during part of the Vicksburg campaign. Although the builder died within two years of its completion, Windsor Castle was a center for the Daniell family until fire destroyed it in 1890. Only the great columns remain.

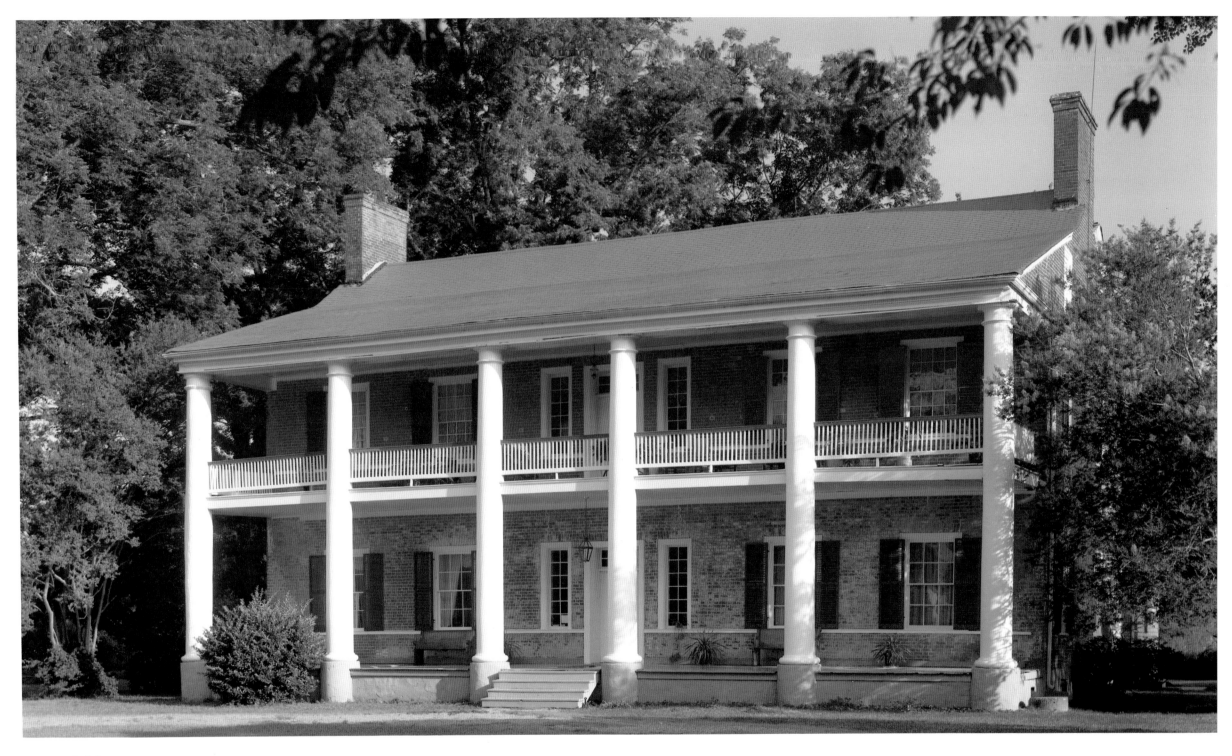

Springfield, 1790

Built during the Spanish ownership of West Florida by a Virginia planter, Thomas Marston Green, Jr., Springfield is said to be one of the first houses in America, and the first in the Natchez District, to have a full colonnade across the entire front eleva-tion. It still has its original woodwork, mantels, most of the doors, and some of the windows and hardware.

Located near the Natchez Trace, the historic trail between Natchez and Nashville, Tennessee, Spring-field was once a 3,100-acre plantation. A thousand acres are still under cultivation.

Andrew Jackson and Rachel Robards were mar-ried, according to tradition, in the drawing room at Springfield in August of 1791.

In January of 1977 the house and grounds, about ten acres, were leased to Arthur E. La Salle of New Orleans, who undertook its restoration and opened Springfield to the public. The mansion is listed in the National Register.

The Burn, 1836

Situated in the northern suburbs of the city, The Burn is one of the earliest documented pure Greek Revival residences in Natchez. The house was constructed in 1836 for merchant-planter John P. Walworth by the contracting firm of Montgomery and Keyes, which also built the west wing and west kitchen at Jefferson College in nearby Washington, Mississippi. The most outstanding architectural feature of the house is its semicircular staircase.

A native of New York, Walworth came to Natchez in the early 19th century and established a prosperous mercantile business. He eventually became a wealthy planter whose plantations were located in Louisiana and Arkansas.

Walworth descendants occupied The Burn until 1935. Recently, the house was purchased by Mr. and Mrs. Reuben L. Harper, natives of Arkansas. The Burn is beautifully furnished with their fine personal collection of antiques.

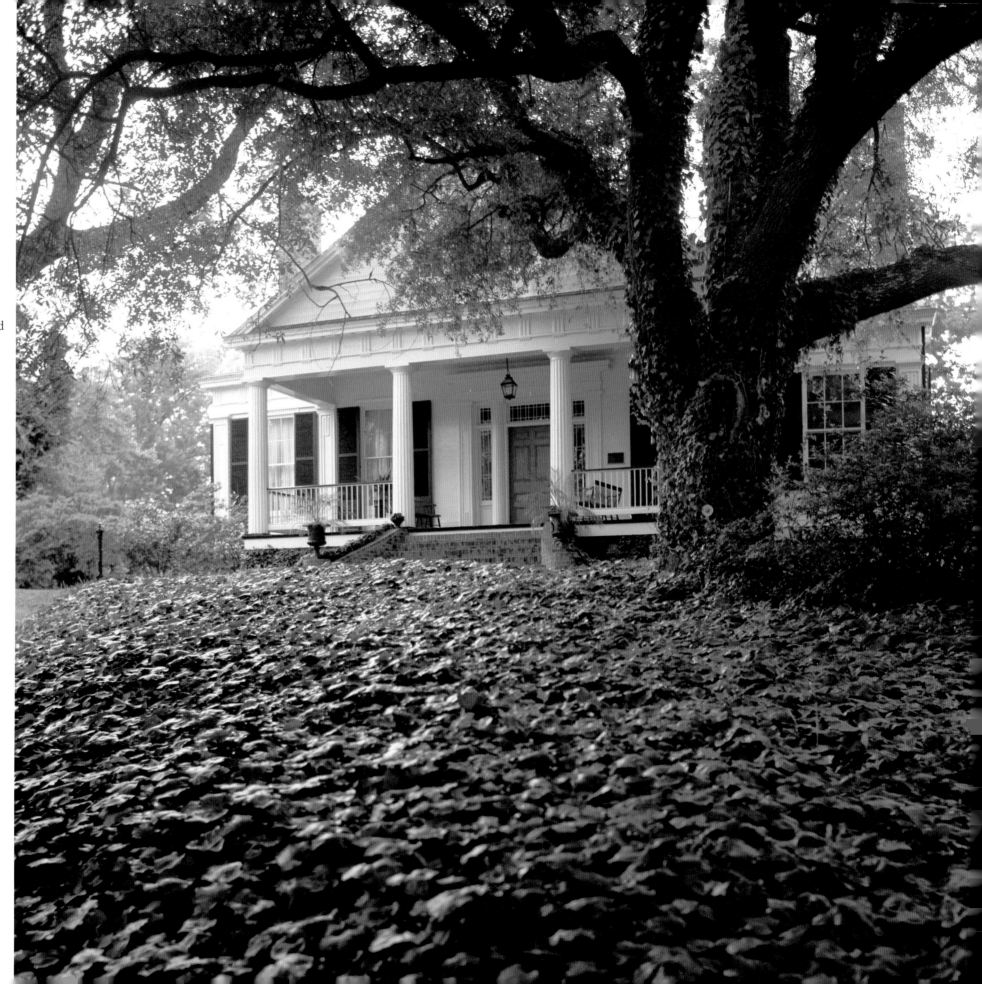

Monmouth, 1818

Constructed in about 1818 for Natchez postmaster John Hankinson, Monmouth is a Federal style mansion rendered more imposing by the massive Greek Revival portico added in an 1853 remodeling by Cincinnati architect James McClure.

Monmouth was purchased in 1826 by a New York–born attorney, John Anthony Quitman, one of Mississippi's most illustrious personalities, who became governor in 1850.

The present owners are Mr. and Mrs. Ronald Riches and Mr. and Mrs. Mason Gordon of California, who have accomplished a tasteful and detailed restoration.

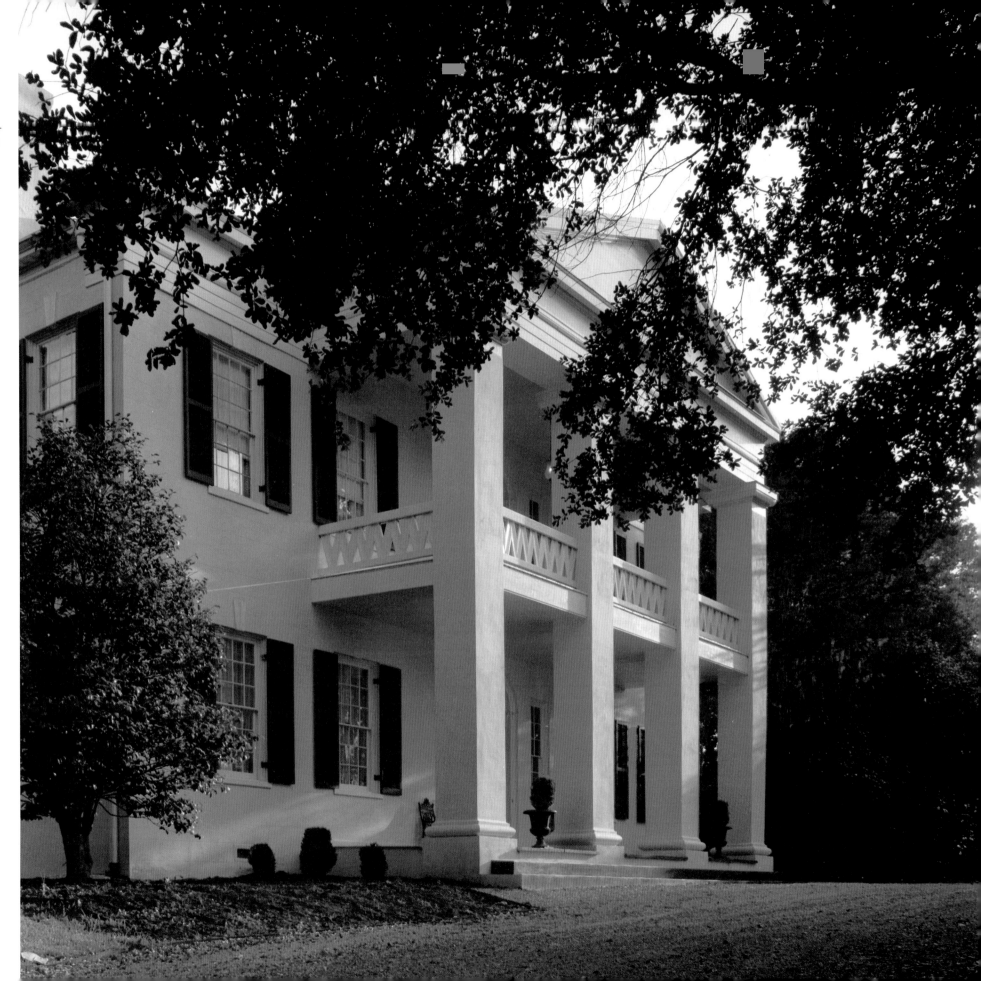

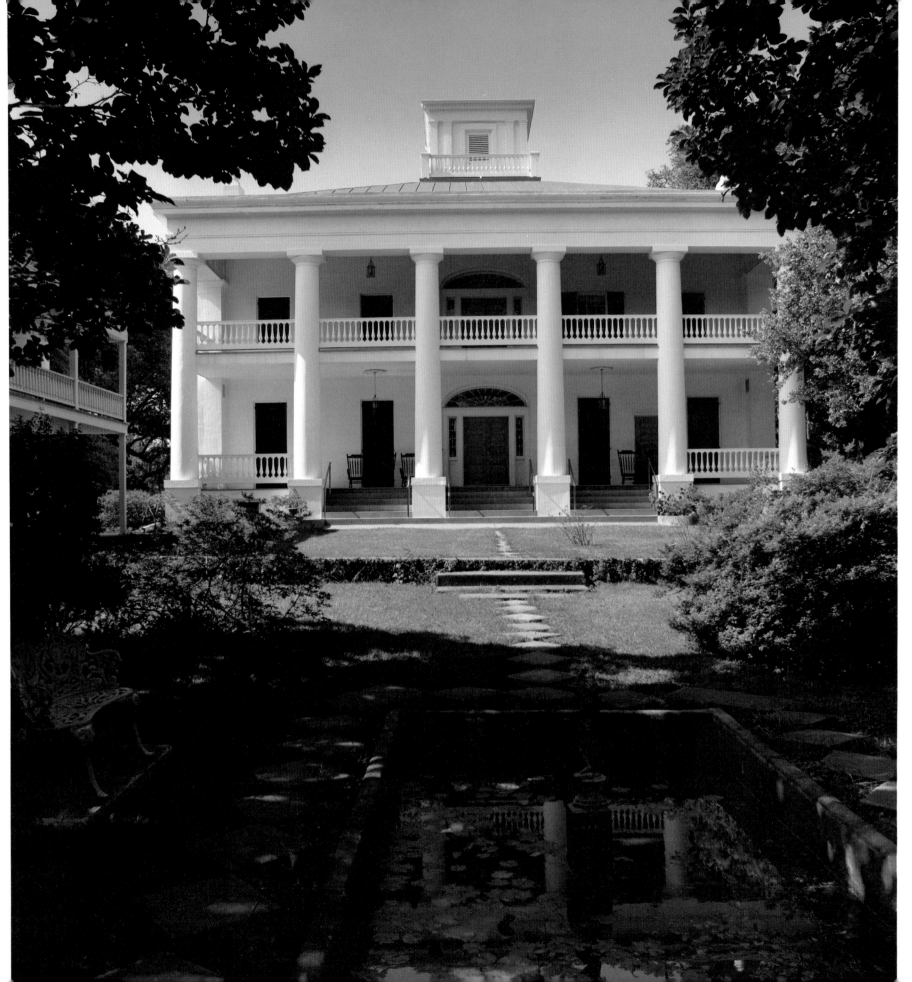

D'Evereux, 1836

D'Evereux, one of America's most outstanding examples of the Greek Revival style, was built in 1836 for William St. John Elliot, a native of Maryland.

The decline of D'Evereux began with the aftermath of the Civil War and continued into the twentieth century when tenant farmers stored crops inside the house. In 1925 the house was purchased from Mrs. Elliot's descendants by Miss Myra Smith, a Chicago schoolteacher. The house was dilapidated and needed 200 window panes to protect it from the weather, but Mrs. Smith initiated restoration and made it her permanent home from the time of her retirement in 1941 until her death in 1961.

Auburn, 1812 (*right*)

A National Historic Landmark, Auburn was designed by the architect Levi Weeks for an attorney and planter, Lyman Harding, both natives of Massachusetts. Weeks's designs for Auburn introduced academic architecture to Natchez, where the prevailing architectural style had been of West Indian derivation. In 1812, while Auburn was under construction, Weeks described the mansion as the "first house in the Territory on which was ever attempted any of the orders of architecture."

In 1827 Auburn was purchased by a Pennsylvania native, Dr. Stephen Duncan, who by the 1850s had become the nation's largest cotton planter and slave-holder. He owned six cotton plantations, two sugarcane estates and 1,041 slaves. Ironically, Duncan was also active in the American Colonization Society, dedicated to the resettling of freed slaves in Africa.

Still owned by the city of Natchez, Auburn is operated as a house museum, by the Town and Country Garden Club.

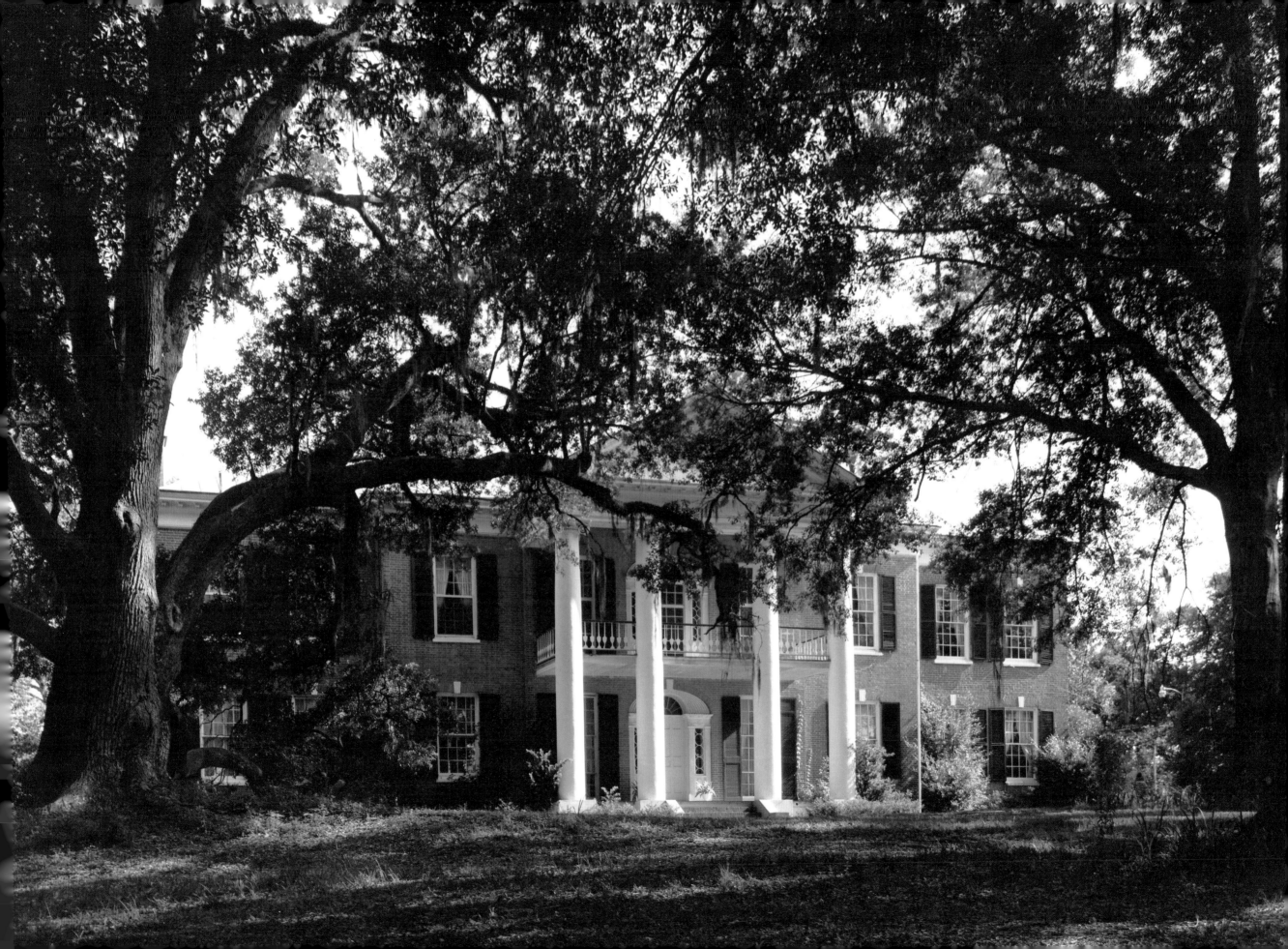

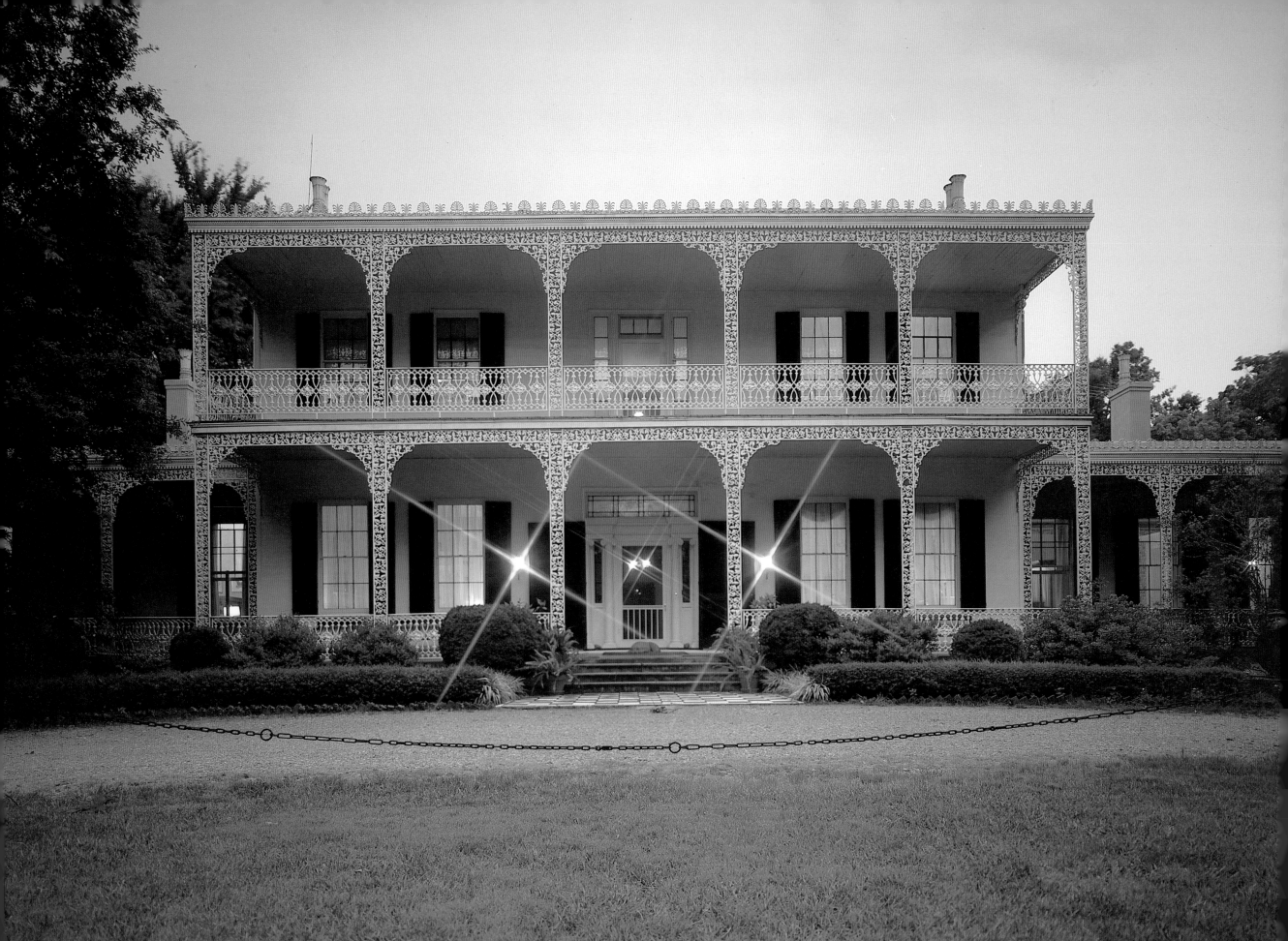

Elms Court, 1836

Situated in the midst of a wooded park, Elms Court is one of Natchez' most outstanding suburban villa residences. The two-story Greek Revival mansion was constructed in about 1836, but the house achieved its final form after it was purchased in 1852 by a Natchez planter, Frank Surget, as a wedding present for his daughter Jane and her husband, Ayers P. Merrill. During the 1850s, the Merrills added the one-story side wings, replaced the original entrance portico with wrought-iron-laced galleries, and richly remodeled the interior.

In 1895 James Surget of Cherry Grove Plantation acquired the house from his relatives and gave it to his daughter Carlotta and her husband, David McKittrick, as a wedding present.

Today Elms Court, known as "the House of a Thousand Candles," is the home of the McKittricks' daughter, Mrs. Douglas MacNeil, former president of the Girl Scouts of America. The house is handsomely furnished with a collection from six generations of Natchez families.

Dunleith, 1856 (right)

Dunleith, a National Historic Landmark, was constructed after an 1855 fire destroyed an earlier house on the site. The imposing Greek Revival structure is the only surviving Mississippi example of an antebellum mansion completely encircled by Doric columns and double-tiered galleries, a form most frequently associated with Louisiana plantation houses along the Mississippi River. Surrounded by forty acres of green pastures and wooded bayous, Dunleith is situated adjacent to the heart of downtown Natchez. Its outstanding collection of outbuildings includes a two-story brick servants' wing adjacent to the rear of the main house, a greenhouse, carriage house with stables, and a poultry house, all in the Gothic style.

Originally called Routhlands after the house that burned, Dunleith was renamed by its second owner, Alfred V. Davis, who acquired the house in 1859. Davis was a wealthy planter whose plantations were located in Louisiana, and in 1860 he was ranked the tenth-largest slave owner in the state of Louisiana.

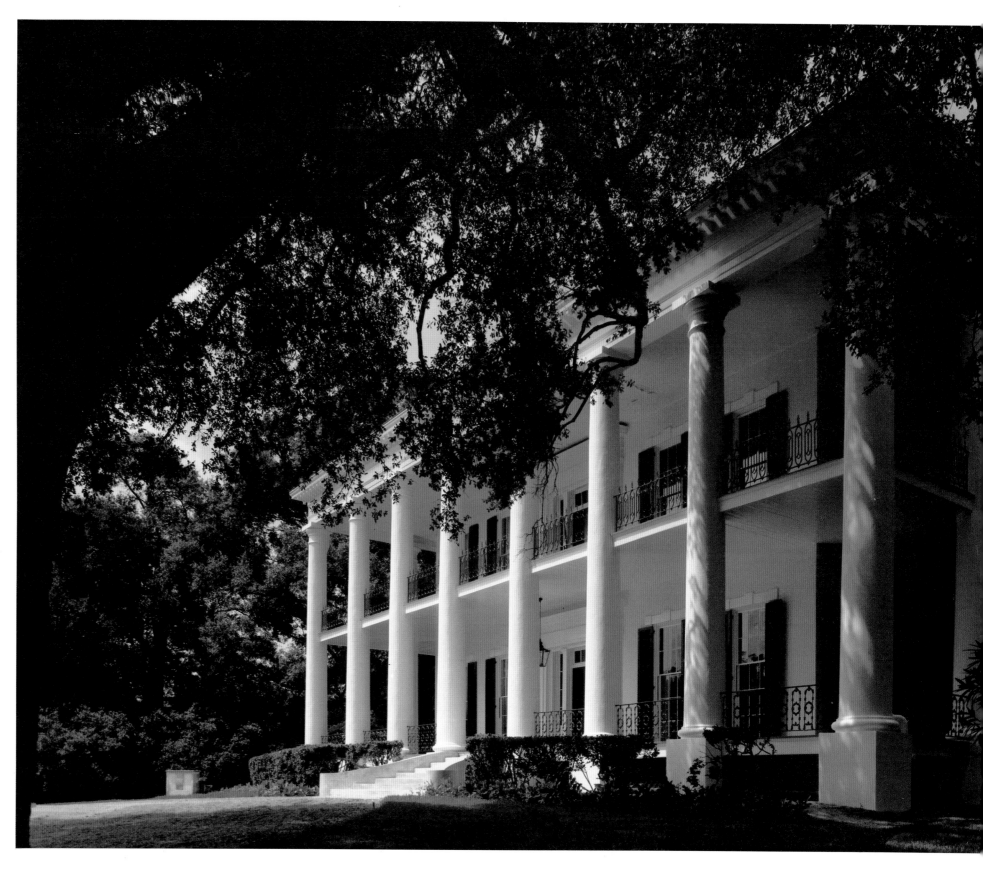

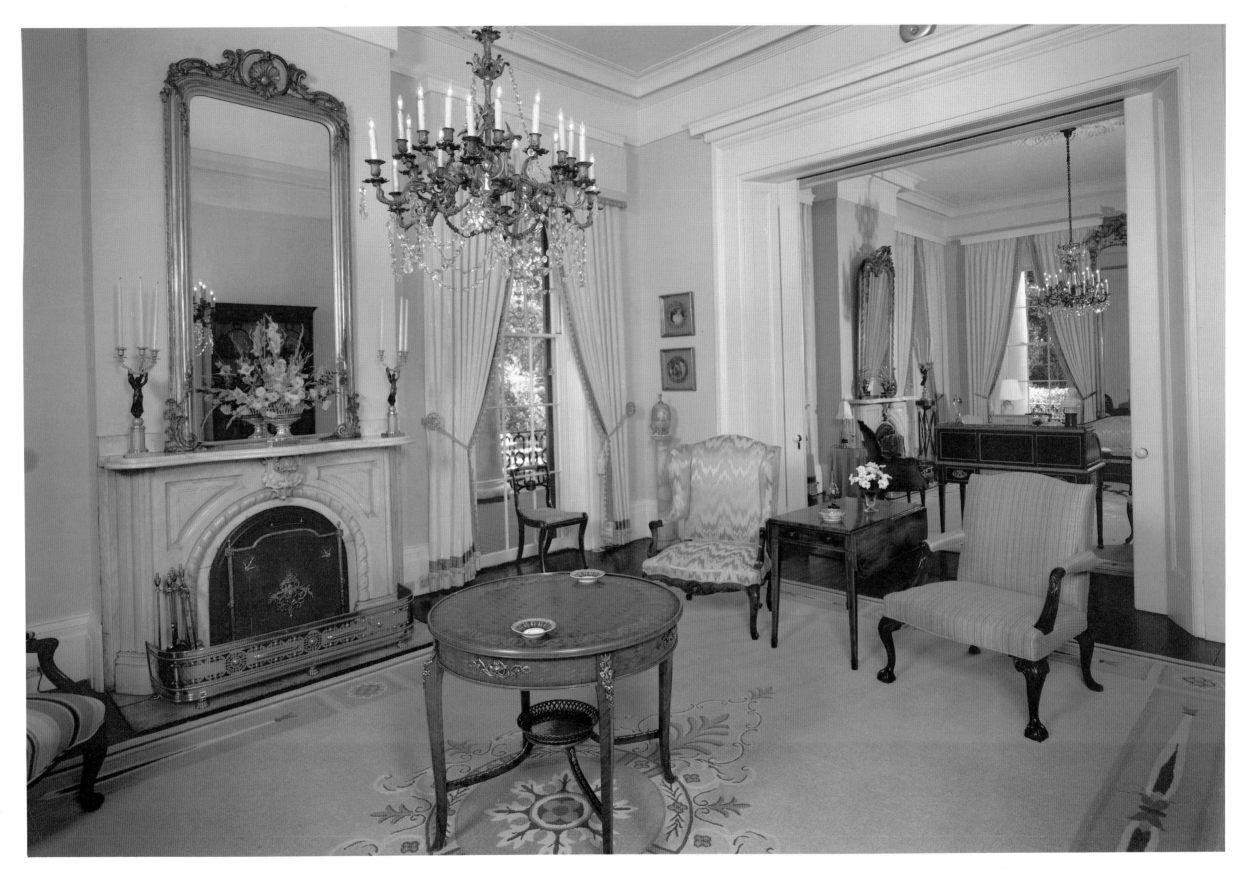

The twin parlors at Dunleith (*left*)

Rosalie, 1823

Located on the Natchez bluffs at the southern end of the old Spanish promenade grounds overlooking the Mississippi, Rosalie was constructed in 1823 for a Pennsylvania native, Peter Little, planter and lumber entrepreneur. The house was named in honor of Fort Rosalie, established near that site by the French in 1716.

Peter and his wife, Eliza, left no heirs, and following their deaths, Rosalie was sold at public auction to a local millionaire, Andrew Wilson, also a native of Pennsylvania.

Rosalie served as headquarters for the Union Army during the occupation from 1863 to 1865, with General Grant spending a few days at the mansion after the siege of Vicksburg in July of 1863.

Now a Mississippi state shrine of the Daughters of the American Revolution, the house contains many of the furnishings of the Little and Wilson families.

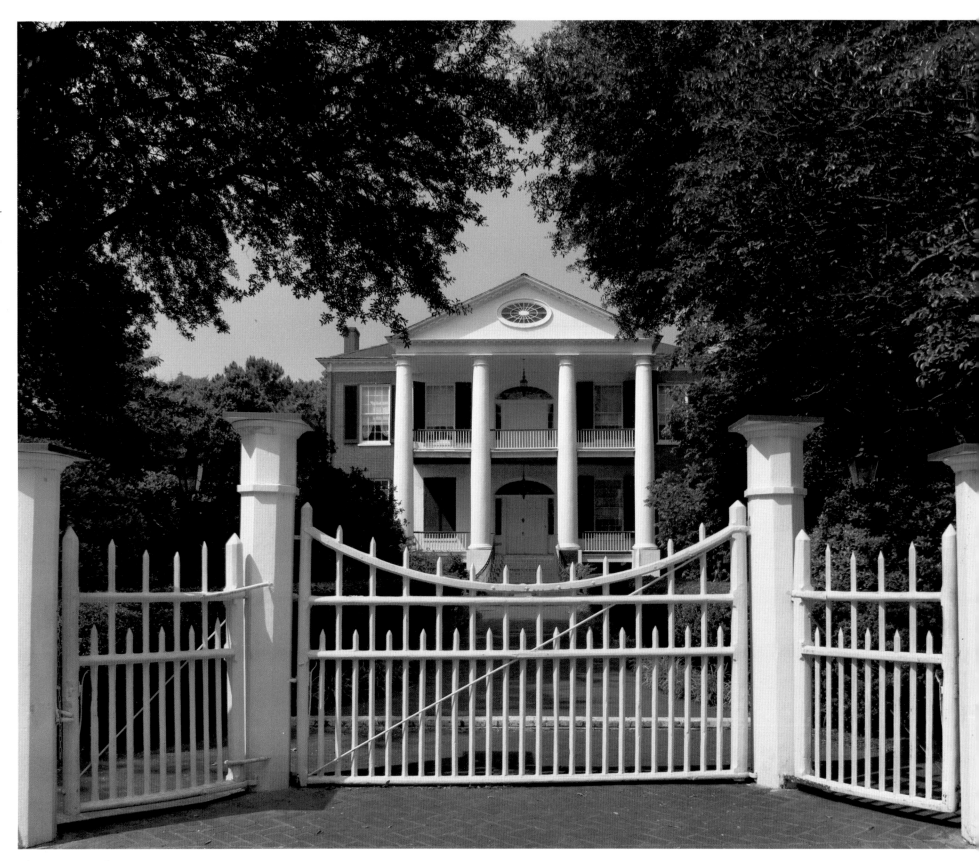

Stanton Hall, 1857

Constructed in 1857, and commanding an entire city block, Stanton Hall is the most palatial mansion in the Natchez area. Originally named Belfast in honor of the builder's birthplace, the eclectic Greek Revival mansion was constructed as the residence of Frederic Stanton, a wealthy cotton broker and planter, who died in 1859, not long after the house was completed. According to an 1858 newspaper: "All the work on the edifice was done by Natchez architects, builders, artists, and finishers."

In the late 19th century, the house was purchased from the Stanton family and became a fashionable girls' school known as Stanton College, and the name of the house itself was changed from Belfast to Stanton Hall. Returned to residential use early in the 20th century, the mansion was later acquired in 1938 by the Pilgrimage Garden Club which presently owns the property and operates it as a house museum.

Longwood, 1860 (right)

Giving silent and dramatic testimony to the impact of the Civil War upon the economy of the South, Longwood is the largest and most elaborate octagonal house in America, and has stood, uncompleted, since 1861.

Longwood was designed by the noted Philadelphia architect Samuel Sloan for a physician and planter, Haller Nutt, who by 1860 owned 21 plantations and approximately 800 slaves. His principal plantation residence was Winter Quarters, across the Mississippi River at St. Joseph, Louisiana, but Longwood was his summer home and Natchez residence.

In 1860 workmen razed the existing colonial dwelling and began construction on the new "oriental villa," as Sloan himself called it. With skilled craftsmen imported from Pennsylvania by Sloan, work proceeded rapidly, but with the advent of the war in 1861, the northern craftsmen dropped their tools and departed for home. Nutt completed the basement floor using local labor, and moved his wife and eight children in for the duration. He died in June of 1864.

Ownership by the Nutt family continued until 1968, when Longwood was acquired by the Mc-Adams Foundation of Austin, Texas. The Foundation in 1970 donated Longwood to the Pilgrimage Garden Club of Natchez.

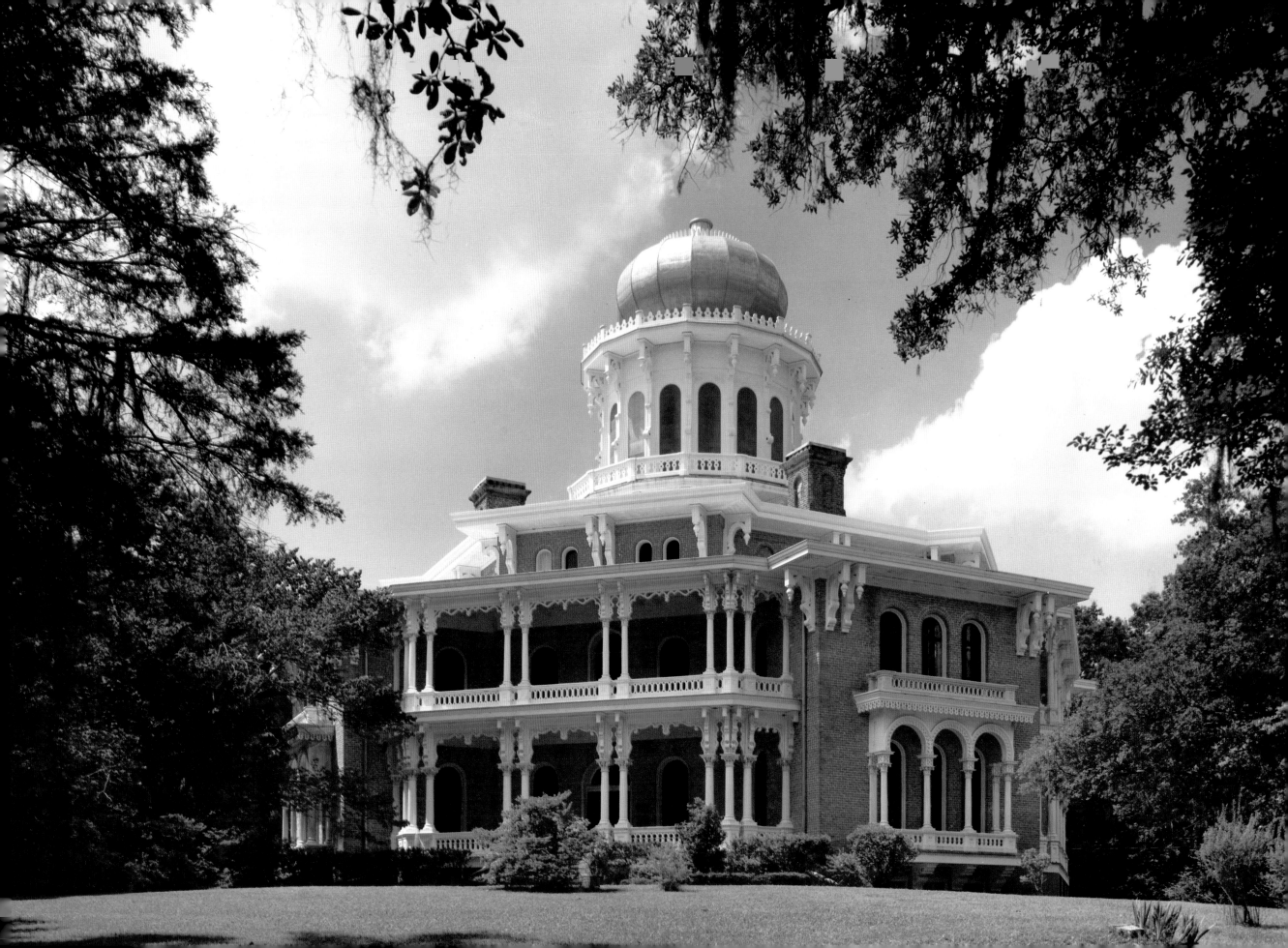

Cherry Grove, 1866

Cherry Grove Plantation was established in the late 18th century by a French seaman, Pierre Surget, on land granted him by the Spanish government. Pierre was the patriarch of the Surget family in Natchez, founding one of the largest planting dynasties in the entire South. One of his sons, Frank, has been described as the most extensive and successful planter in Mississippi, owning acreage in Louisiana, Mississippi, and 50,000 acres in Arkansas.

Since its establishment, Cherry Grove has been in the Surget family, and is presently owned by Mrs. Douglas MacNeil of Elms Court in Natchez. Cherry Grove has an exceptional collection of outbuildings, including stables, corn-cribs, and barns, which reflect the plantation's primary concern with the raising of horses and cattle.

Rosemont, 1815 (*right*)

Rosemont was constructed about 1815 for Samuel Davis and was the boyhood home of his son, Jefferson Davis (1808–1889), president of the Confederate States of America. In his memoirs, Jefferson Davis wrote that his father, Samuel, "found a place that suited him about one mile east of Woodville, in Wilkinson County, Mississippi. He removed his family there, and it is there my memories began."

In the early 1970s, Rosemont was acquired by a Texas attorney, Percival T. Beacroft, who, with assistance from a New Yorker, Ernesto Caldeira, has accomplished one of the most sympathetic restorations in Mississippi. The atmosphere of a working plantation has been redeveloped. Jane Davis' rose garden has been replanted, and appropriate Davis family furnishings and memorabilia have been acquired.

Richland, 1820

Forty miles northeast of Baton Rouge in rich hill land sits Richland Plantation, the 1820 bridal house of Elias Norwood. Four tall chimneys open on each floor. A winding staircase spirals upward from a central hall. Imported slate is used on the turreted and dormered roof and for paving on the lower gallery floor.

Originally the entire third floor of the home was a ballroom, and the kitchen was separated from the house. Remodeled years ago, the third floor has been made into bedrooms, each with its own bath, and the kitchen has been connected with the main part of the house.

Richland is a working plantation, consisting of 4,000 acres, devoted primarily to cattle and soybeans.

The Shades, 1808 (*right*)

Proudly overlooking a broad expanse of shaded grounds north of Jackson, Louisiana, The Shades was built by slave labor, with lumber and brick from the plantation, in an architectural style reminiscent of the eastern seaboard.

Since its construction during Spanish rule, The Shades has been the property of the Scott family. Miss Eva Scott, great-great-great-granddaughter of the original builder, Alexander Scott, lived there until her death. She was widely known for her antique collections, particularly for her 1,000 bells. Miss Scott left her plantation and home to her cousin Mr. George Berger, who now resides at The Shades.

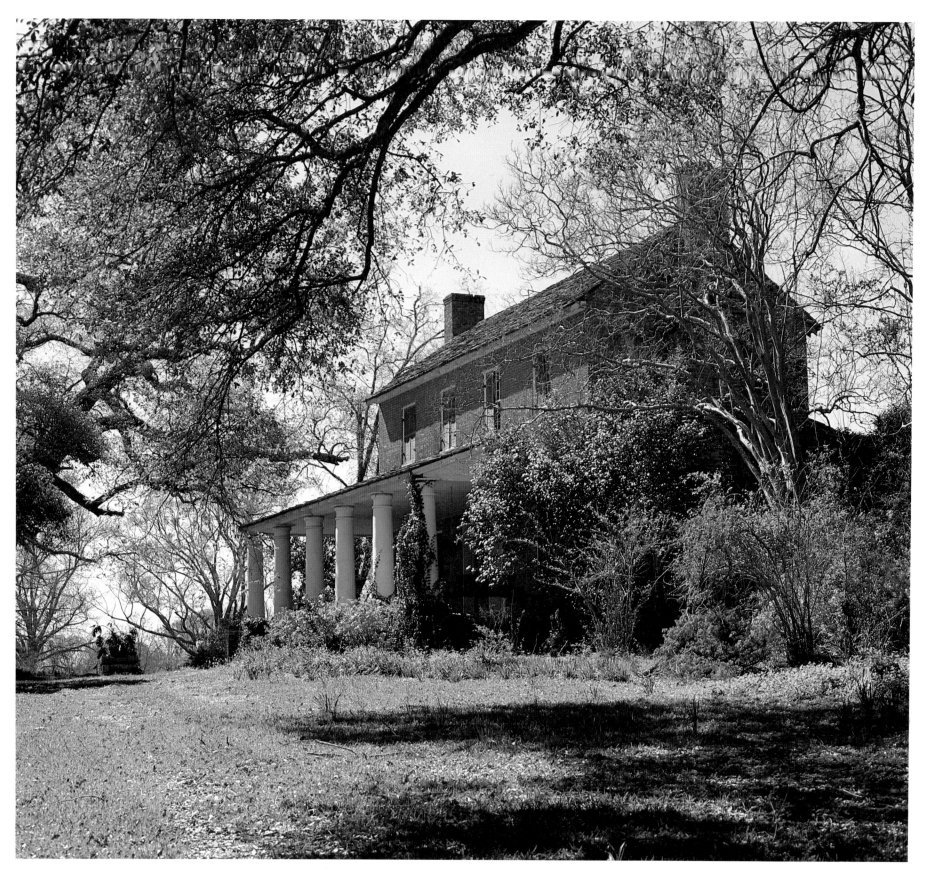

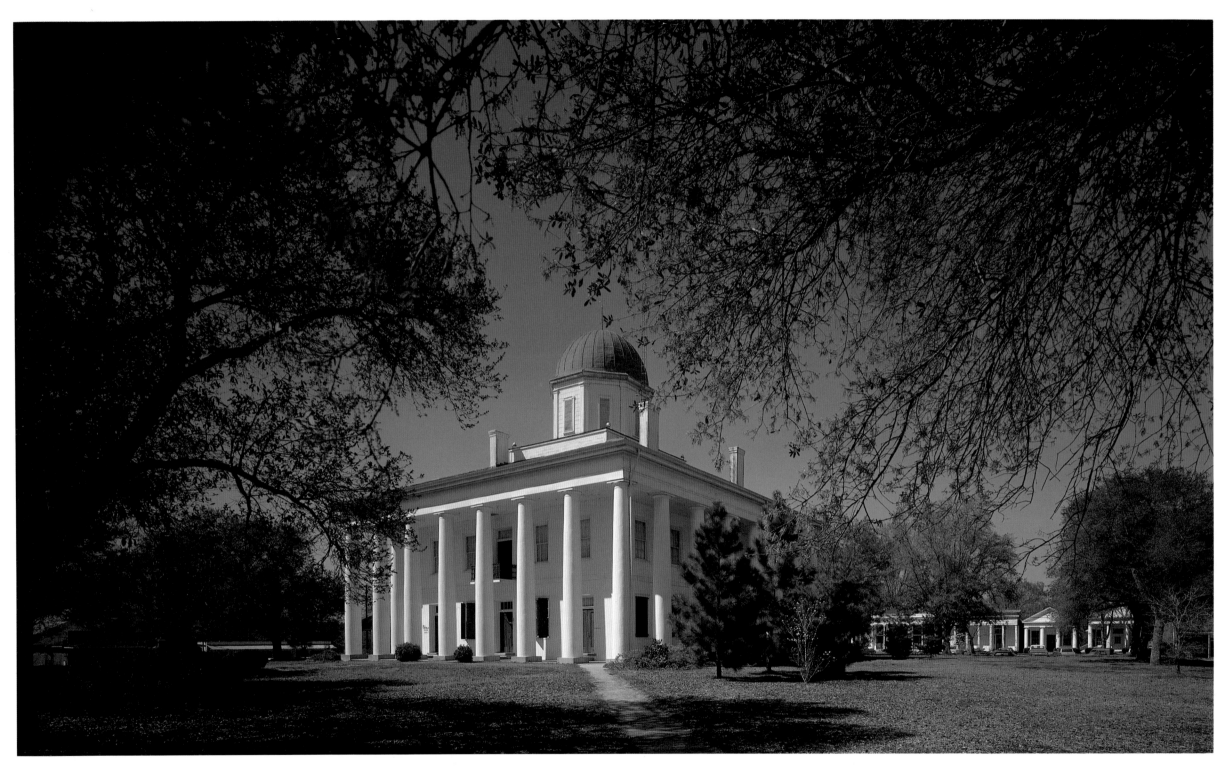

East Feliciana Parish Courthouse, 1841, and Lawyers' Row, 1825

Considered one of the finest examples of Greek Revival architecture in the South, the East Feliciana Parish Courthouse at Clinton was built in 1847 to replace an earlier structure destroyed by fire. It reflects the wealth and quiet good taste of antebellum planters of the Clinton area.

With a classic Doric colonnade on all four sides, the courthouse is crowned by a silver-domed cupola on an octagonal base.

Predating the courthouse is a group of five delicately proportioned office buildings on the north side of Courthouse Square. Built in 1825 for members of the Feliciana Bar serving the district court, the collection is known as Lawyers' Row. It is also known for housing some of the finest legal minds in antebellum Louisiana.

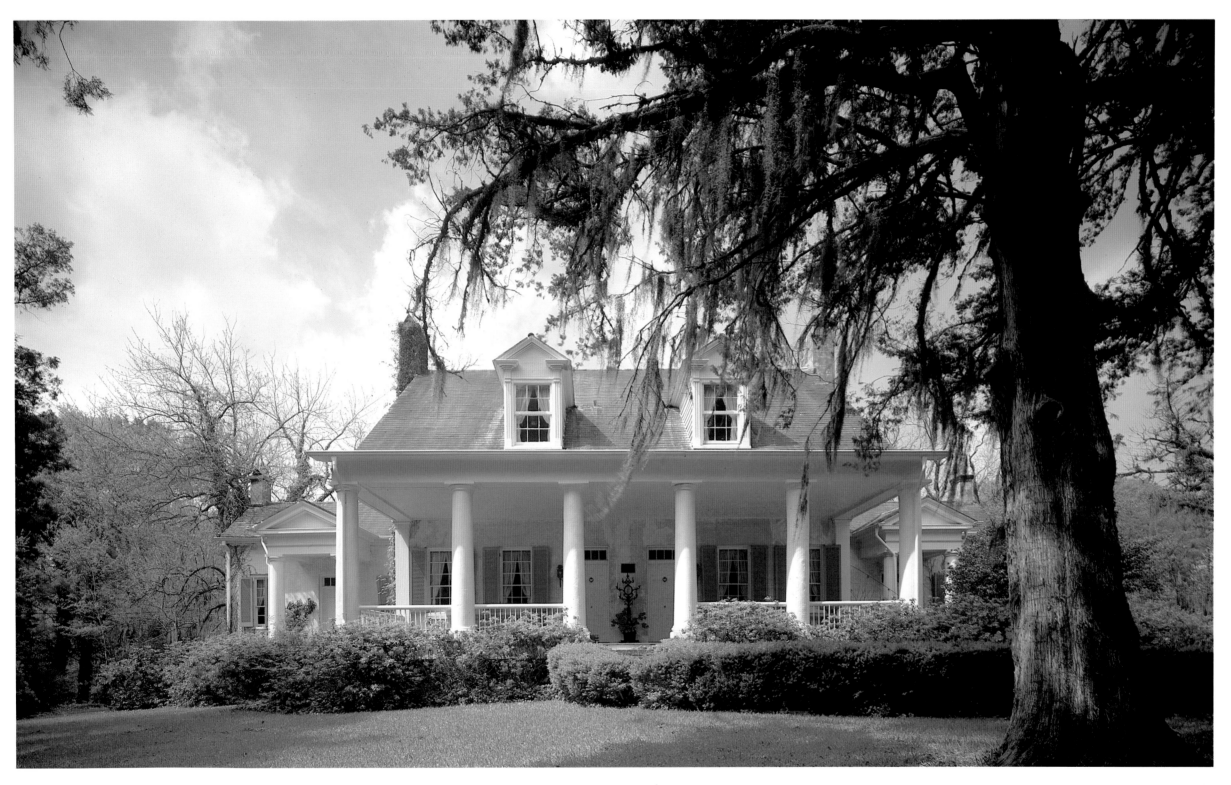

Asphodel, 1820

When Benjamin Kendrick decided to build a plantation home on his beautiful East Feliciana acreage north of Baton Rouge, he chose a clearing on a bluff high above Carr's Creek. The spot reminded him of a passage from Homer's *Odyssey* that described an "Asphodel meadow of vast extent in the fields of Elysium." Kendrick named his home Asphodel.

In the 1950s the home received extensive renovations and restoration by Mr. and Mrs. Robert Couhig, who have added at a nearby site an inn and village, to which diners and overnight guests from the surrounding area come to enjoy the peaceful Felicianas where John James Audubon lived and painted.

87

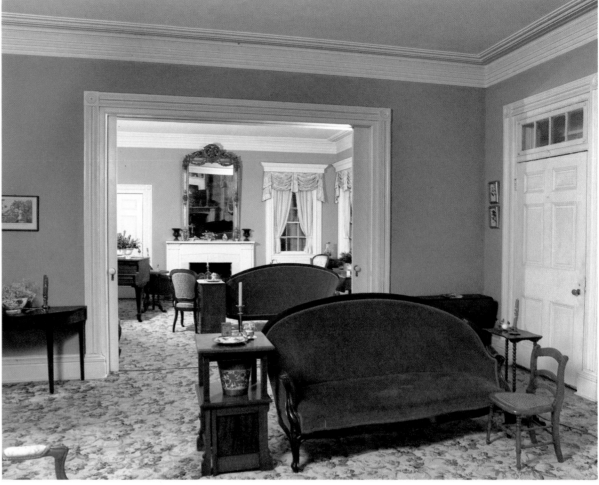

Asphodel's twin parlors feature twin French parlor sets, and twin French mirrors over the mantels. The sliding doors that separate the two rooms move as freely today as the day they were installed.

In the south parlor, the mantel is marble, whereas the one in the north is wood. Medallions under the windows are hand-carved mahogany.

Oakley, 1799 (right)

Oakley Plantation was Audubon's first introduction to West Feliciana. Here he was engaged as a tutor for Eliza Pirrie in an arrangement that allowed him half his time free for roaming the woods, observing, and gathering birds for his paintings.

Oakley has a raised basement, two stories, and an attic. Predating the Greek Revival influence, in southern plantation architecture, the house reflects a Carolina influence. Acquired from Pirrie's descendants in 1947, it is now the center of Audubon State Park.

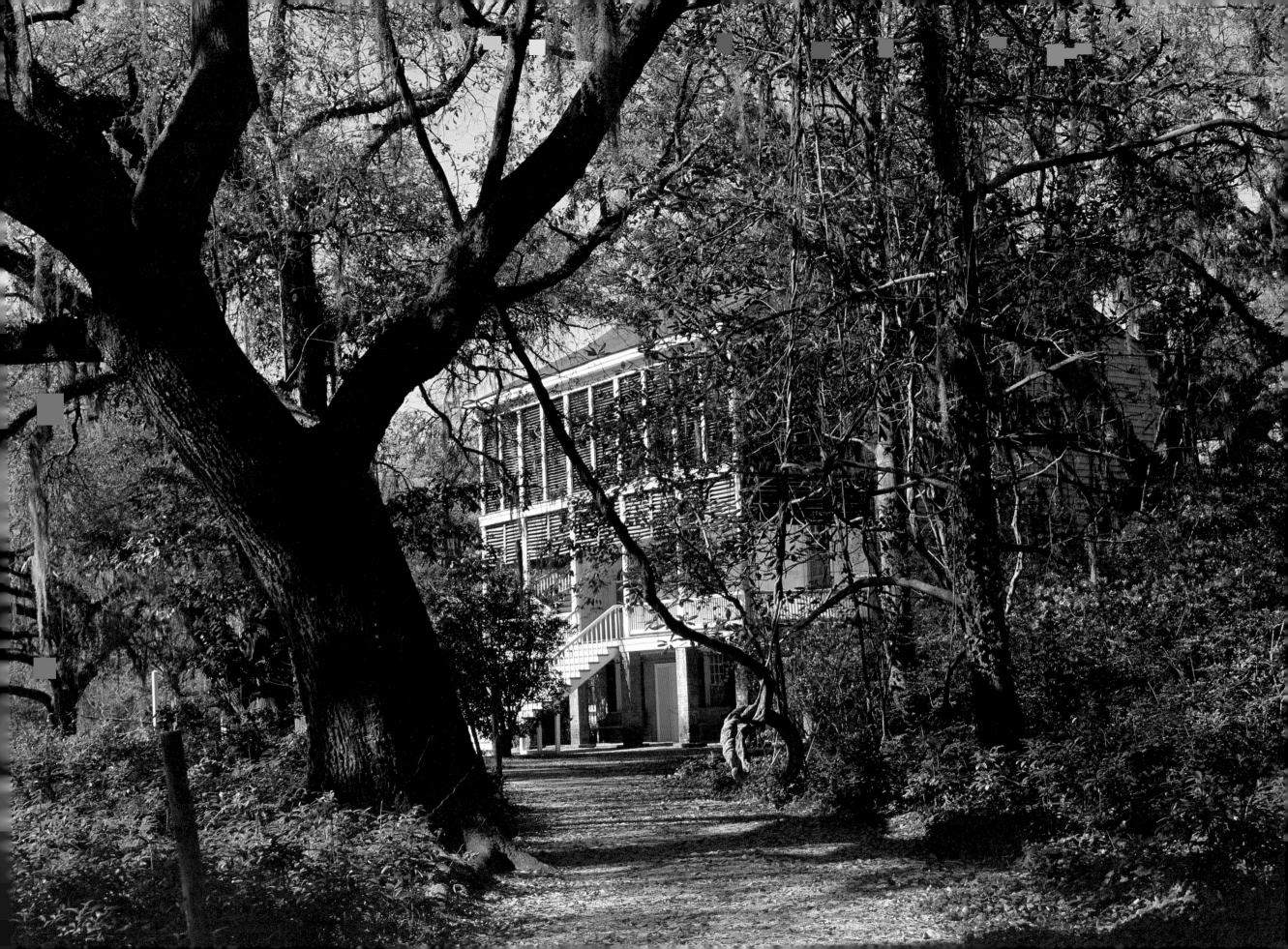

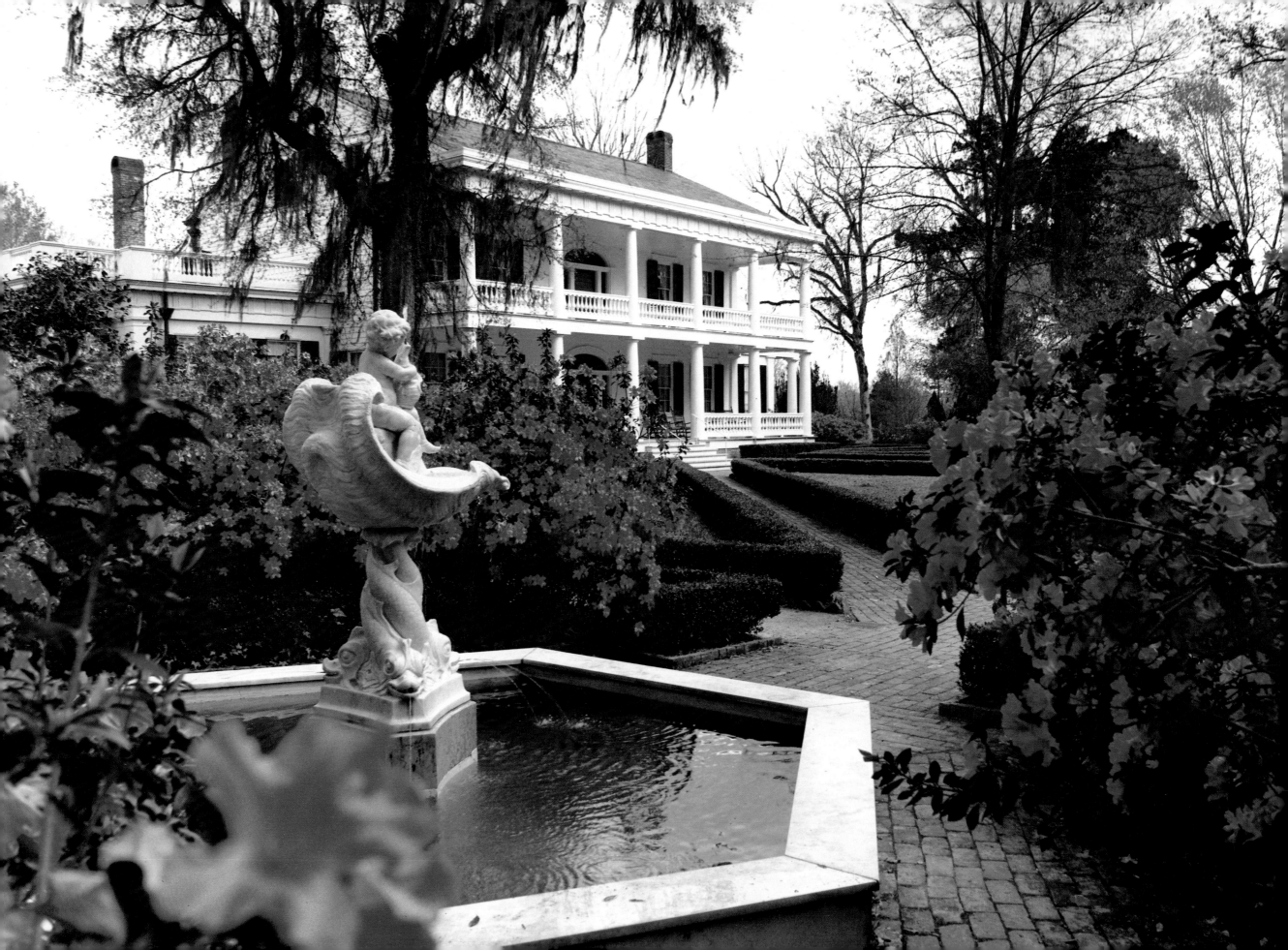

Rosedown, 1835

Built by the wealthy young Daniel Turnbull for his bride, Martha, Rosedown, in West Feliciana Parish, bears the mystical air of eternal romance.

A local master builder started construction in 1834 and finished the main house a year later. Ten years afterward two small Greek-mode wings with fluted Doric columns were added. In 1859 a back wing was added to provide needed bedrooms.

In the interior rooms, each drape, each piece of carefully selected furniture has been maintained unmoved and unchanged.

In 1956 the house and gardens were completely renovated by Mr. and Mrs. Milton Underwood.

The Myrtles, 1794 (*right*)

The Myrtles is set in a grove of ancient oaks, giant mimosas, and large crape myrtles that provide a blaze of color in the spring.

It is a very wide house with a 120-foot gallery extending its width. The woodwork and decorations are exquisitely detailed. European artists were imported to simulate marble and granite on wooden door frames and moldings by painting them in a technique called *faux-bois*. Doorknobs are silver and the mantels are marble.

The house was constructed on a 650-acre Spanish land grant dated 1791. Later owners of The Myrtles expanded their holdings prior to the Civil War to more than 50,000 acres between St. Francisville and Baton Rouge.

The Myrtles was purchased by Arlin Dease and Robert S. Ward in 1975 and given an extensive renovation and redecoration. Then, in 1976 a California couple, Mr. and Mrs. James Meyers, toured the Delta country on the *Mississippi Queen* and, according to Mrs. Meyers, "fell in love with Louisiana." Four years later, they purchased The Myrtles from John L. Pierce, the former owner of Mount Hope in Baton Rouge. The Meyers have added rooms for overnight guests on the second floor.

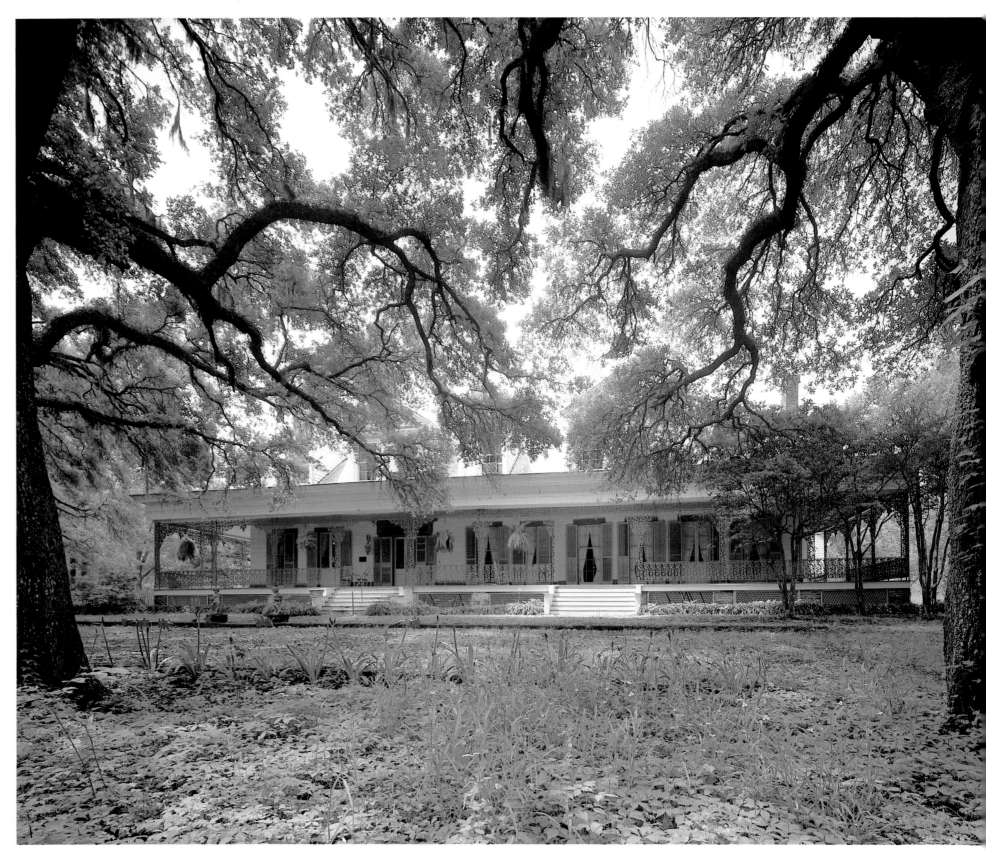

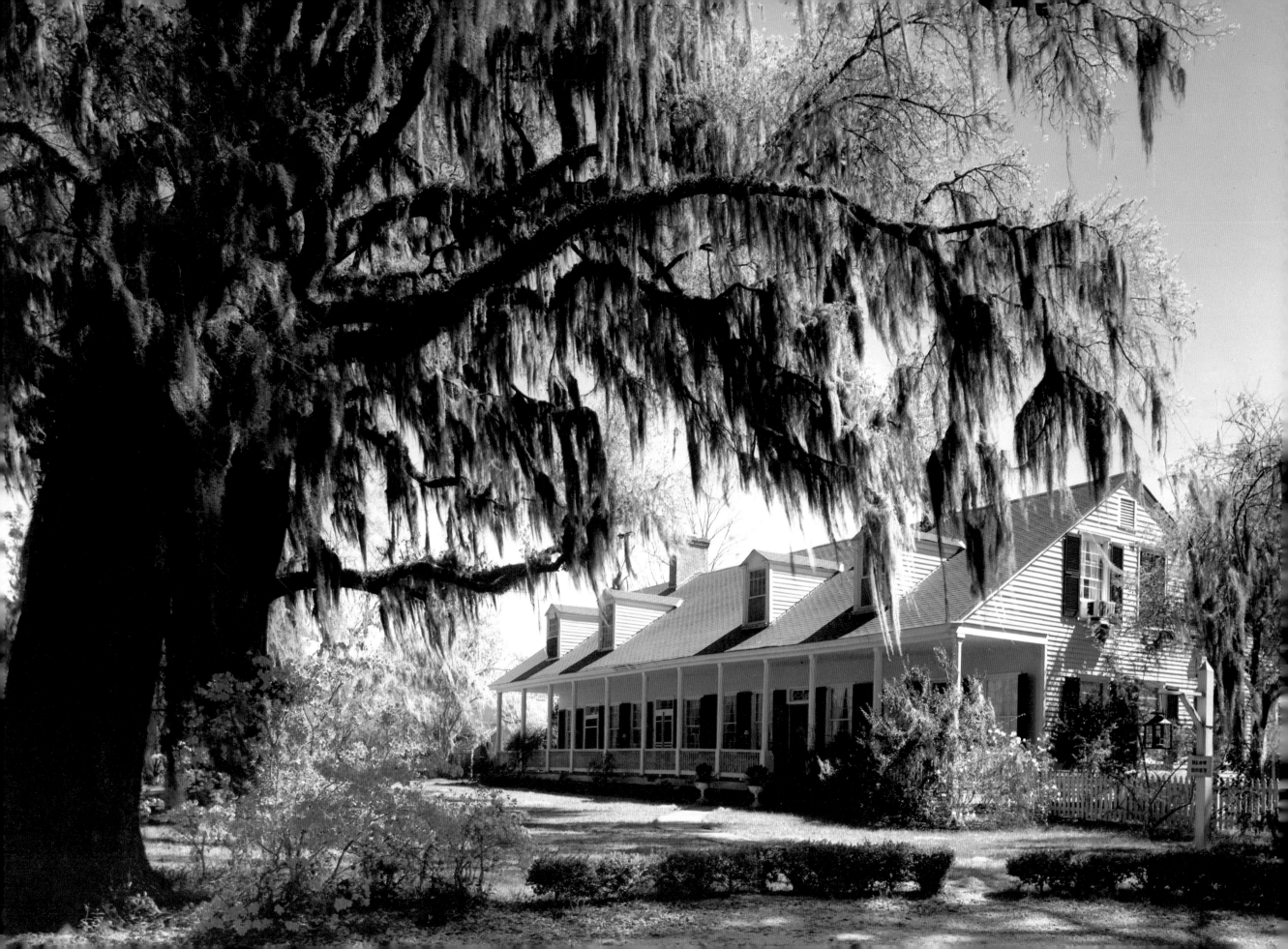

The Cottage, 1795

Built on a Spanish land grant between 1795 and 1799, The Cottage and its property were purchased by the Butler family in 1811. The structure was enlarged over succeeding generations until the result was a low rambling house with wide galleries and 20 rooms. The additions were so well planned that there is little to indicate that all the parts were not completed at the same time. However, additions were made between 1795 and 1859.

The Butler family lived there until 1951 when The Cottage was sold. The outdoor kitchen was used during their entire occupancy. The Cottage complex includes a schoolhouse, milkhouse, slave houses, smokehouse, kitchen, carriage barn, horse barn, Judge Thomas Butler's carriage, and other original farm equipment and implements.

The Cottage is presently owned by Mr. and Mrs. J. E. Brown, who opened the property to the public in 1952.

Waverly, 1821 (*right*)

Waverly was a wooden structure, delicate in design, with some of the finest Georgian architectural details to be found in Louisiana. The house was built by a young physician, Dr. Henry Baines, in 1821 on a Spanish land grant made to his father-in-law, a miller by the name of Patrick McDermott. A son of McDermott's went through several fortunes experimenting with a "flying machine" at Waverly and obtained a patent on the unsuccessful invention seventy years before the Wright brothers flew their airplane. Waverly and its gardens were located on U.S. 61 just north of Baines. Restored in the 1950s, the house burned in 1962.

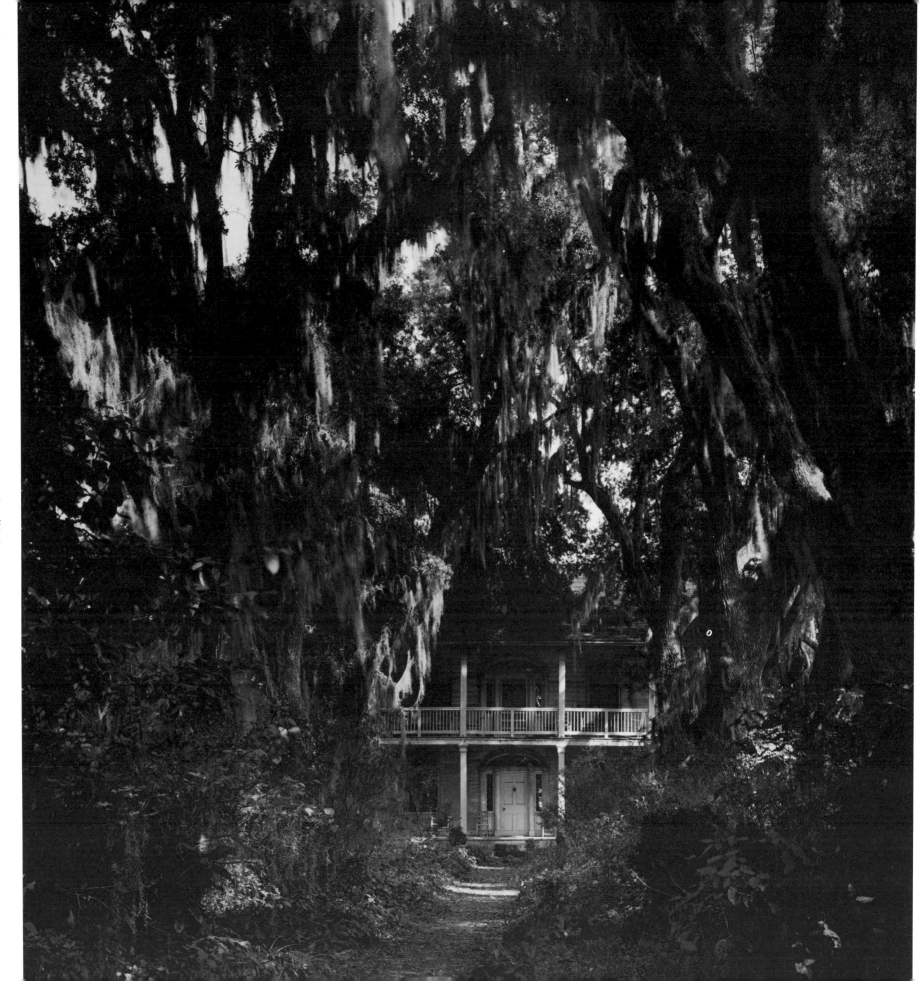

Afton Villa, 1849

Afton Villa was originally a four-room cottage. David Barrow added 36 rooms and the striking Gothic exterior in 1849 for his beautiful young wife. When he brought her from Kentucky, he agreed to build his new bride a grander home, but because of his fondness for the old house, built in 1790, insisted it remain intact in the remodeling plan. The building completely burned in 1964, but the gardens and approach of live oaks dripping in soft moss, interspersed with azaleas, native magnolias, cedars, pines, and yuccas remain intact.

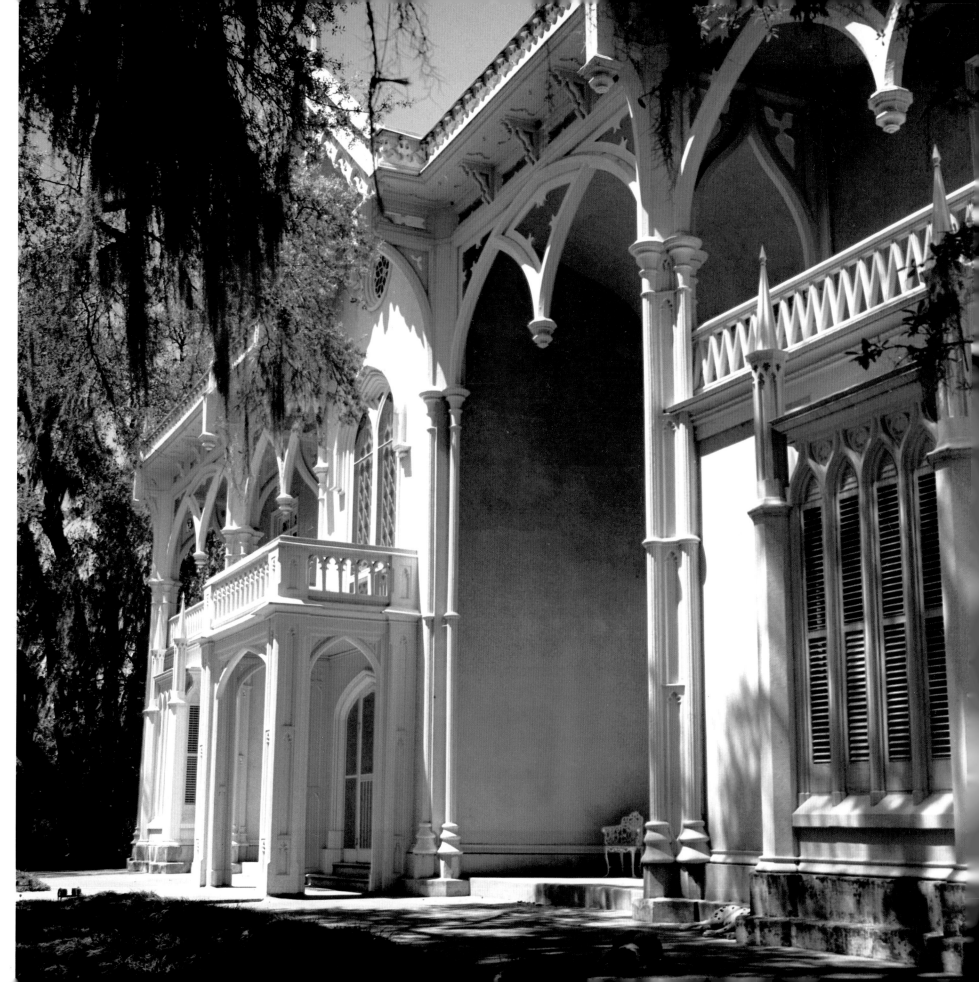

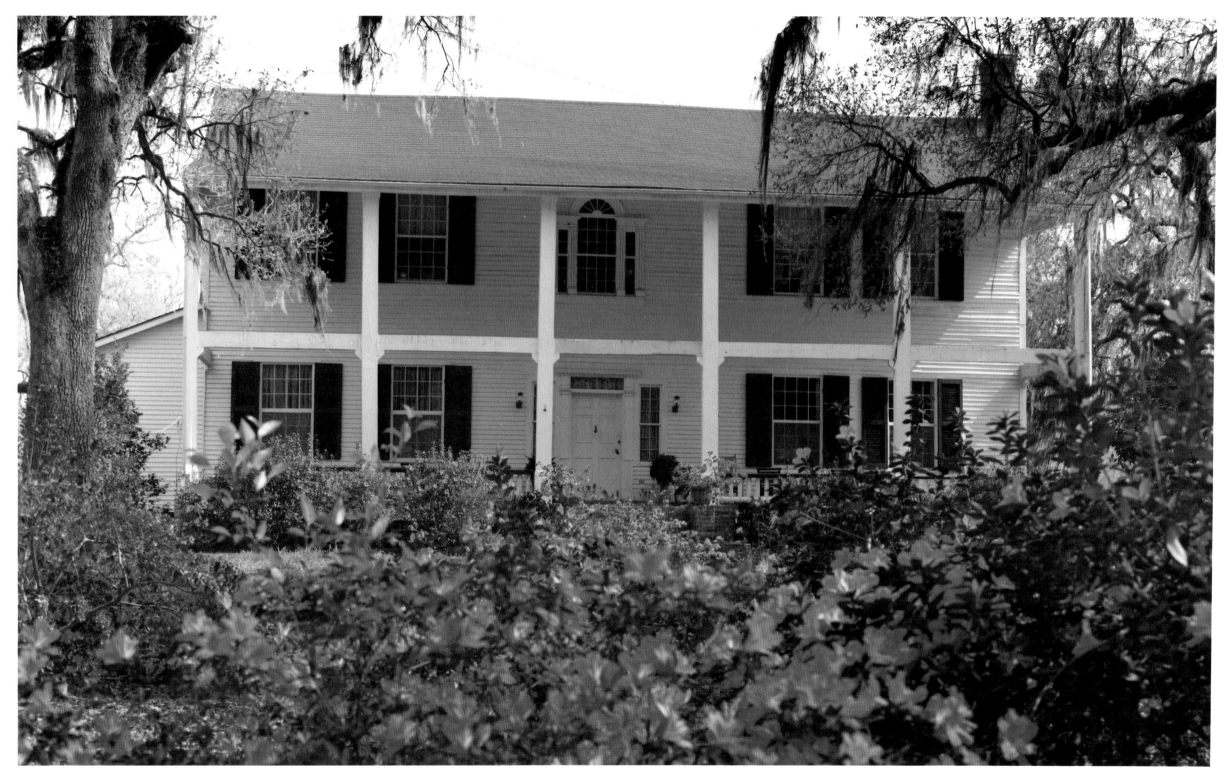

Highland, 1799

The ancestral home of the Barrow family, who built several magnificent plantation homes in the Feli-cianas, and still occupied by descendants, Highland is surrounded by approximately 150 live oak trees planted in 1832 by Bennett Barrow, who also intro-duced a new breed of cotton to the plantation. In fact, the name of the plantation (originally Locust Ridge) was changed to honor the new cotton strain: Highland.

The holdings of the plantation expanded tenfold during a 50-year period, so that by 1850, Highland plantation included 4,350 acres tilled by 280 slaves, a racetrack, dance hall, large sugarhouse, and hospital.

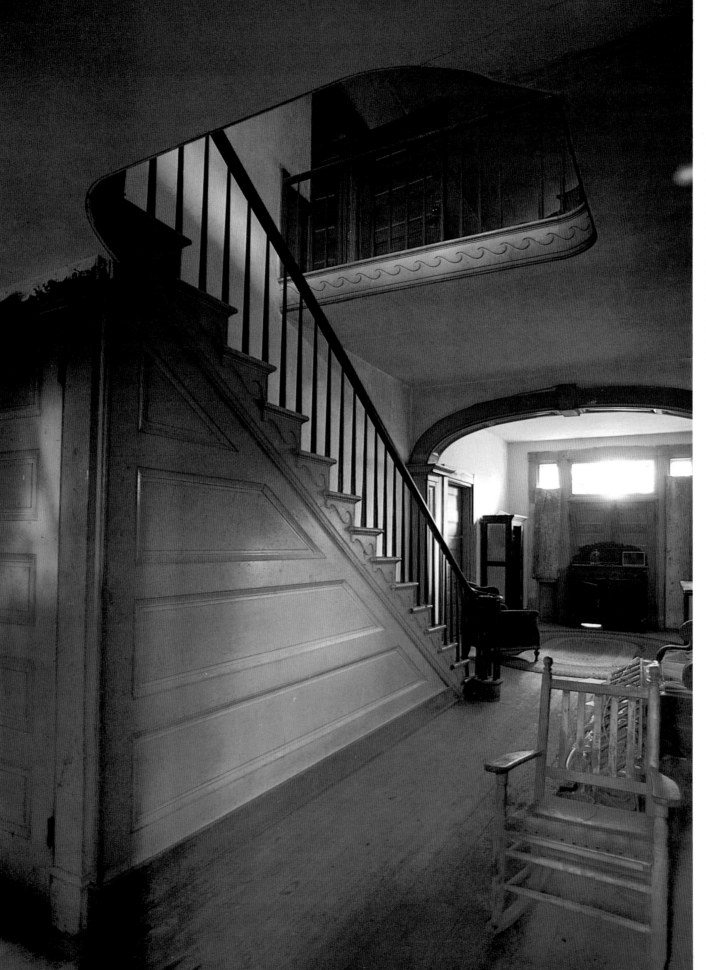

Center hall and staircase at Oakland (*left*)

Oakland, early 1800s

Nathaniel Evans, born in Ireland in 1776, first ac-
quired land north of Feliciana Parish, near Wood-
ville, Mississippi, and then with his New Jersey-
born wife, Sarah Bloomfield Spencer Evans, moved
south into Louisiana and bought property north of
the Angola road in 1813.

A handsome house, Oakland had a large center
hall graced by a carefully detailed spiral staircase,
and four large rooms on each floor, two to either
side of the great hall.

Although deserted for many years, Oakland still
had many of its original doors, and window panes
of hand-blown Waverly glass when it burned in the
late 1970s.

Live Oak, *ca.* 1800

Standing at the end of a winding avenue of live oaks, planted by one of the Barrow family in the 1830s, is one of the oldest homes in the Felicianas, Live Oak, built on a 1,000-acre Spanish land grant on the banks of Bayou Sara. The structure consists essentially of a raised basement and 1½ stories above, and has original handwrought iron hardware, still in use. Doors and mantels are hand carved.

Live Oak was restored in 1976 by Mr. and Mrs. Bert S. Turner.

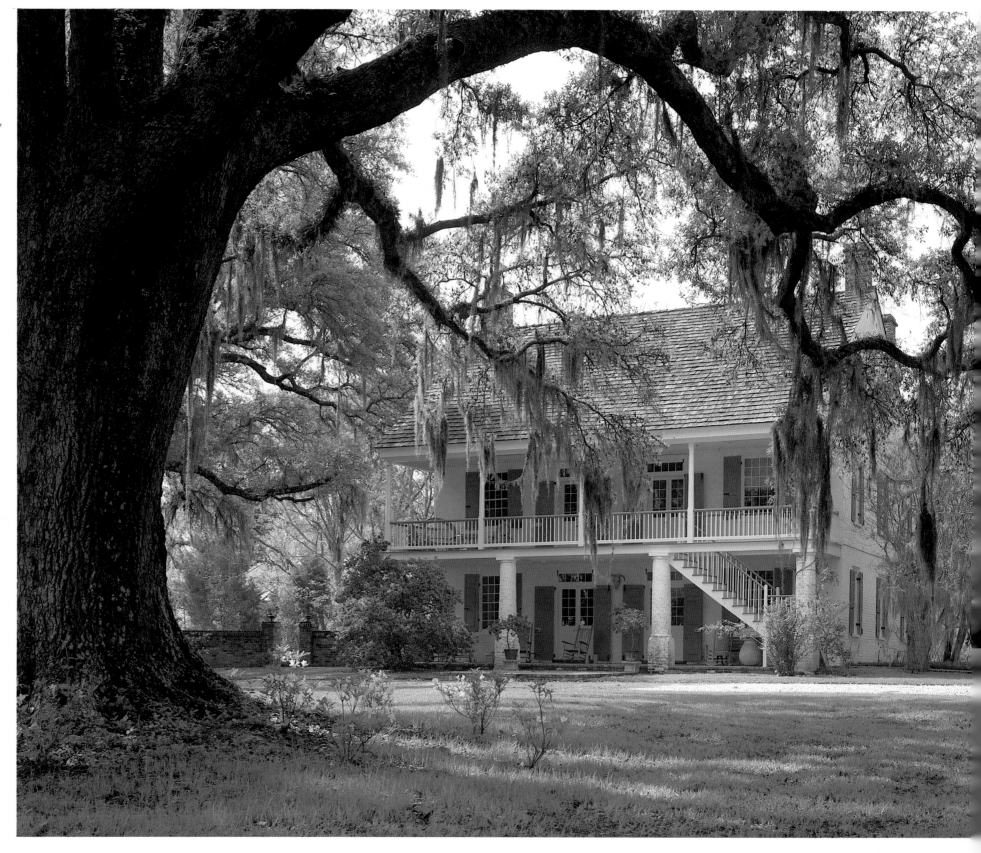

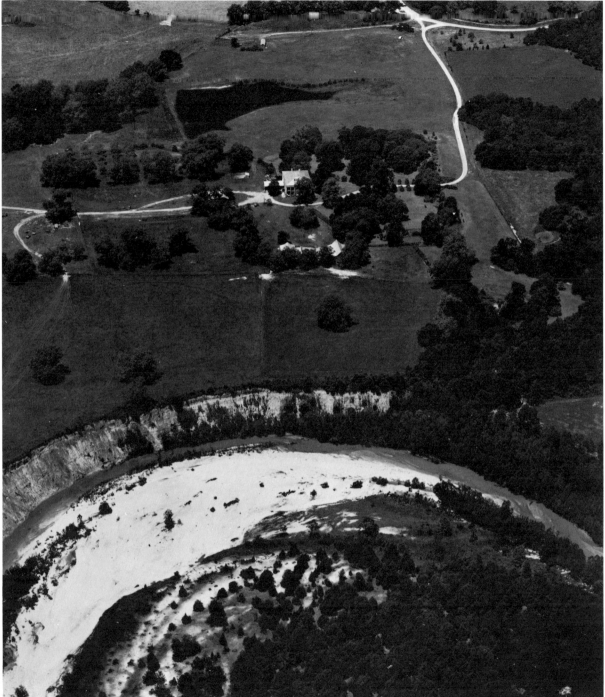

Ellerslie, 1835

High on a bluff in the Tunica hills, Ellerslie personifies the classic Greek Revival plantation home. Eight Doric columns on each side, curved mahogany staircase soaring to the attic, black marble mantels, and elaborate plaster ceiling rosettes make the home one of the most splendid of its time. Lower rooms are 22 feet square with 14-foot ceilings.

Built by slave labor under the ownership of Judge William C. Wade who was from the Carolinas, Ellerslie was sold in 1914 to the Percy family, who now operate it as a cattle ranch.

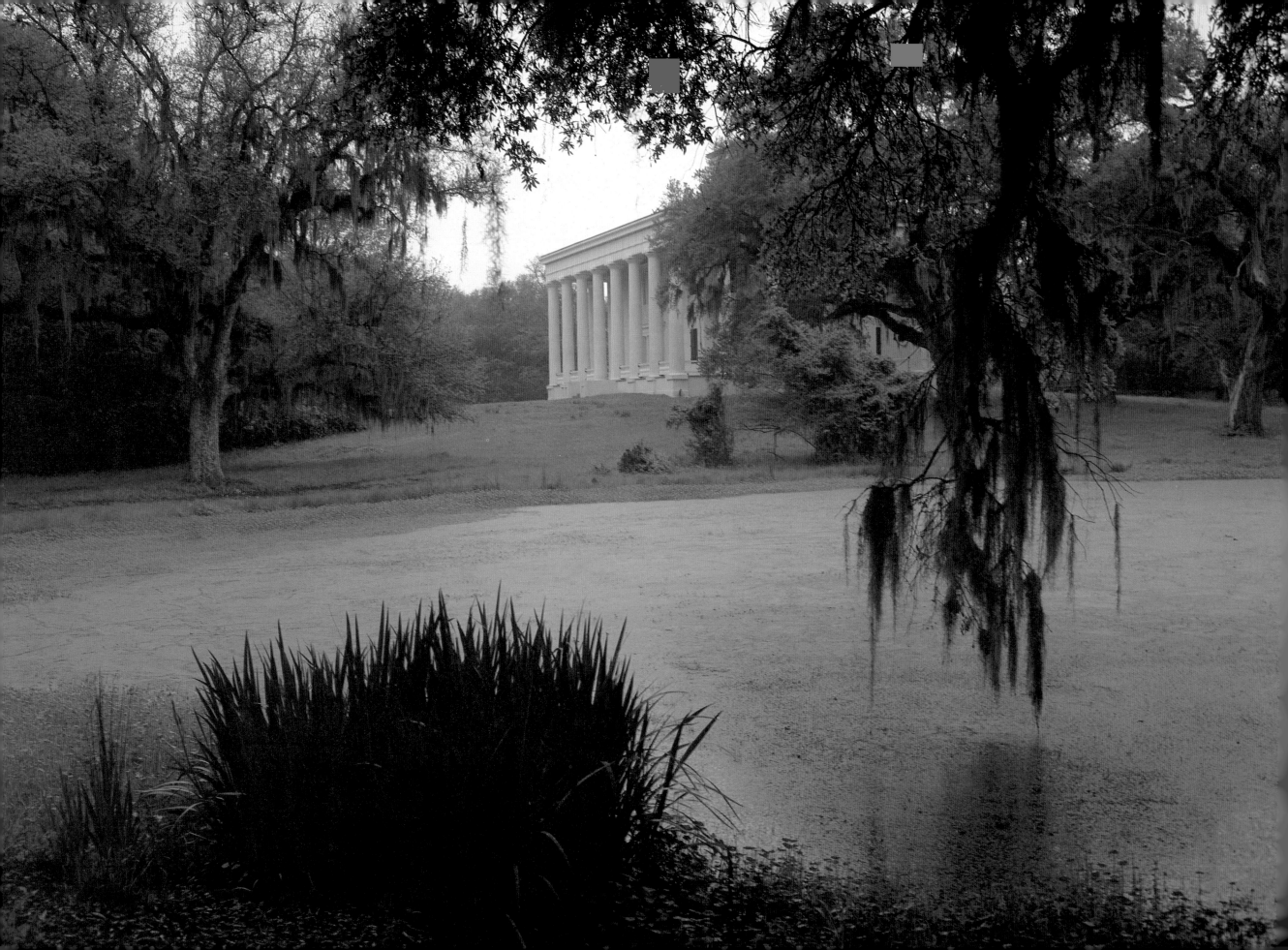

Greenwood, 1830

On a 12,000-acre Spanish land grant purchased from Oliver Pollock, William Ruffin Barrow built Greenwood in the gently rolling lands of West Feliciana Parish.

During the Civil War, when the plantation was owned by the Reed family, Federal troops burned the outbuildings, but saved the house and used it as a hospital.

Mr. and Mrs. Frank S. Percy, in 1906, purchased the house and surrounding acreage. Greenwood was restored at that time, and remained in the Percy family until the 1960s.

On August 1, 1960, Greenwood was struck by lightning, and fire destroyed all but the brick columns and foundations of the great house.

In 1968 Walton J. Barnes, a Baton Rouge attorney, purchased the house site and 300 acres and with his son Richard began a reconstruction effort that continued over a dozen years. Their first project was to straighten the great slave-made brick columns, which surrounded the house on all four sides. They leaned in all directions, presenting an intricate engineering problem that was solved by excavating and placing concrete under each column, and by doing additional brickwork.

The house itself was reconstructed entirely from photographs, which came in from all over the country as the word spread that the Barneses were rebuilding Greenwood. There were numerous photographs of the mahogany staircase, window details, fireplaces, and furniture, which the Barneses used to make a painstaking reconstruction of one of the most beautiful manor houses in the South.

The dining room table at Greenwood was once at Welham Plantation. (*right*)

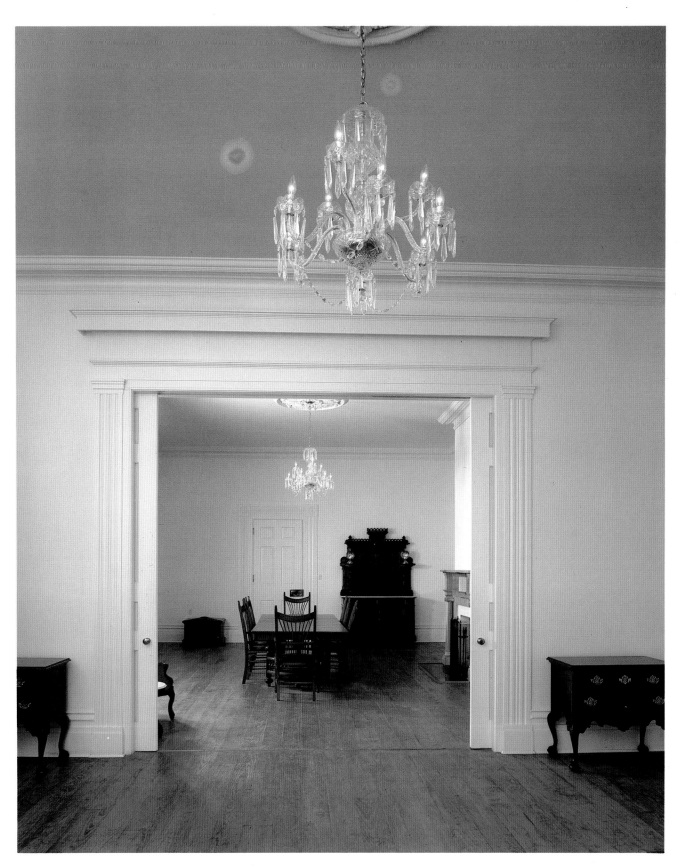

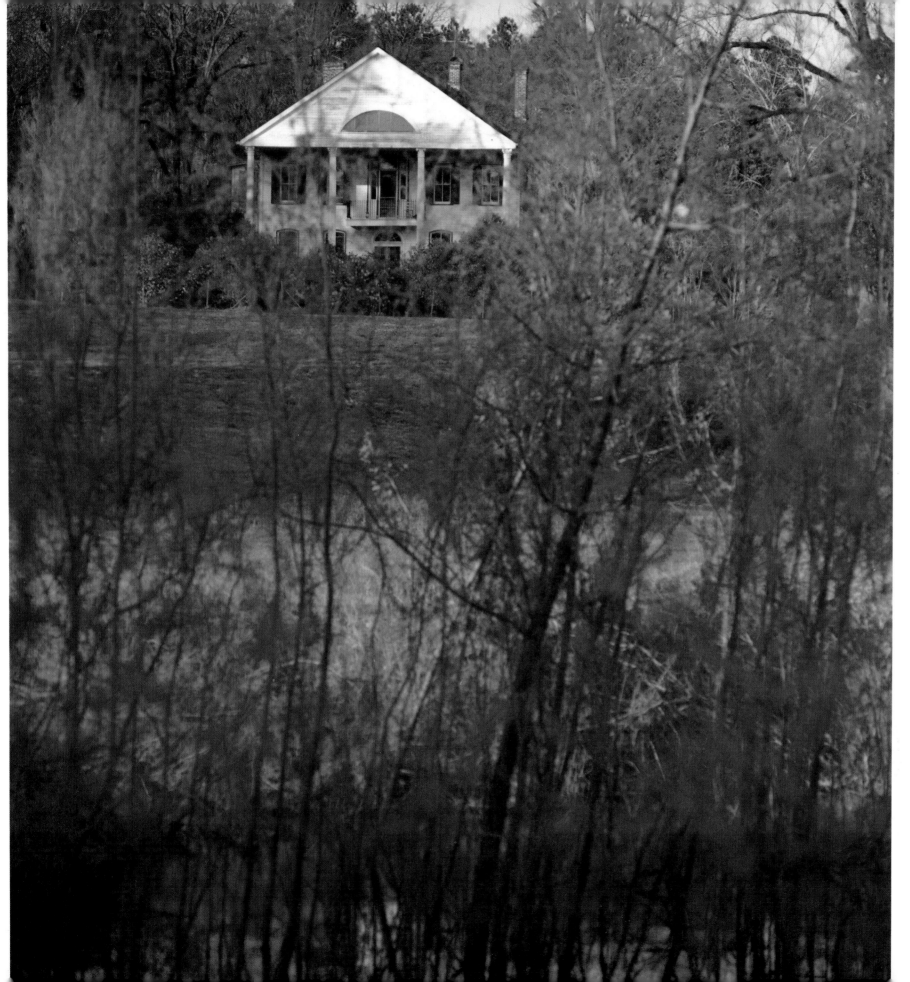

Como, 1890

Named after Lake Como in Italy, Como is the only structure still occupied in what once was a bustling riverboat-landing community on the banks of the Mississippi, upriver from St. Francisville.

Resting on the site of an earlier home that burned in the late nineteenth century, Como was once the manor house of an 1,800-acre plantation, and is the only one in the Felicianas that physically overlooks the Mississippi River. Although much of the original property has been sold, most of it has been taken by the river. Indeed, the great body of the Como plantation of over a hundred years ago is now on the other side of the Mississippi.

The Last Cabin

Years ago, when Como was a working plantation, there was an avenue of fourteen slave cabins, their backs to the Tunica hills, their front porches overlooking a broad plain bordered by the Mississippi.

Now, they and the land are gone, survived by only a few acres, one solitary cabin, and the crumbling ruins of a general store

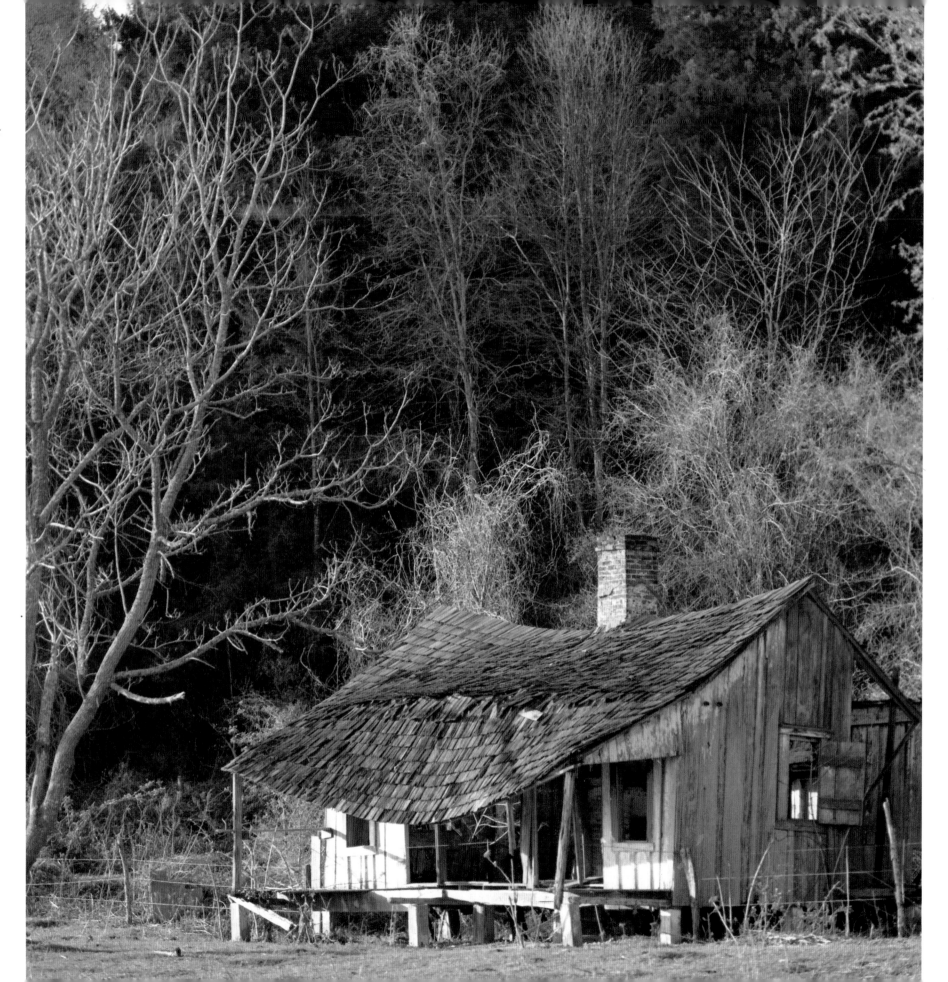

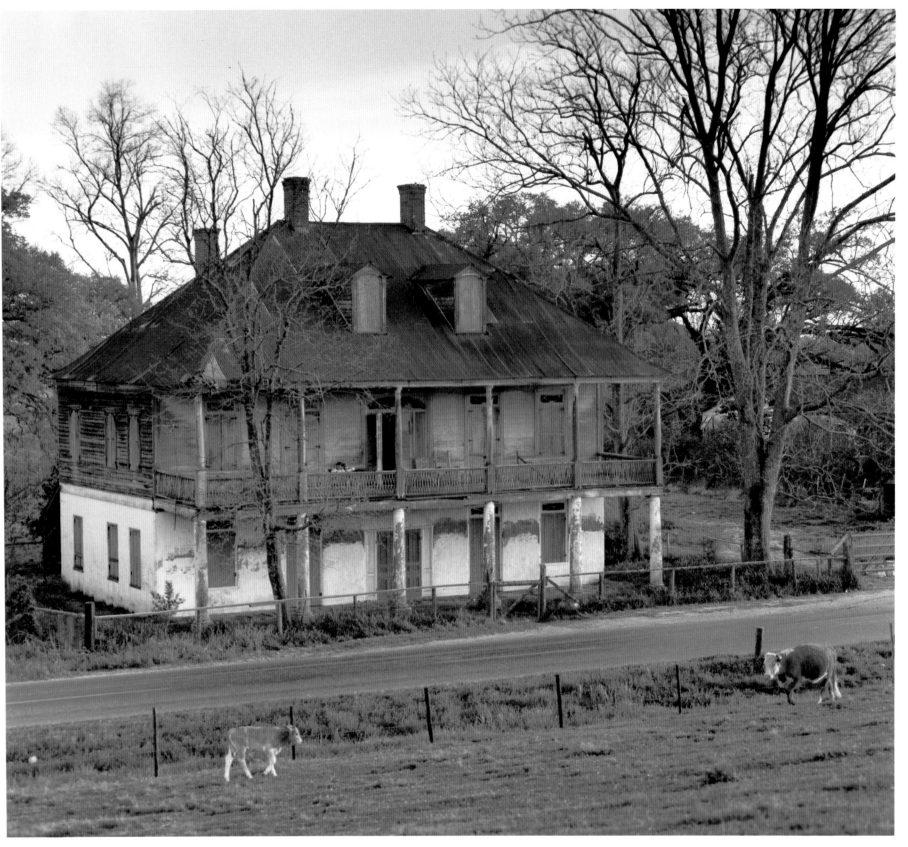

Labatut, 1790

Built in 1790 in Pointe Coupee Parish near New Roads by a Spanish nobleman, Don Evariste de Barra, Labatut overlooks the ever-encroaching Mississippi from the shadow of the levee.

Considered an architectural gem, the delicately proportioned house was once framed by an avenue of oaks leading to the river.

Don de Barra's sister married General Jean Baptiste Labatut, an aide to Andrew Jackson in the Battle of New Orleans, and Labatuts have owned the house ever since.

Parlange, 1750 (*right*)

Built in 1750, Parlange is one of Louisiana's oldest homes, and has remained in the same family since its inception. Originally an indigo plantation, Parlange was built by the Marquis Vencent de Ternant on a French land grant on False River and was changed to a sugarcane plantation in the early 1800s by Claude Vencent de Ternant, son of the builder.

A National Historic Landmark, the two-story mansion has a raised basement, and the second floor is built of cypress with twin chimneys atop the roof. Galleries completely encircle the house which has twin brick pigeonniers at either side of the drive.

Interior furnishings have been in the family for generations.

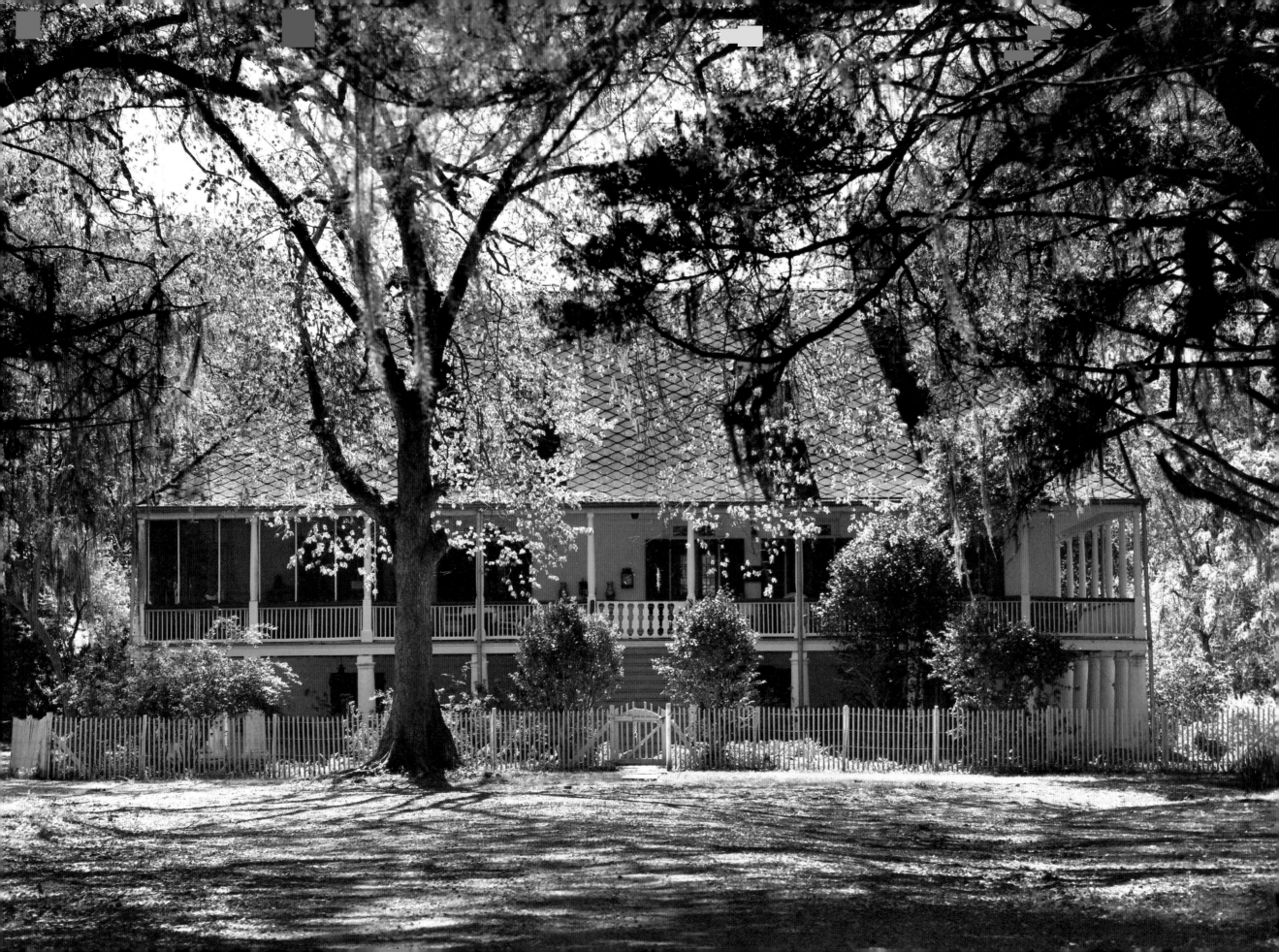

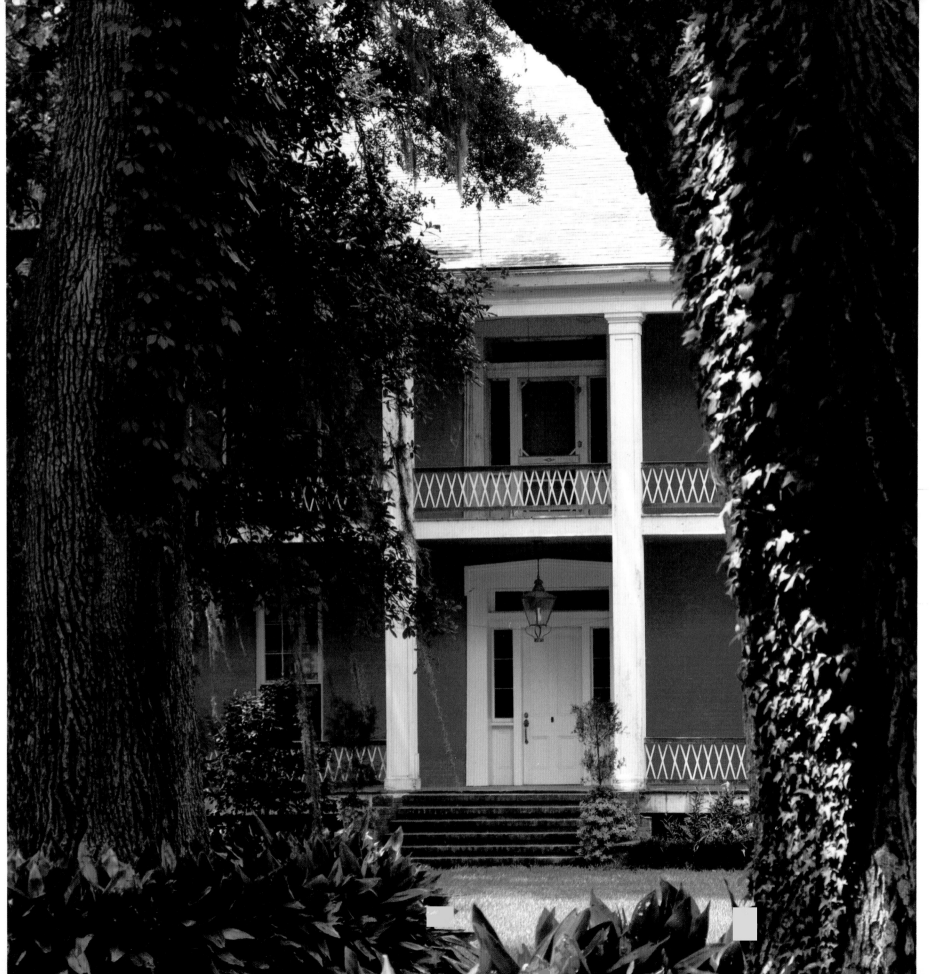

Valverda, 1818

Built on the west bank of Bayou Grosse Tête south of Livonia by Henry John Miller in 1818 is stately Valverda, the center of plantation acreage extending from Grosse Tête to Bayou Maringouin.

Mr. Alfred Richard Miller (no relation to the builder) purchased the property in 1947 and with his son is restoring the house at this writing.

Downstairs ceilings are 13 feet, upstairs are 10 feet; walls are 18-inch-thick brick, and the 9-foot doors weigh 105 pounds each. The house is symmetrical with identical galleries and square columns front and rear.

In stripping the paint down to the prime coat, the Millers found written on the wall, next to the mantel in the living room, an itemized list of construction expenses that totaled $37,875.

Once planted in cotton and cane, Valverda's principal products today are soybean and cattle.

Mound House, 1840 (right)

Mound House was erected on an Indian mound in 1840, on a tract of land three miles south of Maringouin, on Bayou Grosse Tête. It was built by Austin Woolfolk, a large landowner.

The 1½-story house has six square columns supporting the sloped roof, which is accented by three dormer windows and two brick chimneys. The mansion still has its original woodwork, including a walnut staircase and interior door frames identical to those on the exterior. The house has five large rooms on the lower level and two bedrooms and a bath upstairs.

Now the property of the Schwing Company, Mound House has been remodeled and is in excellent condition.

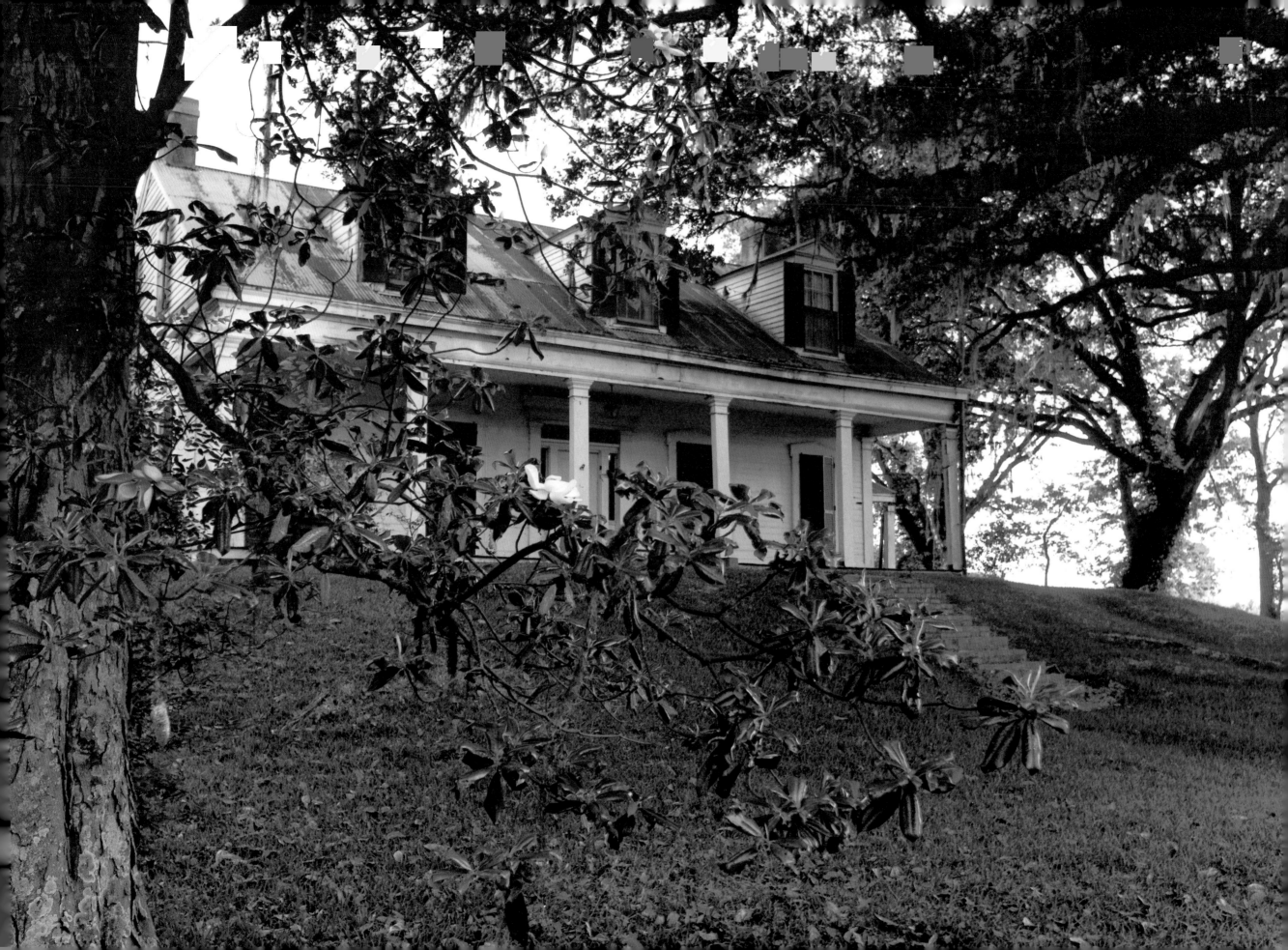

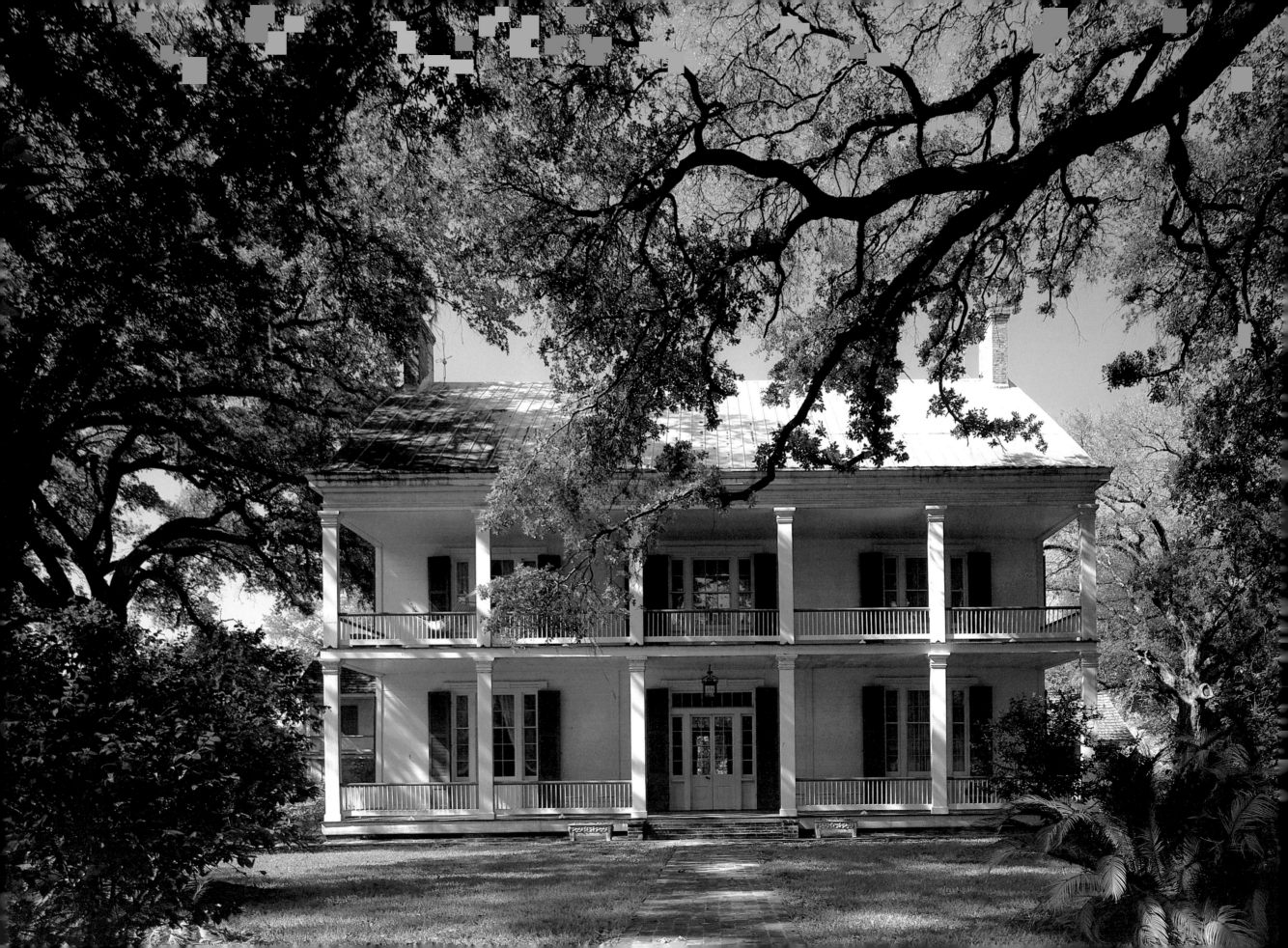

Live Oaks, 1838

His father having been killed in a duel with Andrew Jackson, Charles H. Dickinson moved to Louisiana from Tennessee in 1825 at the urging of his father-in-law, Joseph Erwin, who deeded him property along Bayou Grosse Tête.

Among the unique features of the plantation, which Dickinson called Live Oaks Farms, is the old slave chapel located near the house. It was later used as the first schoolhouse in Rosedale, and later as an Episcopal church.

Live Oaks has been restored by the present owners, Mr. and Mrs. William P. Obier, who have plans to open the property to the public. Mr. Obier has family ties to the original Dickinsons who built the house.

Staircase at Live Oaks is *faux-marbre*, or painted to resemble marble. (*right*)

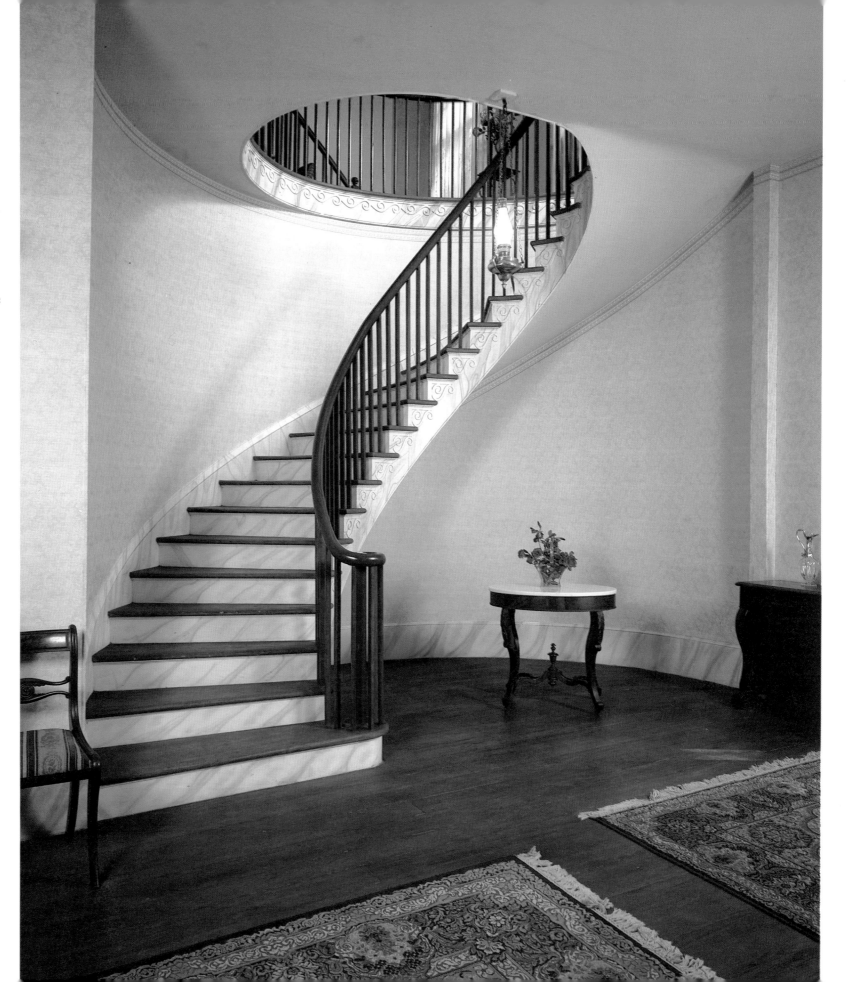

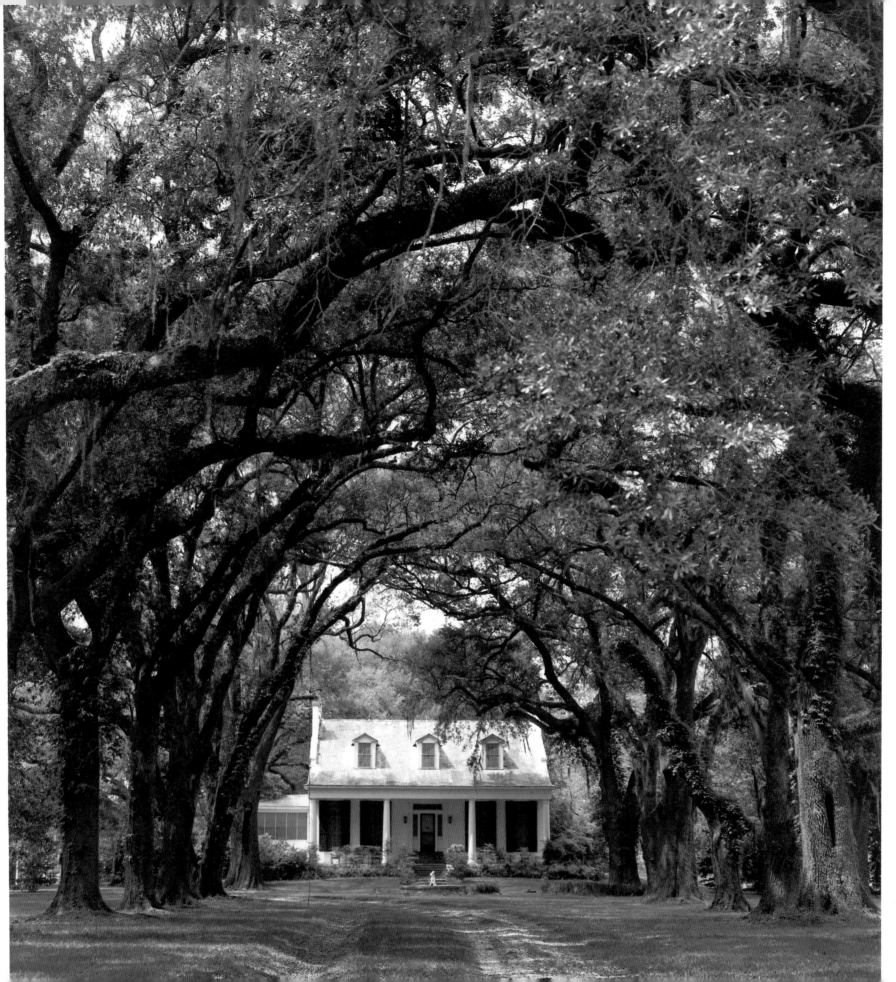

Trinity, 1839

Standing on an Indian mound at the end of a spacious avenue of live oaks is the story-and-a-half Trinity plantation house, built in 1839 by Dr. George Campbell of New Orleans.

The walls are of slavemade brick, and the interior walls are 14 inches thick. Exterior walls are plaster over brick; the floor joists are cypress. There are 30 live oaks on the grounds, and the plantation acreage includes 850 acres planted in soybeans. For years the principal cash crops were cotton and cane.

Purchased in 1966 by Mr. Leon R. Kleinpeter, Jr., of Baton Rouge, the house has been well maintained and is in good condition.

Monte Vista, 1857 (right)

The manor house of what was originally an indigo plantation established by Pierre Joseph Favrot in 1798, Monte Vista was built in a classic French colonial style by his grandson, Louis Favrot in 1857.

Characterized by two large hallways, upstairs and down, with two rooms on either side, the living areas were on the second floor, and the downstairs comprised the dining room, pantry, parlor, and library.

Originally, extensive gardens separated the house from the Mississippi, but a levee setback by the U.S. Corps of Engineers in 1927 took not only the front yard but threatened the house itself.

Saved by the efforts of Horace Wilkinson, Jr., whose ancestor was General James Wilkinson, the official receiver of the Louisiana Purchase territory from the French, the house was restored in the early 1980s by Horace Wilkinson IV, member of the fifth generation of Wilkinsons to reside in the Baton Rouge area.

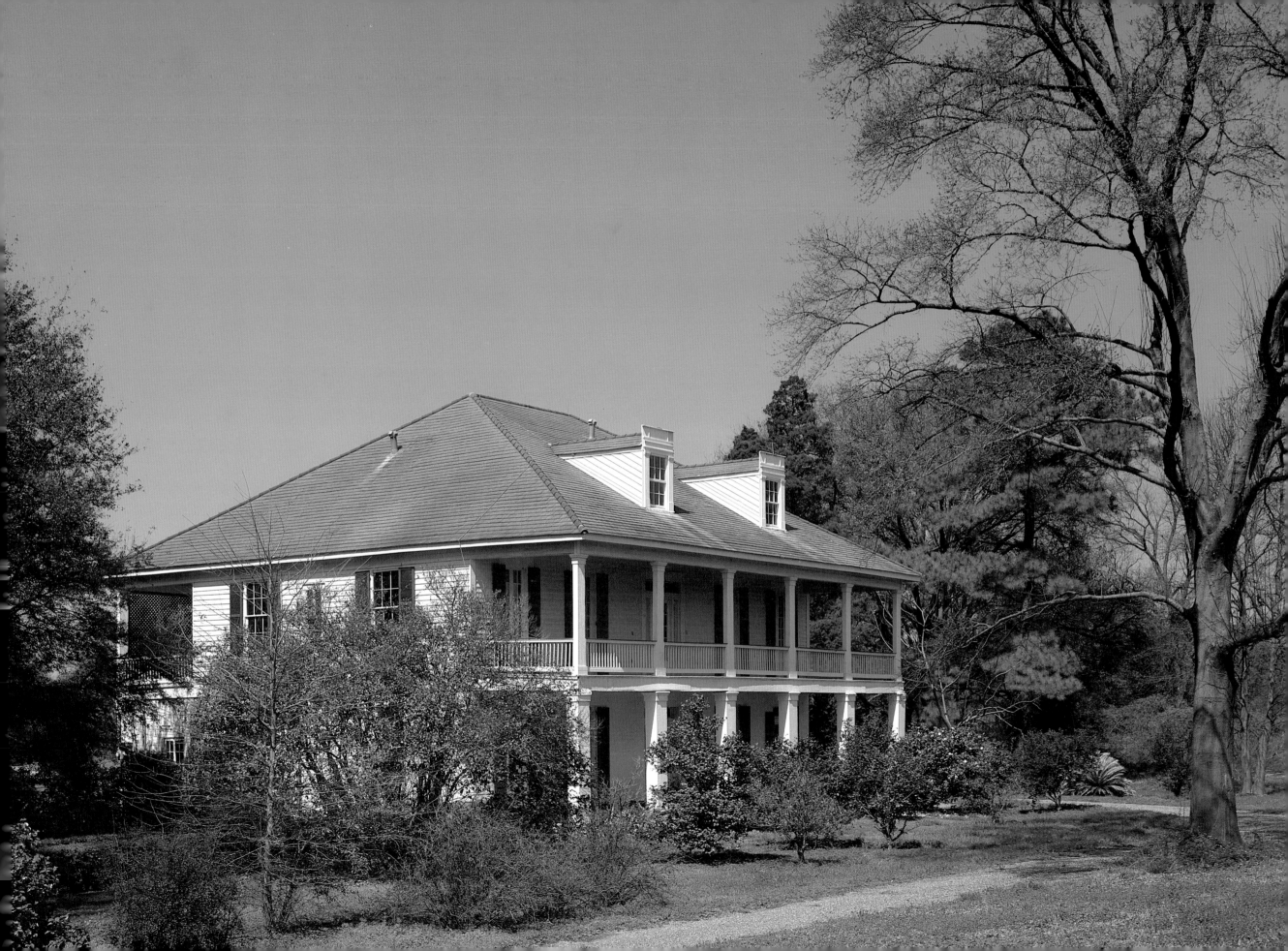

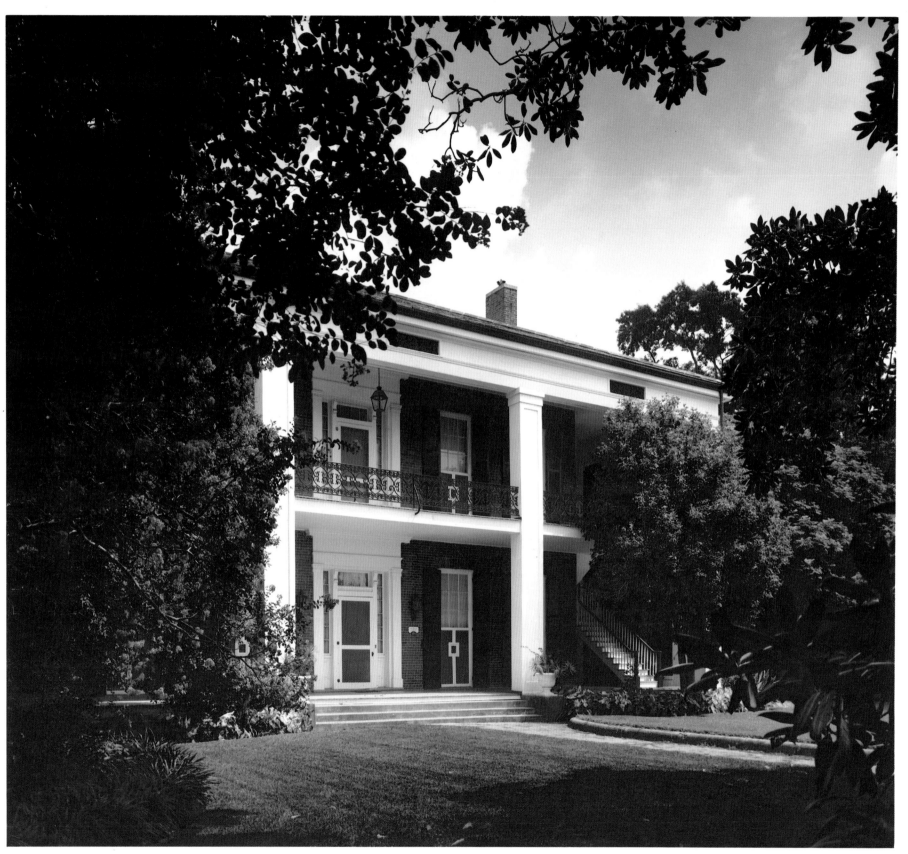

Stewart-Dougherty, 1848

The Stewart-Dougherty house on North Street in downtown Baton Rouge was built by Nathan King Knox between 1848 and 1854 and sold upon completion to Mrs. Nolan Stewart. Maintained since by her descendants, the home has always been passed to a female heir. The plantation acreage is located north of Baton Rouge.

During the Civil War when Union troops captured Baton Rouge, soldiers stacked firewood under the central hall stairway to burn down the house. Instead, it was decided to use the place as a much-needed hospital, and the Stewart-Dougherty home survives today.

Magnolia Mound, 1791 (right)

Saved from destruction by a concerted effort of preservationists in the Baton Rouge area when the house was slated to be replaced by a high-rise apartment building, Magnolia Mound has come to be recognized as a prime example of early Louisiana plantation home architecture.

Constructed in the 1790s, the raised cottage features broad front and rear galleries, which along with the mud-and-moss mixture packed between the posts, provide excellent insulation from the near-tropical Louisiana climate.

Magnolia Mound was originally a 1,000-acre cotton and indigo plantation, founded by John Joyce from Fort Mobile. In the late 1790s or early 1800s, his widow remarried and made additions to the house, furnishing it in the prevailing Federal style.

Members of the Foundation for Historical Louisiana, in conjunction with the city-parish government, have been effective in restoring the house and grounds.

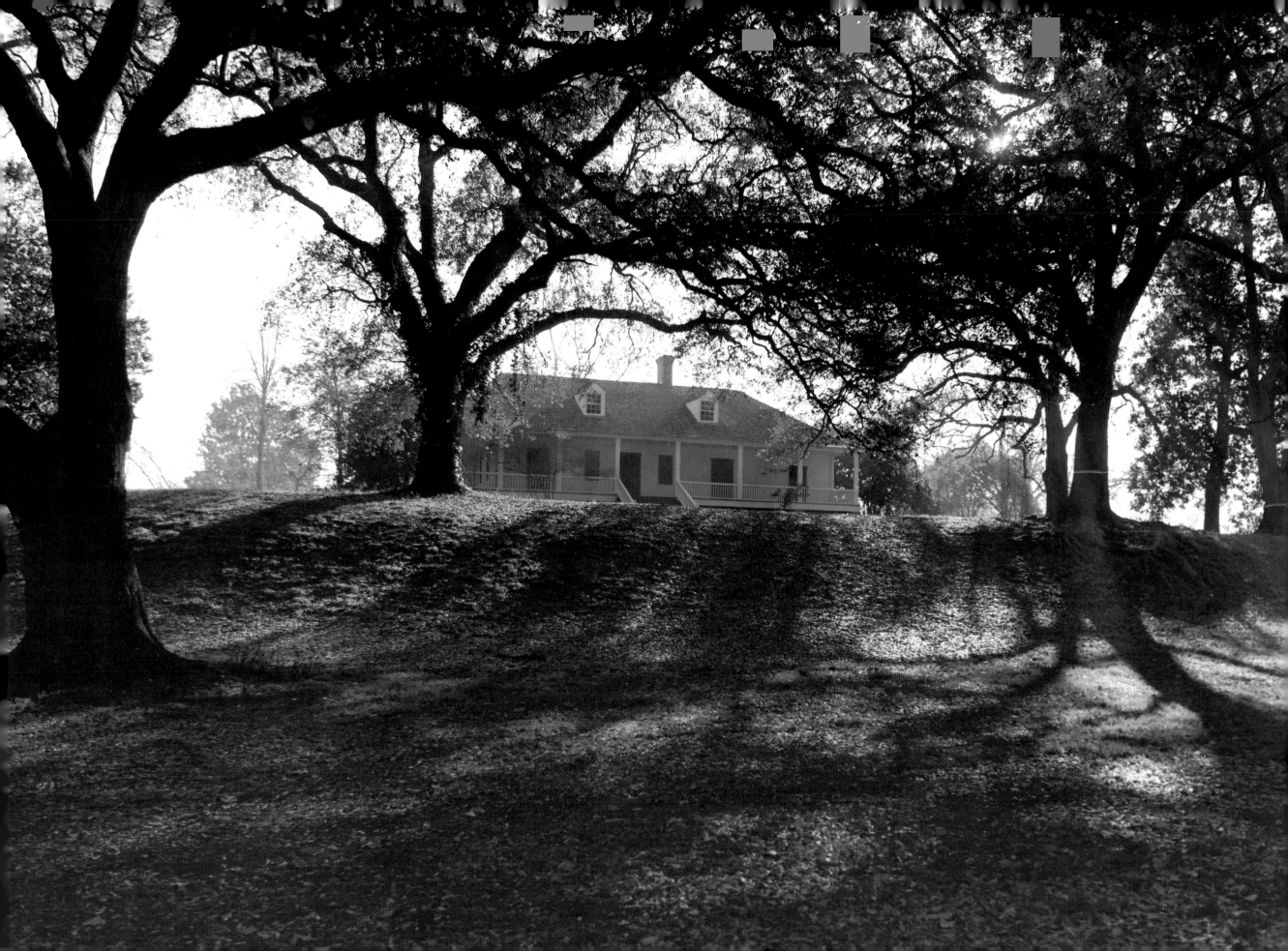

Docents at Magnolia Mound prepare a typical plantation dinner in the reconstructed cook house, a separate structure built on the original location.

Mount Hope, 1790s (*right*)

One of only two surviving 18th-century plantation houses in the Baton Rouge area, Mount Hope was built below the town in the last years of the 1700s in an area known as the Dutch Highlands. The highlands represented the first raised ground along the east side of the Mississippi River before the ridge actually met the river at Baton Rouge.

Studies have placed the time of the home's construction as early as 1790, but through the years, the plantation home would change hands many times before being bought in 1917 by a family that would retain it until the 1970s. Recently, Mount Hope was given an extensive restoration by Arlin Dease prior to his acquisition of Nottoway. Present owners are Mr. and Mrs. Jack Dease, who continue to add to Mount Hope's antebellum style and manner.

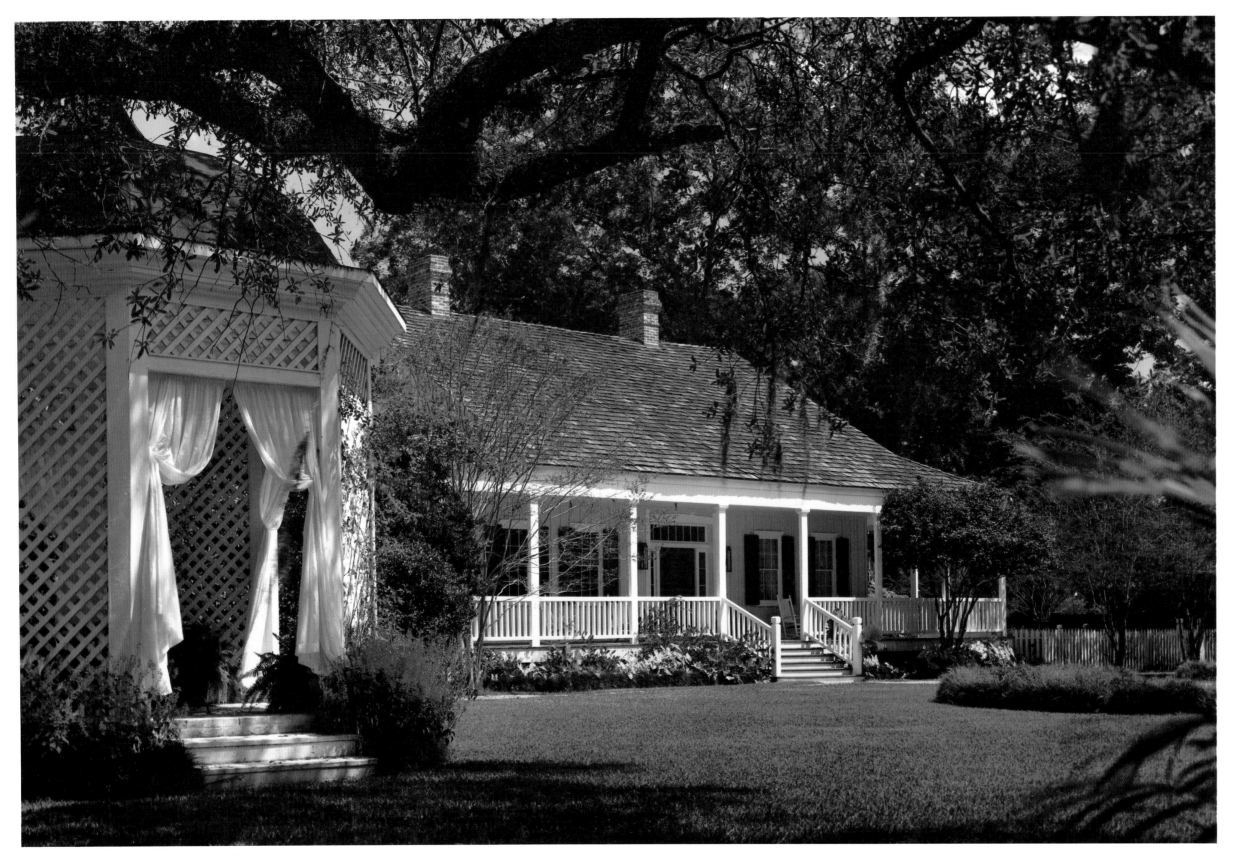

Tally-Ho, 1831

Founded by Virginians in the 1830s, and named after their fond memories of chasing the hounds in Tidewater country, Tally-Ho Plantation located on the River Road below Plaquemine, was once one of the largest along the Mississippi, with holdings totaling over 12,000 acres, 7,000 under cultivation.

The original "big house," which had grown as the family fortunes prospered, was destroyed by fire in 1945, and the smaller structure shown here, believed by some to have been a carriage house, or overseer's house, became the family home.

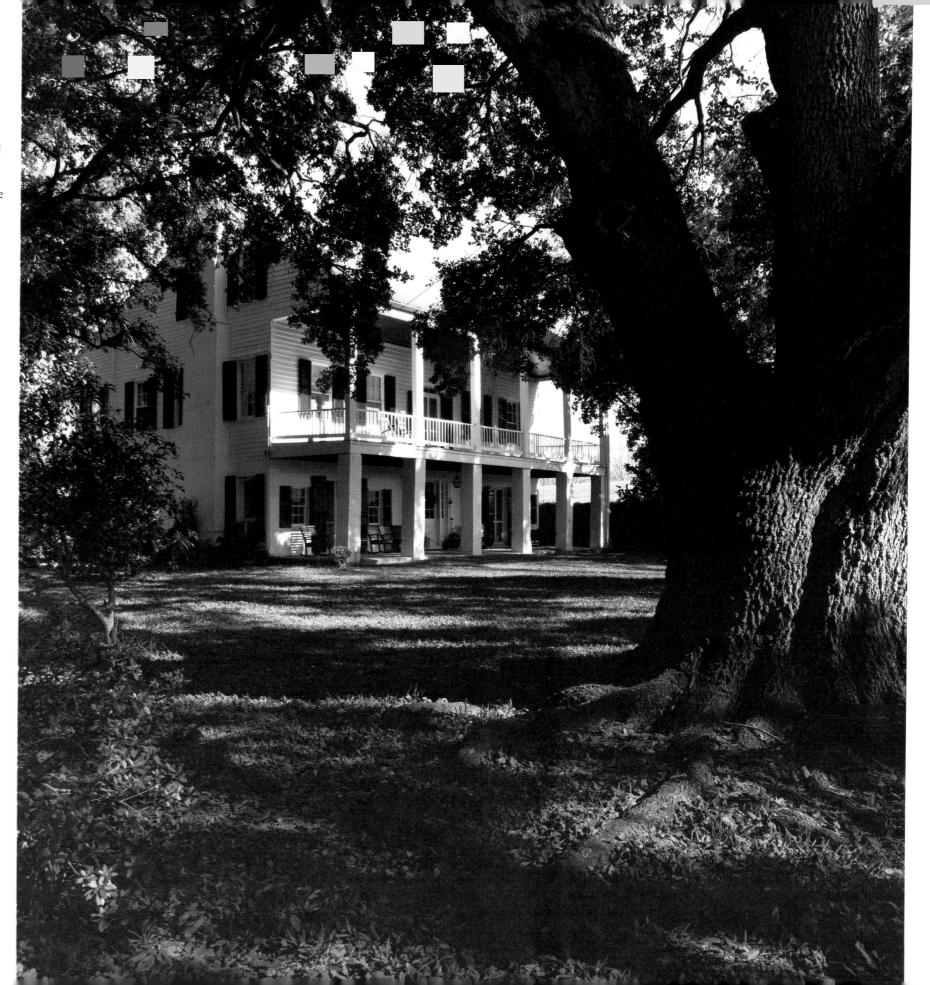

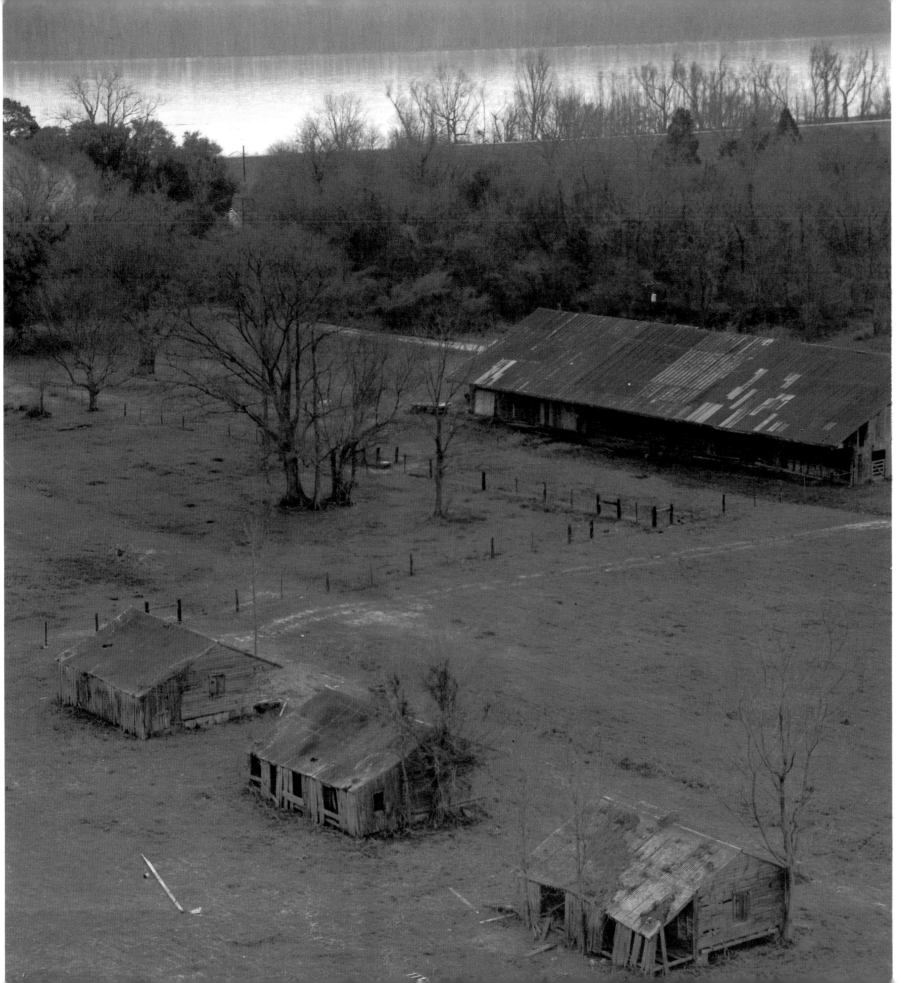

A few slave cabins still remain to the rear of
Tally-Ho.

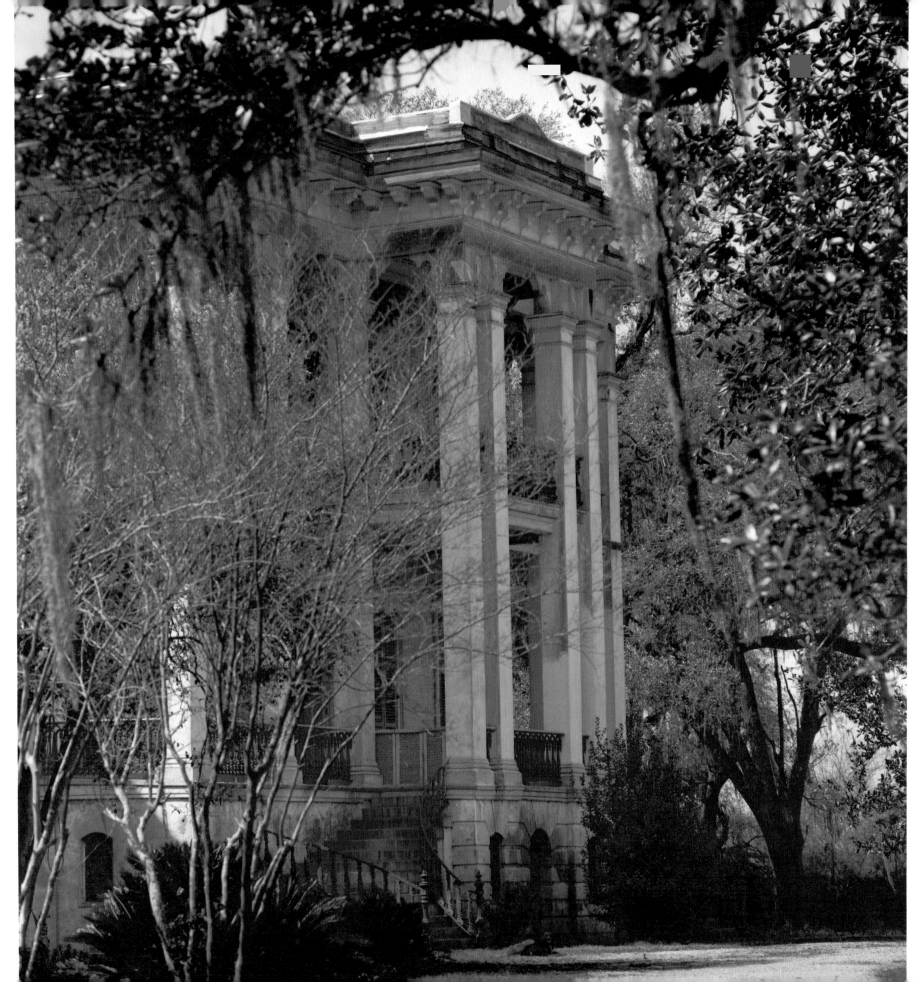

Nottoway, 1859

The largest plantation home in the South, Nottoway was built by John Hampden Randolph, scion of the prominent Virginia family. He named the massive home for a river and county in his native Virginia.

Randolph first settled in Woodville, Mississippi, and then moved to Iberville Parish in 1841, where he built a sugar empire, which by 1857 included over seven thousand acres.

To house his growing family, three sons and eight daughters, Randolph engaged the New Orleans architect Henry Howard, whose design was selected over thirteen others.

Completed in 1859 on the eve of civil war, Nottoway features more than 60 rooms and over 53,000 square feet under the original slate roof.

Nottoway, restored by Arlin Dease, still stands solid and stately. It was opened in 1981 to the public for the first time in its more than 122-year history.

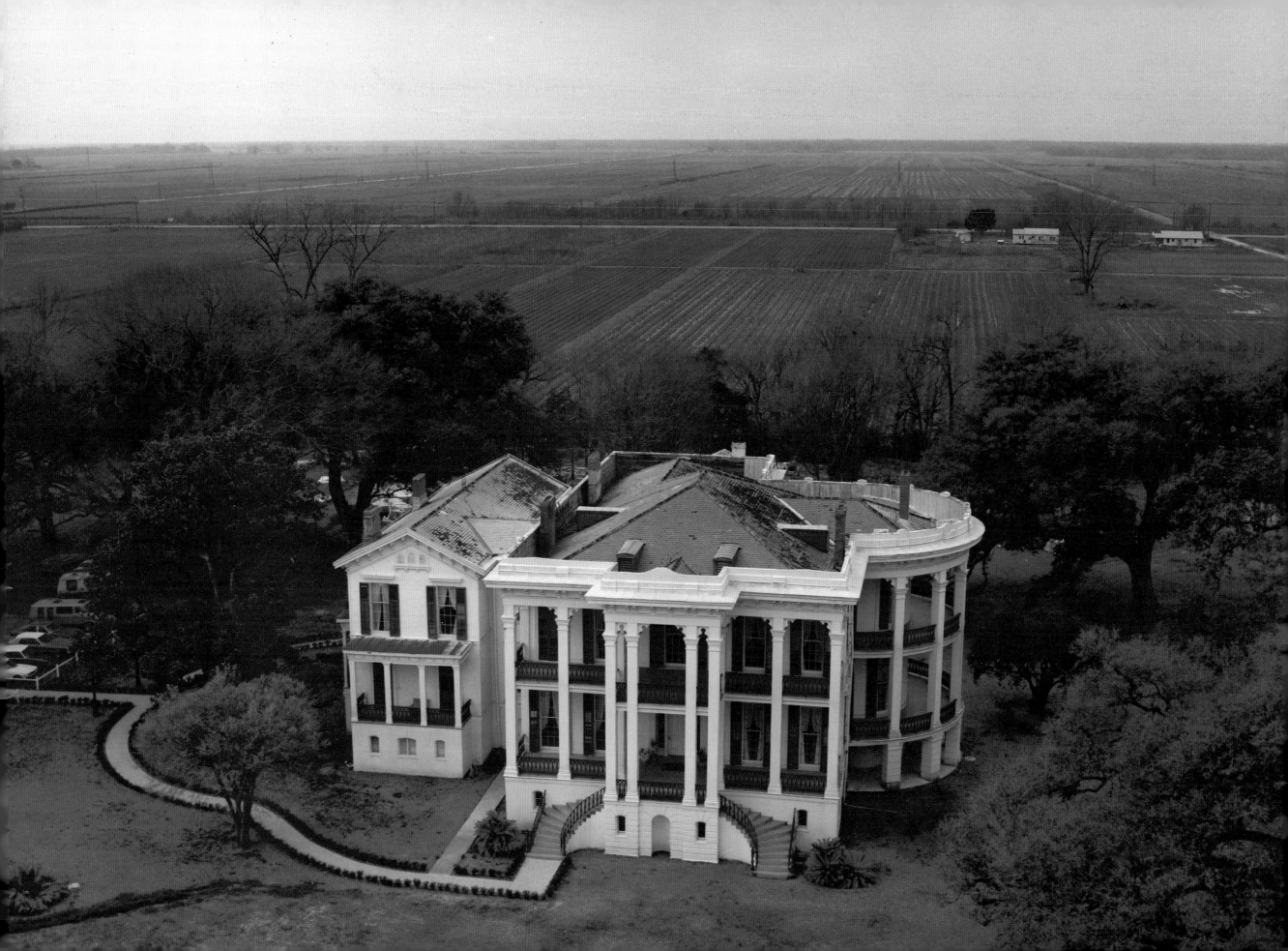

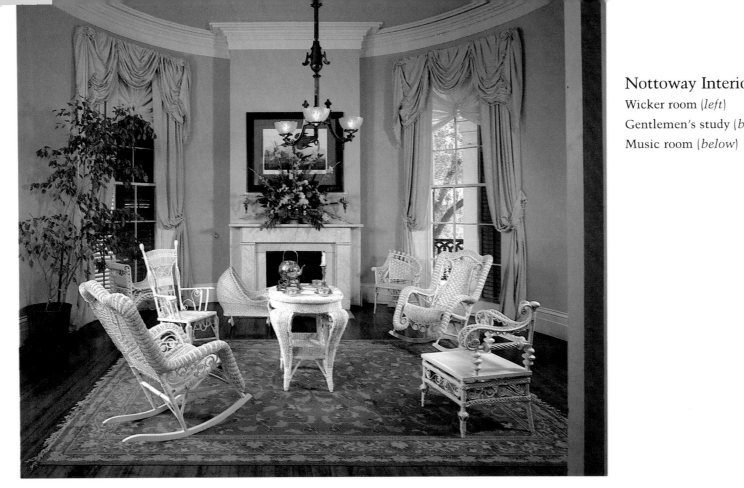

Nottoway Interiors

Wicker room (*left*)

Gentlemen's study (*bottom left*)

Music room (*below*)

White ballroom (*far right*)

Dining room (*right*)

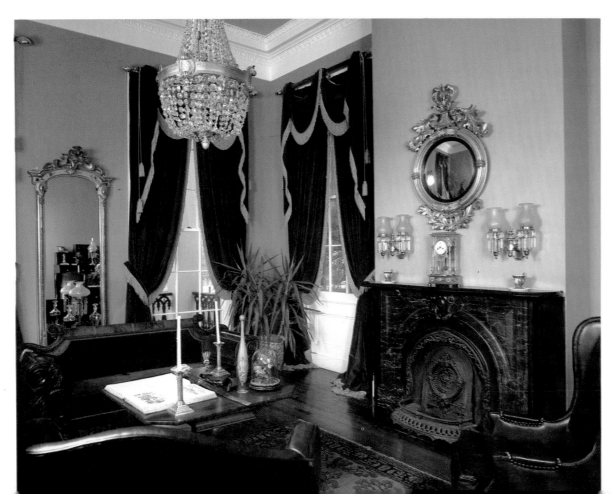

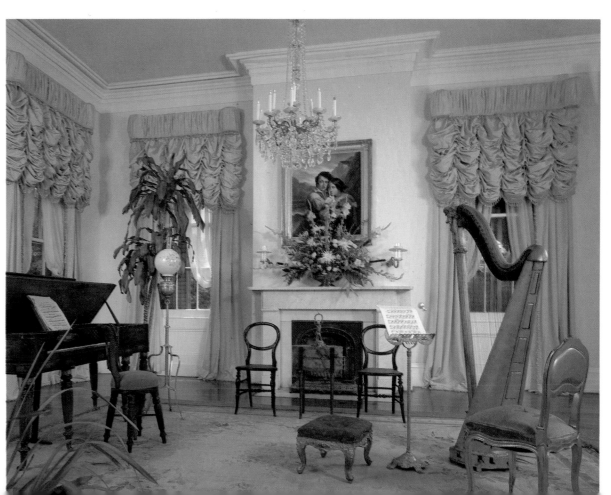

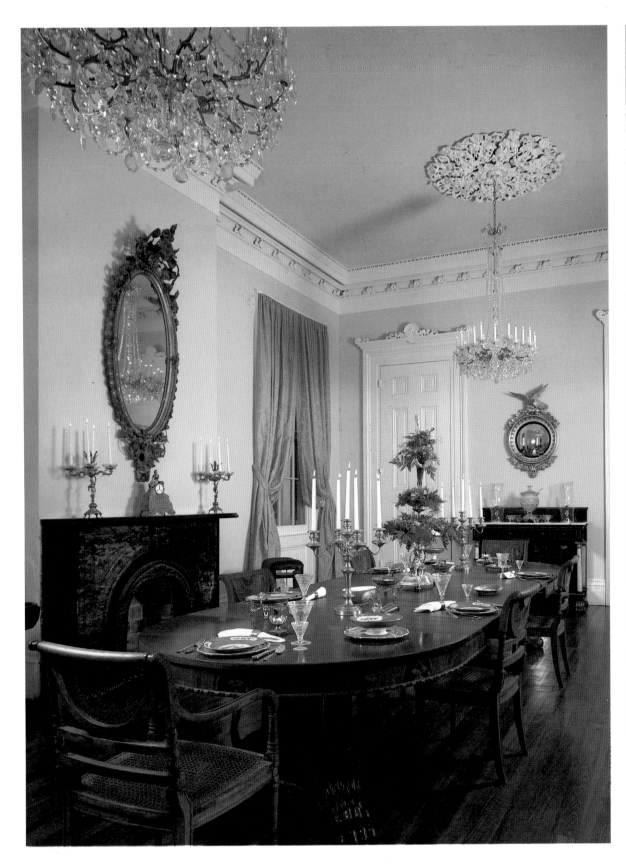

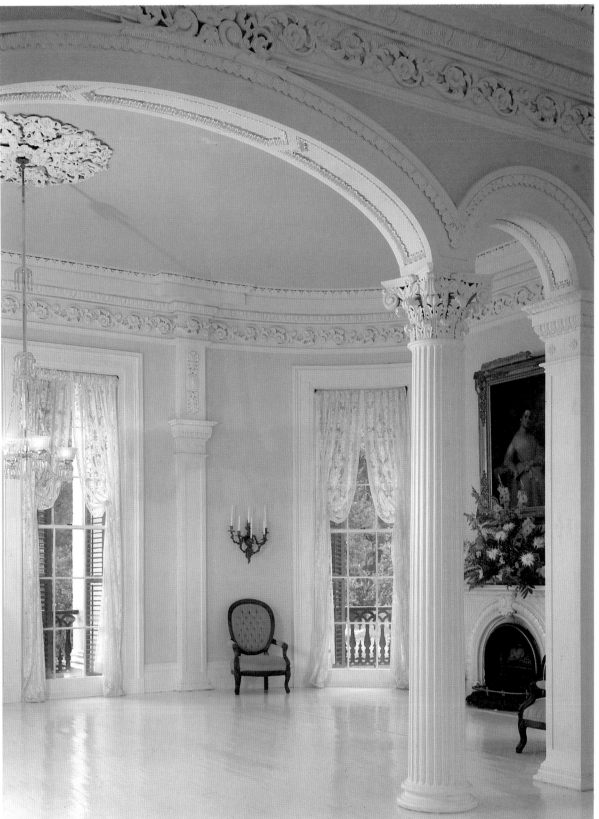

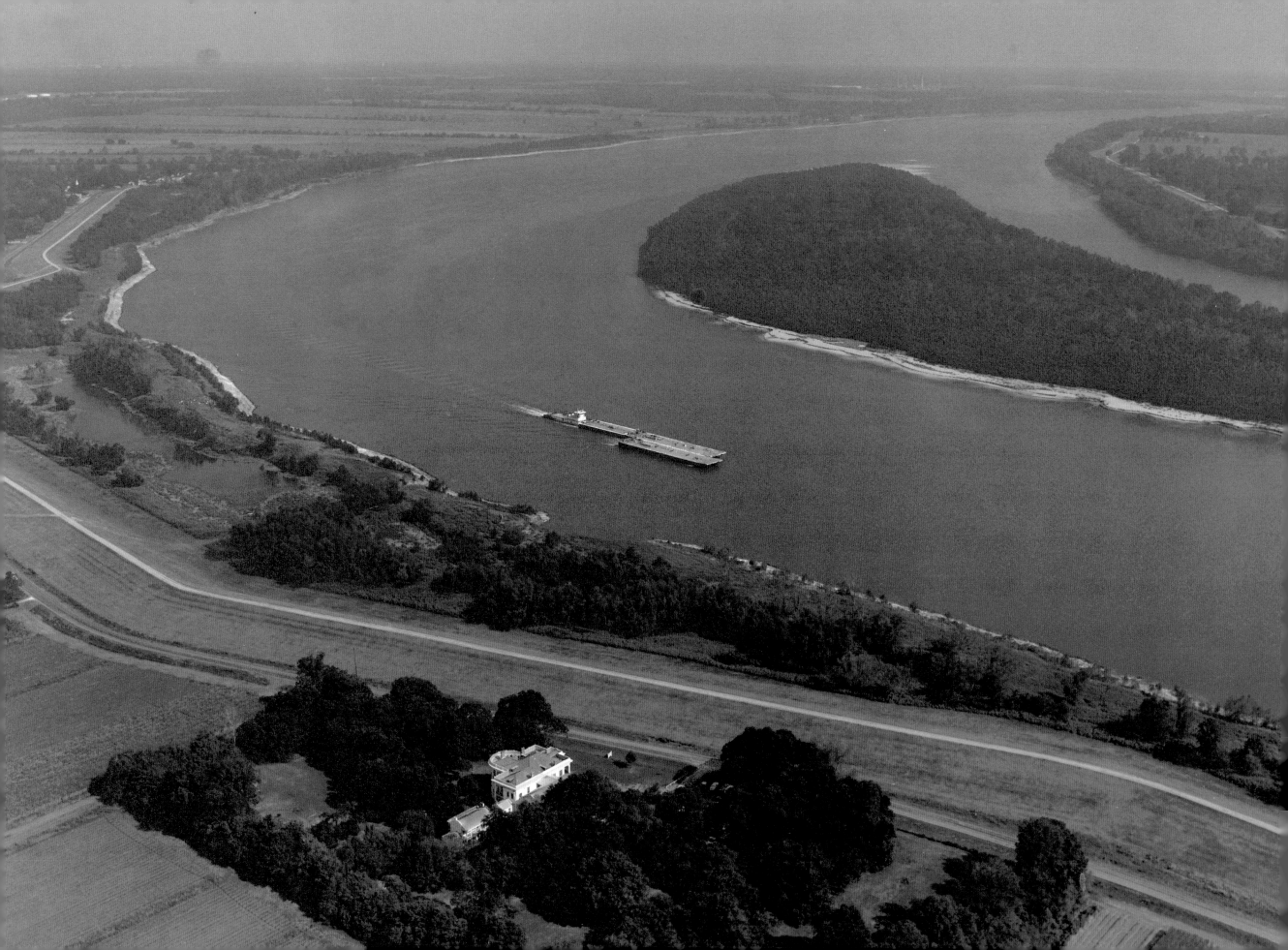

Indian Camp, 1850

When R. C. Camp built his plantation home across the Mississippi River from the town of White Castle, he retained the New Orleans architect Henry Howard, designer of other notable homes and public buildings in the area.

By the late 1800s, the plantation had fallen into decline. Just prior to the turn of the century, a New Orleans physician acquired a 5-year lease on part of the plantation and quietly moved upriver with seven leprosy victims, housing the patients in the former slave cabins. In 1894 the old Indian Camp tract became the Louisiana State Leprosarium, which then became the United States Public Health Service Hospital for the care and treatment of leprosy in 1921.

Today, the house serves as the administration building for the complex, now known as the National Center for Hansen's Disease.

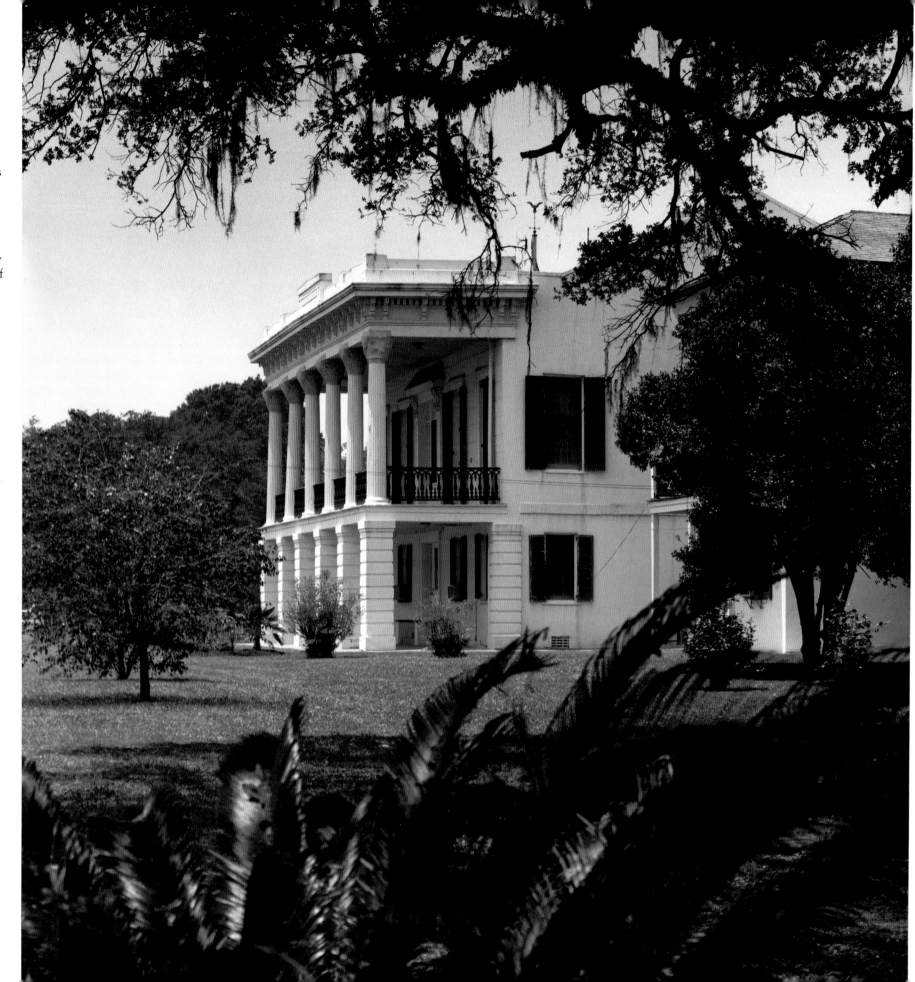

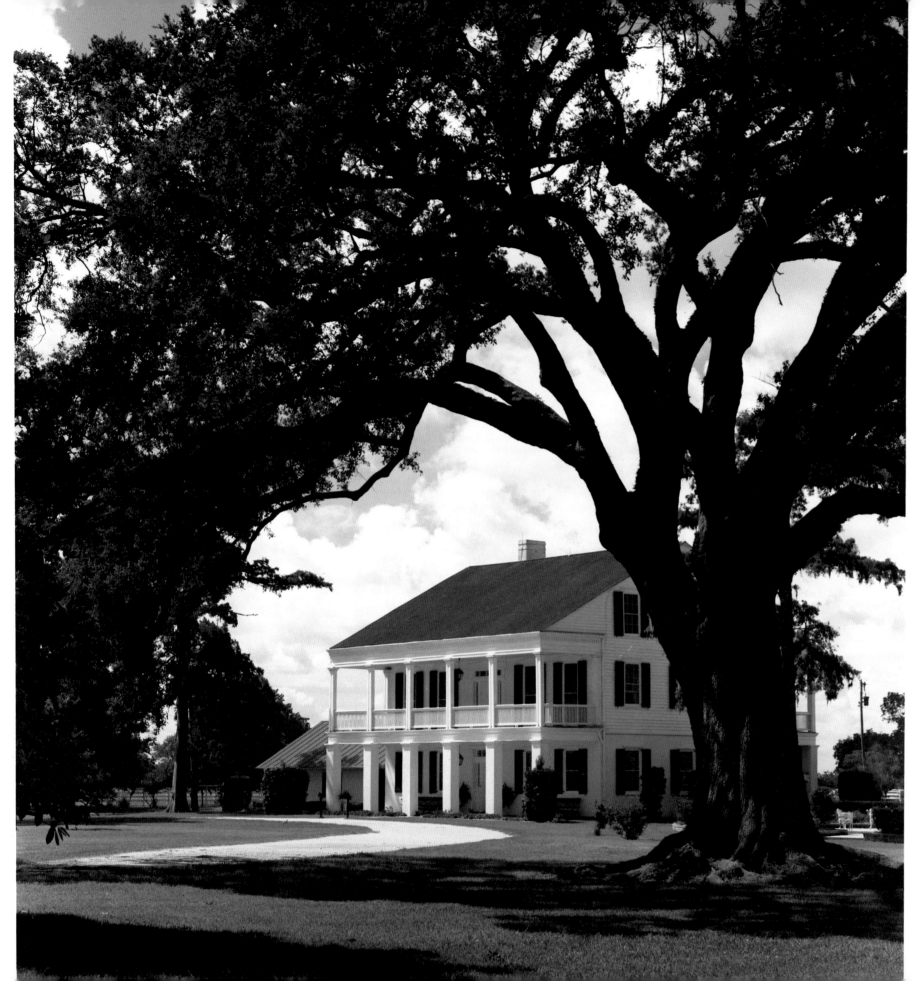

Mulberry Grove, 1836

A Virginian, Dr. Edward Duffel, built Mulberry Grove for his Acadian bride, Anne Marie Antoinnette Desirée Landry, and the house reflects both its French and Anglo-Saxon backgrounds.

In later years, after Mulberry Grove was purchased by John B. Reuss, and grouped with other properties in the area, it was considered a part of Reuss's Germania plantation.

In 1951, when the manor house was being used as a haybarn, Mrs. C. C. Clifton purchased the 704-acre Mulberry Grove portion of Germania from Reuss's daughter and restored the house to its original specifications. House and grounds are in an excellent state of preservation.

Sugarcane is still cultivated at Mulberry Grove. (*right*)

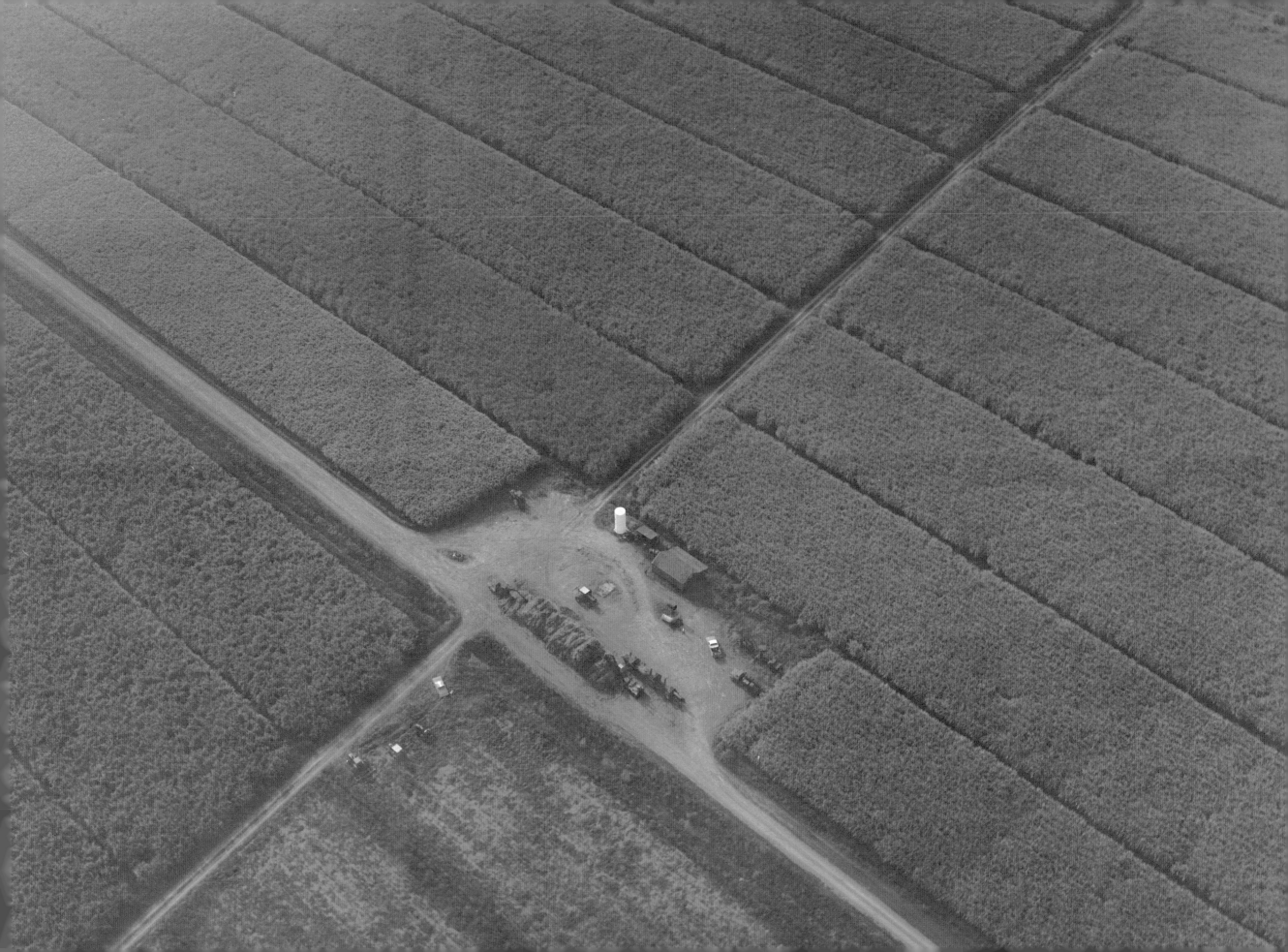

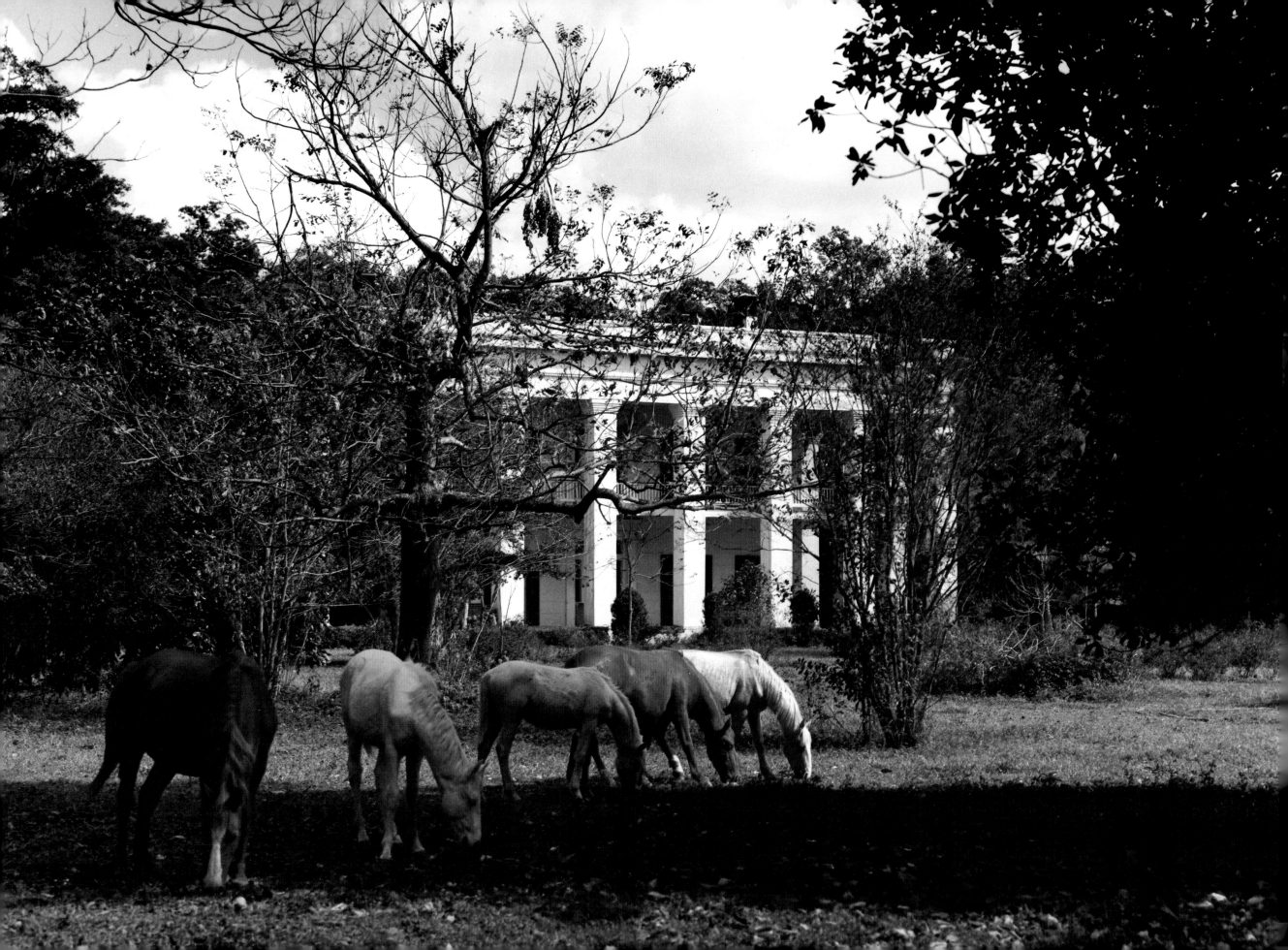

Belle Helene, 1841

Like an ancient Greek temple, Belle Helene over-
looks the Mississippi between Geismar and Dar-
row, on the east bank of the River Road.

Built by Duncan Kenner, who later became
the Confederate Minister to France, the square-
columned mansion is surrounded by great plastered
brick columns, set eight to a side, on galleries
twenty feet wide.

Inside is a great hall on the first and second
floors, with two large rooms on either side. At the
rear of the hall is one of the most graceful spiral
stairs to be found in the state, lofting to the attic.

Although severely vandalized, Belle Helene is
now gradually being restored. Several motion pic-
tures have been filmed on the grounds, including
The Beguiled, in which Clint Eastwood was the
star.

Aerial view of Belle Helene (*right*)

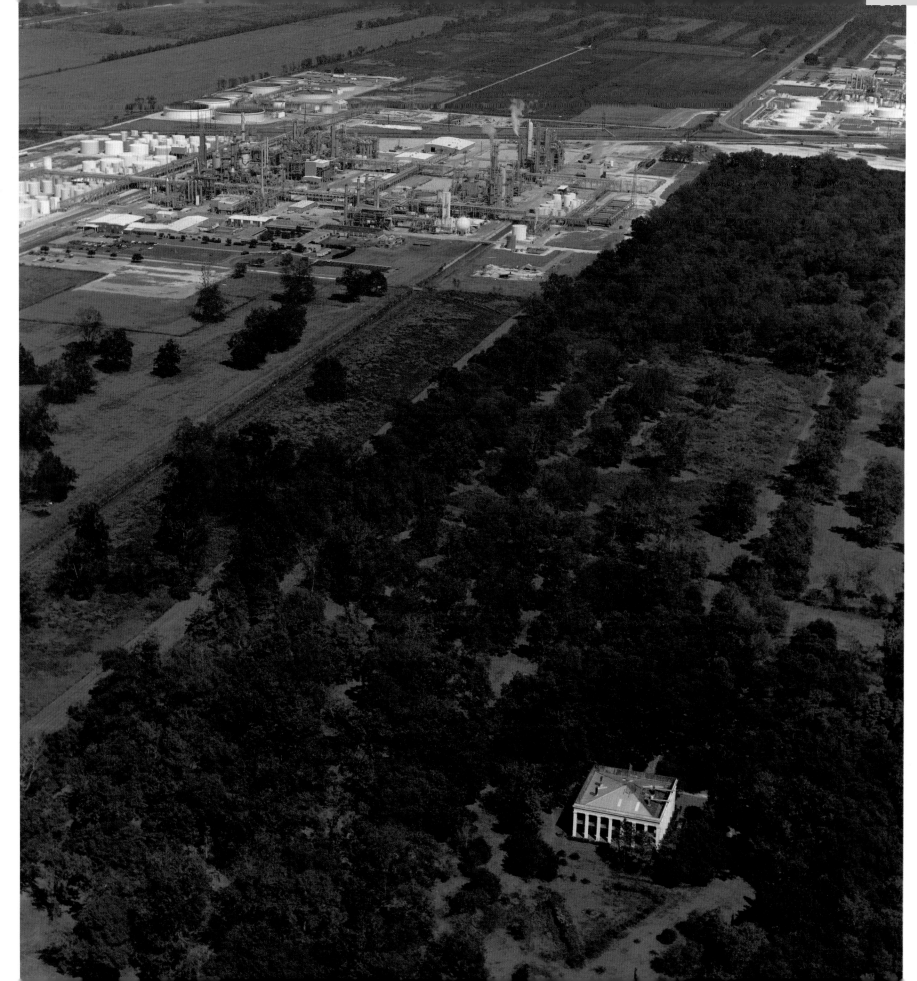

Belle Helene

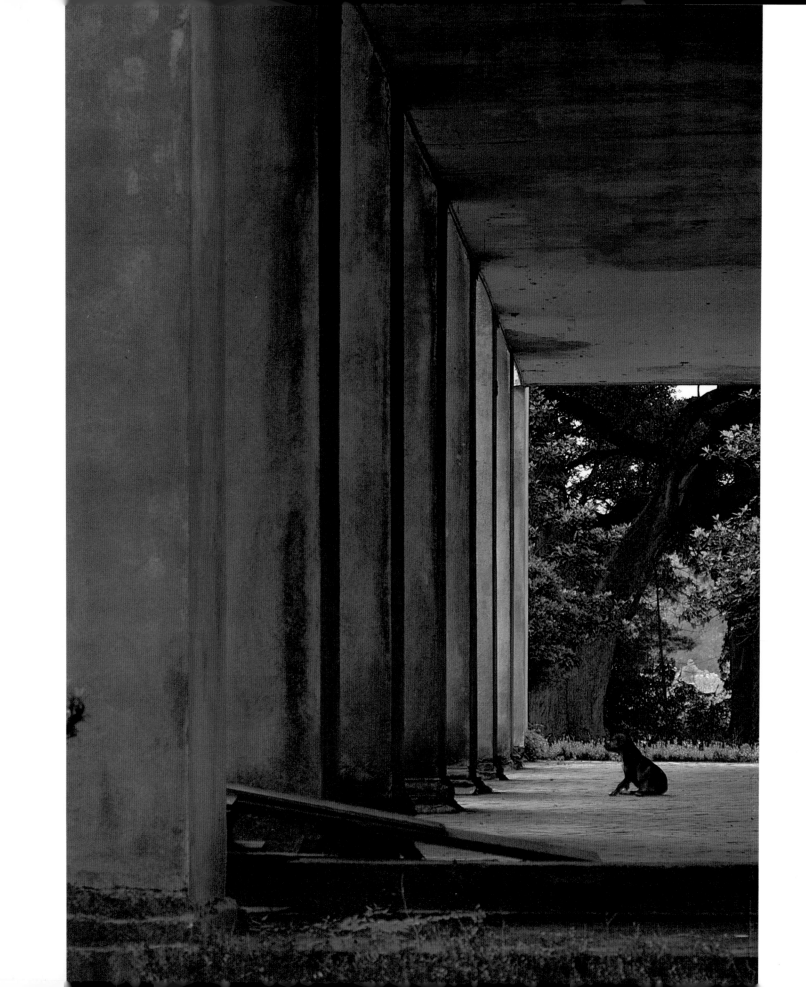

Reflections of Belle Helene

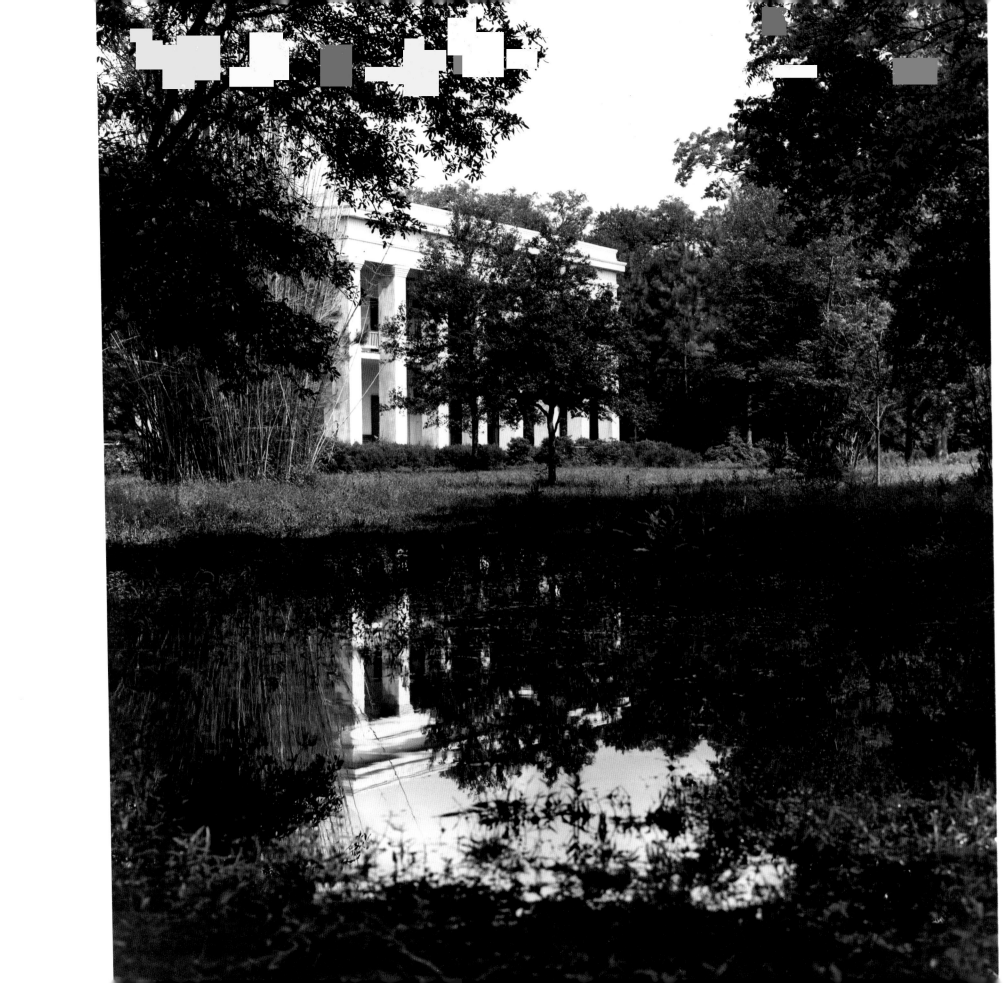

One of the most delightful plantation-life customs still remaining is the lighting of bonfires on the levee on Christmas Eve "to light Santa's way." Several practices contributed to the formation of the custom, which has become almost an annual festival in the Gramercy-Lutcher area, about half-way between Baton Rouge and New Orleans.

On the plantation, slaves were allowed to build a Christmas bonfire to celebrate the occasion, and bonfires were lit on the levee to summon a passing steamboat or to mark the landing for arriving passengers.

Building the bonfire has become a family tradition, its construction techniques handed down from generation to generation. Work begins toward the end of November, and gradually the twenty-to-thirty-foot-tall pyramids rise on the levee, filled with more wood for a mightier flame. On the outside, after construction, stalks of **sugarcane are** layered on the pile, and when the bonfire is lit on Christmas Eve, the rapidly expanding steam in the stalks fills the air with multiple rapid-fire explosions.

Notes on Photography

Photography of Louisiana's plantation homes is essentially architectural photography, and since the work in this volume spans a period of about 20 years, the cameras and negative materials used reflect the influence of a rapidly changing technology.

In the early 1960s most of my work was in black and white, done with a 4 × 5 Sinar view camera equipped with a battery of Schneider lenses ranging from 65- and 90-mm Super Angulons to longer focal length Symmars, a 150-mm and 210-mm (I have reshuttered the lenses, and still use them regularly). Some of the photographs taken recently, including Mount Hope and Nottoway after restoration, were made with that 22-year-old Sinar.

Black-and-white architectural photography can be quite exacting, particularly in south Louisiana. Lighting contrast extends well beyond the easily printable range of most of our current film-developer combinations, and in order to hold detail in sun-light-bathed white columns and deep shadows made more intense by the shade of centuries-old live oaks, I had to resort to water-bath and compensating developers for my negatives. Most black-and-white Kodak Plus-X negatives were tray-developed by inspection in Edwal FG-7, in a 1-16 dilution. This is a semicompensating developer, giving fuller development to the shadows and restraining the buildup of excessive density in the highlights. By using it in conjunction with the time-proven technique of "expose for the shadows and develop for the highlights," I was able to capture a full range of tones, in most instances, on the negative and printed on #2 paper.

Black-and-white aerials, as well as color, were done with a 6 × 7 Pentax, using lenses ranging from 75-mm to 200-mm. In black and white, I used Ilford FP4 film, developed an additional 50 percent at higher altitudes for added contrast, but with normal development at lower altitudes. The Pentax offers shutter speeds up to 1/1000 of a second, which I used whenever possible to minimize the effects of the vibration that is sometimes quite a problem in a light plane.

Color films, in the air, were primarily Ektachrome 64 and 200, depending on the quantity and quality of light, and the altitude at which I was working. In general, I like to use as slow a film as the light will allow.

When Eastman introduced Vericolor negative film in the early 1970s, it made photography of our plantation homes much less complicated. The film brought about a huge breakthrough in terms of sharpness and lack of grain, and had an almost incredible exposure latitude. About the time Vericolor was introduced, I acquired my first 6 × 7 Pentax and during the next few years found the combination of the Pentax and Vericolor entrancing. The large single-lens reflex, built like an oversized 35-mm, allowed me to work in a much more fluid manner. The Pentax lenses gave me a new vision, whereas the camera allowed me to capture a sometimes fleeting image that might have vanished while I was setting up the view camera.

Now, in the early eighties, I seem to be returning to extensive use of the view camera. Although slower to use, the view camera requires more disciplined thought and a meditative approach.

There is a proper time of day and time of year for the best photographic rendition of any structure. In the Louisiana springtime, foliage is more delicate, brighter in color, and allows more light to penetrate the shadows that become heavier and heavier as the season progresses. Springtime comes early in south Louisiana, and sometimes the grass greens and flowers blossom in late February and early March.

Of course, some mansions face north, although they are nearly unanimous in facing their waterway. Hence, there is no sunlight on a north elevation until late March at best. In Natchez, however, few plantation homes face the river. Most were well placed in their own parklike settings, and a large number of builders chose to escape the heat of the noonday sun by facing their houses to the north. This brought us to their front lawns in the early morning and late afternoon, in the warmest part of the year.

If an amateur were to ask which film is best for this particular kind of photography, I would recommend Kodachrome 25. Unfortunately, Eastman doesn't make it in larger sizes, but I feel that it is the best, sharpest, and most forgiving transparency film on the market. For archival purposes, the image is the most permanent of any color material. The disadvantage, of course, is that the film is slow, but if the photographer will carry a tripod, the results will be well worth the effort.

If the house is open to the public and photography is permitted inside, Ektachrome 400 will allow the user to work without a tripod.

Index

Acadian House Museum, 44
Acosta, Dr. and Mrs. Val, 7
Afton Villa, 94
Aime, Felicité, 19
Aime, Gabriel, 17
Aime, Valcour: builder of La Petite Versaille, 17; purchased Felicity for daughter, 19; saved Jefferson College, 23
American Colonization Society, 74
American Oil Company, 13
Arlington (Franklin, La.), 36
Arlington (Lake Providence, La.), 66
Asphodel, 87–88
Auburn, 74–75
Audubon, John James, 87, 88
Austin, Stephen F., 62
Ayo, Dr. and Mrs. Ben, 35

Baines, Dr. Henry, 93
Banks, Nathaniel, 54
Barbour, C. A., 36
Barnes, Richard, 101
Barnes, Walton J., 101
Barroso, Thomas Villanueva, 33
Barrow, Bennett, 95
Barrow, David, 94
Barrow, William Ruffin, 101
Bauer, Mr. and Mrs. Carl, 36
Bayou Boeuf, 50–56 *passim*
Bayou Bourbeau, 46
Bayou Grosse Tête, 106, 107, 109
Bayou Huffpower, 53
Bayou Lafourche, 31, 32
Bayou Rouge, 53
Bayou St. John, 9
Bayou Sara, 98
Bayou Teche, 36–45 *passim*
Bayside, 41
Beacroft, Percival T., 83
Beauregard, P. G. T., 8
Beauregard, René, 8
Beauregard House, 8
Belfast (Stanton Hall), 80
Belle Alliance, 31
Belle Helene, 126–29
Berger, George, 85
Bienvenu, Pierre Antoine, 7
Bocage, 26–27
Bonfire, 130
Bon Sejour (Oak Alley), 20–21
Bowie, Jim, 62
Bradish, George, 3
Braithwaite (Orange Grove), 5–6
Bringier, Emmanuel Marius Pons, 26, 28
Bringier, Françoise, 26
Bringier, Michel Douradose, 26, 28
Brown, J. E., 93
Bry, Henry, 65
Bry House (Layton Castle), 65
Bubenzer, 54
Buckles family, 74
Burn, The, 72
Butler, Thomas, 93

Caldiera, Ernesto, 83
Campbell, George, 110
Cane River, 59, 60, 61
Carlin, Euphrasie, 36
Chalmette Battlefield, 8
Chalmette National Historic Park, 8

Cherry Grove, 82–83, mentioned, 77
Chretien, Felicité, 46–47
Chretien, Hypolite II, 46
Chretien, Hypolite III, 46
Chretien, Jules, 46
Chretien Point, 46–47
Churchill, Mr. and Mrs. C. S., 31
Clayton, Mrs. C. C., 124
Coincoin, Marie Therese, 60
College of Louisiana (Jefferson College), 23
Como, 102–103
Cornay, Mr. and Mrs. Louis J., 46
Cottage, The, 92–93
Couhig, Mr. and Mrs. Robert, 87
Crockett, Davy, 62
Crozat, Dr. George B., 24–25

Daigle, General and Mrs. E. J., 24
Dakin, James, 26
Daniell, Smith II, 70
D'Arby, François St. Marc, 43
Darby House, 42–43
Daughters of the American Revolution, 79
Davis, Alfred V., 77
Davis, Jane, 83
Davis, Jefferson, 83
Davis, Samuel, 83
Dease, Arlin, 91, 114, 118, 121
Dease, Mr. and Mrs. Jack, 114
De Barra, Don Evariste, 104
De Blanc, Despanet, 44
De la Houssaye, Paul Augustin le Pelletier, 44
DeLogny, Robin, 13
Delta Queen (steamboat), 20
Destrehan de Beaupre, Jean Noel, 12
Destrehan, 12–13
De Ternant, Charles Vencent, 104
De Ternant, Marquis Vencent, 104
D'Evereux, 74
D'Hauterive, 44
Dickinson, Charles H., 109
Ducros, Pierre, 33
Ducros, 33
Duffel, Dr. Edward, 124
Duncan, Dr. Stephen, 74
Dunleith, 77–78

East Feliciana Parish Courthouse, 86
Ellerslie, 99
Elliot, William St. John, 74
Elms Court, 76–77; mentioned, 83
Erwin, Joseph, 109
Evangeline State Park, 44
Evans, Nathaniel, 97
Evans, Sarah Bloomfield Spencer, 97
Evergreen, 14–15; mentioned, 53

Favrot, Louis, 110
Favrot, Pierre Joseph, 110
Felicity, 19
Fitzgerald, Mr. and Mrs. Frank, 56
Fort, Dennis, 62
Fortier family, 13
Fort Miro, 65
Fort Rosalie, 79
Foundation for Historical Louisiana, 112

Gabriel Oak, 44
Germania plantation, 124
Gordon, Mr. and Mrs. Mason, 73

Grant, Ulysses, 69, 79
Grant's canal, 66
Green, Thomas Marston, Jr., 71
Greenwood, 100–101
Grey, Mrs. E. J., 14
Grey, E. J. Foundation, 14

Hall, Weeks, 40
Hankinson, John, 73
Harding, Lyman, 74
Harper, Mr. and Mrs. Reuben L., 72
Hermitage, L', 28
Highland, 95
Hinckley, Mr. and Mrs. Arthur, Jr., 49
Hinckley, Oramel, 49
Hinckley, 48–49
Homeplace (Bayou Boeuf), 51
Home Place (Keller House), 13
Houmas House, 24–25
Houston, Sam, 53, 62
Howard, Henry, 118, 123

Indian Camp, 123
Irish Bend, 39
Isles Dernières, 38

Jackson, Andrew: Battle of New Orleans, 8; l'Hermitage, 28; signed land grant for Wytchwood, 55; married at Springfield, 71; duel with Dickinson, 108; mentioned, 33, 104
James Monroe (steamboat), 65
Jefferson College (Manresa Retreat House), 23
Johnson, William, 3
Joyce, John, 112
Judice, Dr. and Mrs. Robert C., 28

Keller House (Home Place), 13
Kendrick, Benjamin, 87
Kenilworth, 7
Kenner, Duncan, 127
Kleinpeter, Leon R., Jr., 110
Knobloch, Mr. and Mrs. E. R., 4
Knox, Nathan King, 112
Koch, Charles, 31

Labatut, Jean Baptiste, 104
Labatut, 104
Lady of the Lake, 45
Landry, Anne Marie Antionnette Desirée, 124
Land's End, 64
La Salle, Arthur E., 71
Last Island, 38
Lawyers' Row, 86
Layton, Robert II, 65
Layton Castle, 65
Lecompte, Ambrose II, 59
Le Petite Versaille, 17
L'Hermitage, 28; mentioned, 26
Little, Eliza, 79
Little, Peter, 79
Live Oak (West Feliciana Parish), 98
Live Oaks (Bayou Grosse Tête), 108–109
Locust Ridge (Highland), 95
Longfellow's *Evangeline*, 44
Longwood, 80–81; mentioned, 69
Lorreins, Don Santiago, 9
Louisiana Landmark Society, 9
Loyd's Hall, 56

McAdams Foundation, 80
McClure, James, 73

McCoy, Mary, 54
McDermott, Patrick, 93
McDonald, E. R., 69
McKittrick, Carlotta, 76
McKittrick, David, 76
Macland (Payne House), 50
MacNeil, Mrs. Douglas, 76, 83
Madewood, 32
Magnolia (Cane River), 59
Magnolia (below New Orleans), 3
Magnolia Mound, 112–14
Magnolia Ridge, 49
Manresa Retreat House (Jefferson College), 23
Marathon Oil Company, 22
Marist fathers, 23
Marmillion, Edward Bozonier, 17
Marmillion, Valsin, 17
Marshall, Mrs. Harold K., 32
Marshall, Henry, 64
Martin, Natalie, 35
Mary, 4
Melrose, 60
Merrill, Ayers P., 76
Merrill, Jane, 76
Metoyer, Augustine, 60
Metoyer, Claude Thomas Pierre, 60
Mexican Petroleum Company, 13
Miller, Alfred Richard, 106
Miller, Henry John, 106
Missionary Sisters of the Sacred Heart, 9
Monmouth, 73
Monte Vista, 110–111
Montgomery and Keyes, contractors, 72
Moore, John, 49
Morgan, Thomas Ashton, 5
Mound House, 106–107
Mount Hope, 114–115; mentioned, 131
Mulberry Grove, 124–125
Munson, Mr. and Mrs. Robert J., 55
Myrtles, The, 91

National Center for Hansen's Disease, 123
National Park Service, 8
National Trust for Historic Preservation, 40
Norton, Asa, 49
Norwood, Elias, 85
Nottoway, 118–22; mentioned, 114, 131
Nutt, Dr. Haller, 69, 81

Oak Alley, 20–21
Oakland (Cane River), 61–62
Oakland (West Feliciana), 96–97
Oaklawn Manor (Bayou Teche), 36–37
Oakley, 88–89
Oakwold (Evergreen, La.), 53
Obier, Mr. and Mrs. William P., 109
Opelousas Steamboat Company, 51
Orange Grove, 5–6

Pacquet, Charles, 13
Paillette, Jacques, 62
Pan American Southern Company, 13
Parlange, 104–105
Patten, Mrs. T. R., 66
Payne House (Macland), 50
Pearce, William, 53
Percy family, 99
Percy, Mr. and Mrs. Frank S., 101
Perkins, S. M., 53
Pilgrimage Garden Club, 80

Pirrie, Eliza, 88
Pitot, James, 9
Pitot House, 9
Pollock, Oliver, 101
Polmer, Irwin, 33
Polmer, Samuel, 33
Porter, Alexander, 38
Poste des Attakapas, 44
Potts, Dr. and Mrs. Robert, Jr., 24
Prescott, Aaron, 52
Prescott, Lewis D., 49
Prescott, Marshall, 52
Prescott, William Marshall, 49
Prothro, William, 62
Prudhomme family, 61
Pugh, Thomas, 32

Quirk family, 51
Quitman, John Anthony, 73

Randolph, John Hampden, 118
Reed family, 101
Reuss, John B., 124
Richardson, Francis D., 41
Riches, Mr. and Mrs. Ronald, 73
Richland, 84–85
Rienzi, 34–35
River Road Historical Society, 13
Roane, Mr. and Mrs. Robert, Jr., 41
Robards, Rachel, 71
Robin, François, 51
Roman, Jacques Telesphore III, 20
Rosalie, 79
Rosedown, 90–91
Rosella, 35
Rosemont, 83
Routh, Job, 69

Sandefur, T. T., 52
San Francisco, 16–17
St. Joseph Planting and Manufacturing Company, 19
St. Maurice, 62–63
Schwing Company, 106
Scott, Alexander, 85
Scott, Miss Eva, 85
Seven Oaks, 10–11
Shades, The, 85
Shadows-on-the-Teche, 40
Slave Cabins: brick, 59; wooden, 15, 117
Sloane, Samuel, 81
Small, Luther, 62
Smith, Myra, 74
Sparrow, Edward, 66
Springfield, 71
Stanton, Frederic, 80
Stanton College, 80
Stanton Hall, 80
Stephenson family, 51
Stewart, Mr. and Mrs. Andrew, 20
Stewart, Mrs. Nolan, 112
Stewart-Dougherty, 112
Sunflower, 52
Surget, Frank, 76, 83
Surget, James, 76
Surget, Pierre, 83

Tally-Ho, 116–17
Tanner, Robert, 55
Tezcuco, 24
Thibodaux, Jean Baptiste, 35

Thistlewaite home (Macland), 50
Thistlewaite Planting Company, 50
Thompson, Mr. and Mrs. George, 36
Town and Country Garden Club, 74
Trade Winds (hotel), 38
Trinity, 110
Tureaud, Aglae, 24
Tureaud, Benjamin, 24
Turnbull, Daniel, 91
Turnbull, Martha, 91
Turner, Mr. and Mrs. Bert, 98

Underwood, Mr. and Mrs. Milton, 91
United States Public Health Service Hospital, 123

Valcour Aime, 17–18
Valverda, 106
Van Buren, Martin, 55
Vicksburg campaign, 66, 69, 70, 79

Wade, William C., 99
Walworth, John P., 72
Ward, Robert S., 91
Waverly, 93
Webb, Amelia and Dr. Lewis, 50
Weeks, David, 40
Weeks, Mrs. David, 49
Weeks, Levi, 74
Welham, Riene Theriot, 22
Welham, William Peter, 22
Welham, 22
Westwego, 10
Wikoff, Stephen W., 51
Wikoff House (Homeplace, Bayou Boeuf), 51
Wilkinson, Horace, Jr., 110
Wilkinson, Horace IV, 110
Wilkinson, James, 110
Wilson, Andrew, 79
Windsor Castle, 70
Winter Quarters, 69; mentioned, 80
Woodland (Macland), 50
Woolfolk, Austin, 106
Wright, Mr. and Mrs. Porter B., 53
Wytchwood, 55